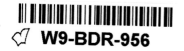

THOMAS HART BENTON

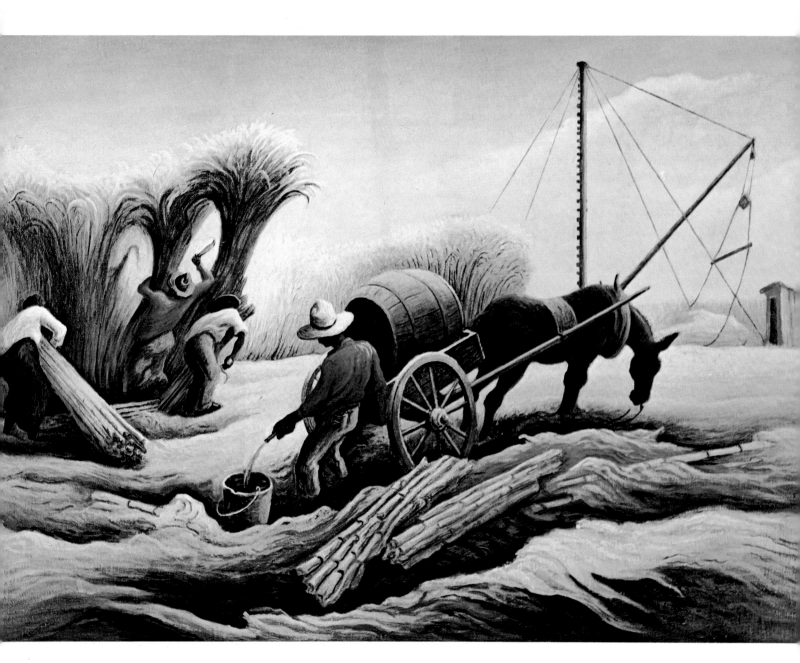

Frontispiece. *Sugar Cane*. 1943. Oil and tempera on canvas mounted on panel, 31 × 48″. Collection Rita Benton, Kansas City

NEW CONCISE NAL EDITION

THOMAS HART BENTON

Text by MATTHEW BAIGELL

HARRY N. ABRAMS, INC., PUBLISHERS, NEW YORK
Distributed by NEW AMERICAN LIBRARY

TO BESS AND JOE

Nai Y. Chang, *Vice-President, Design and Production*
John L. Hochmann, *Executive Editor*
Margaret L. Kaplan, *Managing Editor*
Barbara Lyons, *Director, Photo Department, Rights and Reproductions*
Ruth Eisenstein, *Editor*
Michael Sonino, *Abridgment*

Library of Congress Cataloging in Publication Data
Benton, Thomas Hart, 1889–1975.
 Thomas Hart Benton.
 Bibliography: p.
 1. Benton, Thomas Hart, 1889–1975. I. Baigell, Matthew.
ND237.B47B3 1975 759.13 75-8851
ISBN 0-8109-2055-7

CONTENTS

ACKNOWLEDGMENT

During the preparation of this book, the late Thomas Hart
Benton answered innumerable questions and checked many dates
and facts. For his constant encouragement and good cheer, I offer
my heartfelt thanks. I owe a special debt of gratitude to Ruth
Eisenstein for her splendid editorial supervision of all aspects of
the text. I also want to thank Lisa Pontell, who in securing the
illustrative material revealed great imaginative resources.

INTRODUCTION

During the 1930s Thomas Hart Benton held a commanding and conspicuous position in American art. Controversial in the extreme, both as an artist and as a social commentator, he generated the degree of publicity associated with such other artists as Picasso, Dali, and Rivera in that highly polemic decade. To some he was one of the best contemporary painters, savior (and instigator) of a truly American stream of art. To others he was a "bully" and a "loudmouth," vehement and highly vocal in his opinions, prolific and notably successful in his art, but limited or even of negative value from an aesthetic point of view. In either case the intensity of feeling he aroused was consistent. Few observers of the fortunes of American art were neutral toward him.

As the partisan arguments of that earlier time have receded, Benton has remained a prominent figure. Nowadays, however, his name is most often invoked by those who view the period between the two world wars as "classic camp" or, more seriously, by those who make him the scapegoat for an entire school of American artists who clung to their "provincialisms" instead of exploring international stylistic innovations or adopting politically radical positions.

Benton's work, manner, and personality must carry some enduring substance, some impact, to have provoked such sharp responses over the decades. If his paintings are to be lightly regarded, then both he and the criticisms of him should have been forgotten years ago, but that is not the case. What nerves has he touched to so irritate his critics? And what values inhere in his work to give it a secure place in the art history of his period in America?

A dispassionate assessment cannot be made by anybody who, assuming an old-fashioned, Darwinian attitude, considers an artist's work only within the context of the evolution of modern art. Rather, the questions raised by Benton's art are related to the perennially conflicting viewpoints on what the function of an artist in society may or should be: his commitment to his local and national heritage and his responsibility for the communication of art and ideas to a general public. Benton was committed to the development of an American art derived from the American Scene. His achievements and his struggles toward this goal are the subject of this book.

Benton belonged to the last generation of artists who considered seriously the dreams and myths of the country. The end of a line that reached back to the early years of the Republic, these artists wanted to provide Americans with a democratic art easily accessible to the average citizen. The emphasis in this volume on Benton's murals has been deliberate because they represent, to a greater extent than his easel paintings, an intimate relationship between the artist and his society that has probably disappeared forever.

1. *Self-Portrait*. 1970. Polymer tempera on canvas, 40 × 30″. Collection Rita Benton, Kansas City

I have a sort of inner conviction that for all the possible limitations of my mind and the distorting effects of my processes, for all the contradicting struggles and failures I have gone through with, I have come to something that is in the image of America and the American people of my time. This conviction is in me pretty deeply. . . . My American image is made up of what I have come across, of what was "there" in the time of my experience—no more, no less.

<div align="right">THOMAS HART BENTON</div>

PART I

THE FAMILY HERITAGE

FIRST ARTISTIC VENTURES

THE YEARS IN FRANCE

FIRST NEW YORK EXPERIENCE

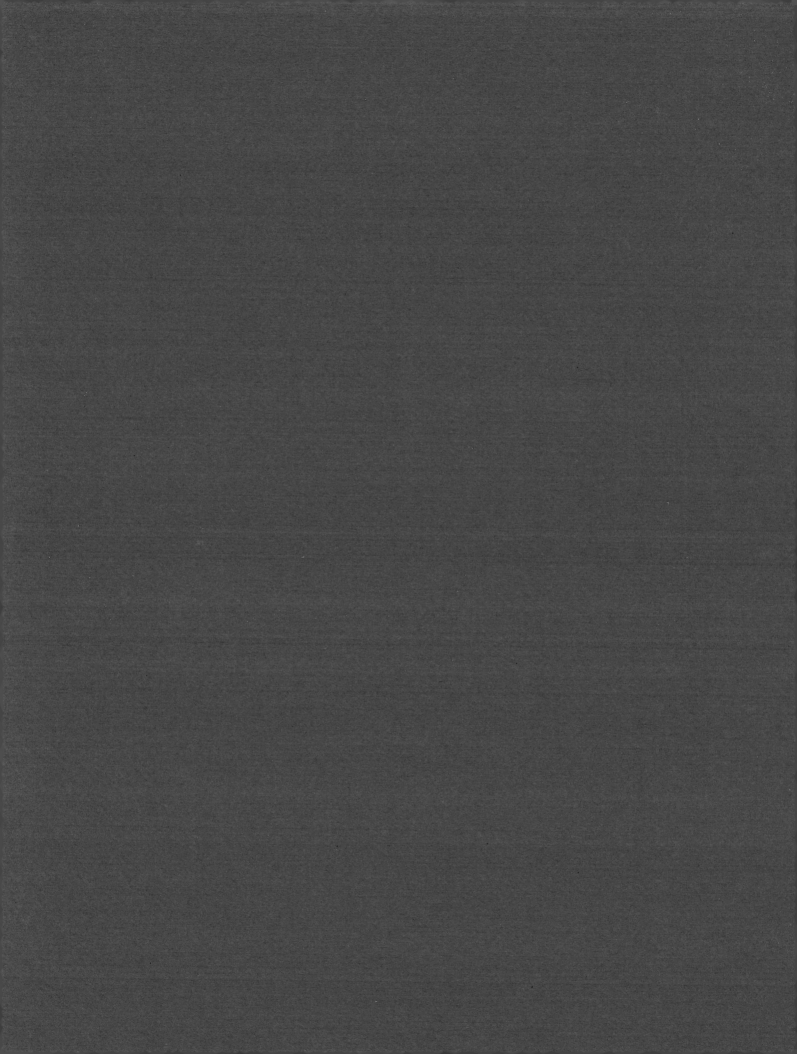

THE FAMILY HERITAGE

Benton's mature production falls easily into two broad categories: works executed up to about 1918, adhering to the modern styles then current in Paris, and those done afterward, when he abandoned the School of Paris in search of an art with American meanings for the American majority culture.

The "Americanist" Benton, as opposed to the "modernist" Benton, might have developed differently had he come into a different family heritage. Born in Neosho, Missouri, in 1889, Thomas Hart Benton was named after his great-uncle, a major political figure and an exponent of Western expansionism who served in the United States Senate between 1821 and 1851. Benton's father, a Tennessean who had been in the Confederate army, settled in Neosho in 1869 and in time also became prominent in politics, serving as United States Attorney for western Missouri and as a member of the United States House of Representatives between 1897 and 1905, where he was a member of the Committee for Indian Affairs and the Committee for Appropriations.

These genealogical facts are significant because Benton (unlike certain others of his contemporaries) deliberately cultivated his roots when he became a painter, absorbing through his family interests an intense concern for the American land, its citizenry, its politics, and its destiny. One might view him, in fact, as a latter-day John Trumbull: just as that son of a Connecticut governor believed that recording events of the Revolutionary War was a noble accomplishment for an artist, so Benton, following family ties and personal inclination, seems to have decided that he could best serve in his chosen field by celebrating American experiences. In view of his heritage and his deep respect for it, the wonder is not that he chose to develop an Americanist style but that he ever dallied with Parisian modernism.

Benton remembered that during his childhood politics formed the core of his family life. His father often invited famous persons to the house, including such figures as William Jennings Bryan, and frequently took the boy to camp meetings, rallies, and barbecues, both in backwoods regions and in county seats. Repeatedly exposed to the types of political enterprise undertaken in a rural constituency, Benton identified closely with his father's activities and became intimately involved with them. From his father's cronies he heard many old Civil War stories and tales of the early settlements, and when, as a youngster, he sometimes traveled into Indian territory (in what is now Oklahoma), he observed actual frontier conditions that confirmed the older men's descriptions.

Benton did not find growing up in a small town emotionally inhibiting, as did so many other artists and writers of his generation. At or near the center of attention in his community, he lived the kind of youthful existence more often read about than actually

experienced. Family finances were certainly adequate, visitors frequently appeared, and jollity, if not frivolity, marked the temper of his days. The trips to rustic areas provided the kind of adventures that others could enjoy only in fantasy. He recalled shaking hands with Buffalo Bill. Few artists have had combined in their childhood the privilege of being the son in a leading family and the pleasure of growing up a Huck Finn.

Past history, for Benton, reached into the present. Completely at home with the background of his ancestors, he viewed his own personal history as evolving directly from theirs. Not only did he hear stories about the past; he could also, in effect, visit it. His family was a tangible part of the area's history, and to a child growing up in a small, isolated town in southwestern Missouri this was not a fact that could be accepted casually or readily forgotten.

The society he knew and the attitudes he absorbed early in life help to explain Benton's often belligerent posture in his later career. He wanted to emerge not only as an artist but as a man, to live up to the expectations of his family and prove himself equal to his political upbringing. Perhaps this was what prompted him to project a personal image emphasizing physical strength and masculinity—witness his boasting about drinking exploits. He must have particularly resented the notion, common in the materialistic business and legal world of America in his youth, that an artist was not quite a full man. In actuality he had great stamina, and the energy with which, as a struggling young artist in New York City, he would swim across the Hudson River was again evident in the remarkable speed with which he was able later to execute large mural projects. Although well-read, he tended to strike an anti-intellectual pose, and his disdain for homosexuals in the art world was outspoken.

Perhaps his family heritage also motivated Benton to seek a broader audience than that provided solely by his art. The author of not one but two autobiographies (the first is devoted more to his life-style, the second to his development as an artist), he also wrote a considerable number of articles and essays and had often appeared as a public speaker. From his writings there emerge the vigorous images of the artist as a David fighting the Goliath of the School of Paris and as a Paul Revere warning his fellow artists against the modern-day redcoats. Not a little of Daniel Boone and other such pioneering characters seems to be evoked as well. Benton, by his own example, perhaps made more rough-and-tumble than necessary, tried to show how an American art might be explored and developed in ways pertinent to and reflecting the American experience.

His art, then, is not only a matter of chronology, stylistic development, and artistic insight. It also carries elements of a saga, and one can observe how it was created in relation to the culture that nourished it.

FIRST ARTISTIC VENTURES

Children of Benton's day were not exposed to art in as many ways as children are today. Nevertheless, he displayed an early interest in art, and his curiosity was not discouraged. When he began to sketch and paint, he often pictured railroad trains and Indians, normal objects of attraction for any small-town youth. Engines particularly fascinated him, an interest maintained into adulthood. For Indian subjects Benton was able to recall actual observation rather than having to rely upon the caricatures and, in many cases, misrepresentations in popular lithographs and paintings. Since the mature Benton profoundly believed that art should develop from experience, these first artistic ventures may have a significance far beyond their level of accomplishment; they suggest the beginnings from which he developed his lasting attitude toward subject matter.

His formal art instruction began in Washington, D.C., where his father was serving in the House of Representatives. Attending classes at the Corcoran Gallery of Art, he learned to draw arrangements of cubic blocks. This teaching device may have lingered on in Benton's later habit of blocking in both figures and spatial units by means of cubic forms (plates 2) before making his final studies (plate 3).

His decision to become an artist, however, was not consciously reached in Washington while admiring the paintings in the Corcoran Gallery or the Library of Congress but was arrived at almost by chance on a Saturday night in a bar in Joplin, Missouri. After the family returned to Neosho, following his father's failure to win reelection in 1904, Benton became restless and went to Joplin to get a job. Examining rather too closely a painting of a barroom nude, he became the butt of some wisecracks. He countered by saying that he had been studying the work because he was an artist. Challenged at once to prove this, he felt moved to apply that very evening for a position with the Joplin *American* as a cartoonist, a job that he was ill-prepared to handle but obtained nevertheless. Although it lasted only a few months, it gave the young man's life the direction that had been lacking. By February 1907, Benton began to study seriously at the Art Institute of Chicago, intending to become a newspaper illustrator.

He spent nearly two years in Chicago, and they were both disappointing and satisfying. The liberating influences provided by that city for a host of poets and writers in the years before World War I were largely lost on Benton. In part the reasons were personal. His choice of art as a career immediately caused emotional tension between himself as an artist and his political and business-oriented family, a conflict that probably was never fully resolved, even though he always remained on good terms with them. Furthermore, Benton's notions of an artist's role did not correspond to the regimen the Institute imposed on its students. Already wanting to learn about life from the living,

he found deadening the prescribed studies from plaster casts, and made his way into the life classes.

He learned to enjoy Whistler's paintings and Japanese prints through the guidance of Frederick Oswald, one of his teachers. The city itself also helped to color his subsequent responses to both urban and rural environments. Living there at the end of the great building boom that saw the emergence of the modern skyscraper, Benton first became aware of the incredible speed with which the country was developing. Basically a country boy, despite his years in Washington, he found a modern romanticism in the architectural expression of steel. The urban exuberance of movement, expansion, and height was, years later, transformed into the thrusting images that recorded his sense of the kinetic energies coursing through American life.

Responding to these stimuli but also realizing that he was learning little of immediate value, Benton wanted to leave Chicago for a more cosmopolitan center, hoping to find answers to the vaguely formulated questions he was then asking about art and the life of the artist. He convinced his family that his needs were vaster than Chicago could satisfy and, with his parents' consent, sailed for Europe in 1908, arriving in Paris toward the end of the summer.

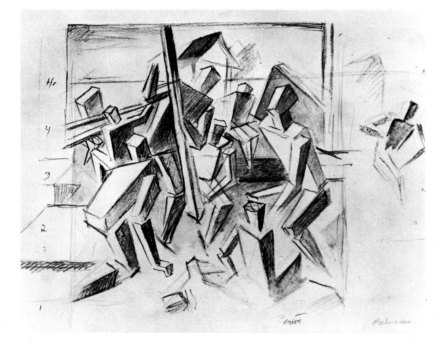

2. Study (sketchbook exercise) for *Palisades*. c. 1920. Pencil drawing, 9 × 12″. Collection the artist

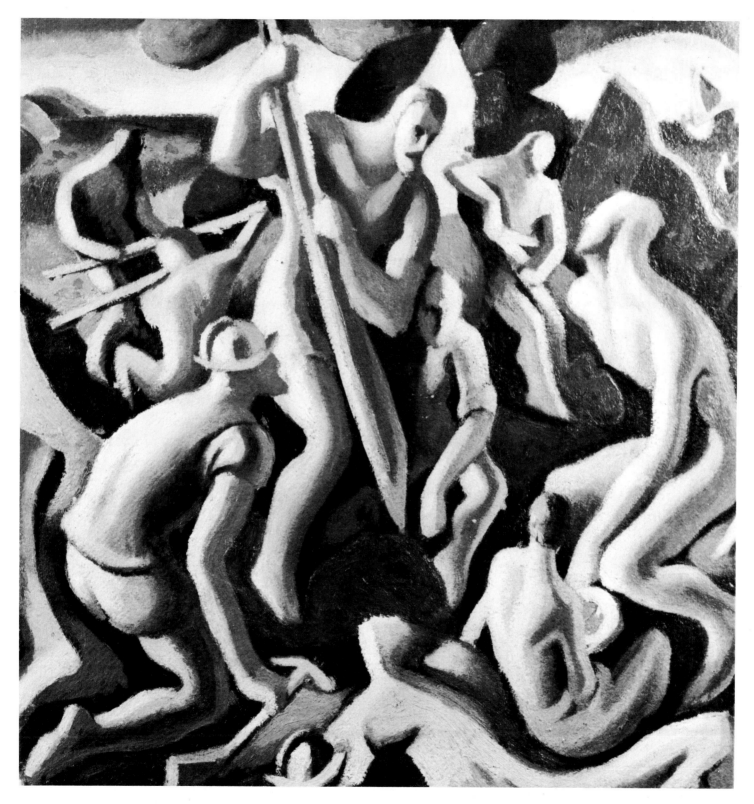

3. Study for *Palisades (American Historical Epic)*. c. 1921. Oil on canvas, c. 18 × 20″. Collection the artist

THE YEARS IN FRANCE

Initially, Benton was not prepared for the intellectual and visual shocks of avant-garde art. The Armory Show, which helped to introduce modern art to American audiences, was still five years away, and there were as yet relatively few Americans in Paris devoted to the newest movements. (Max Weber, for example, had arrived only three years before, in 1905.)

Benton enrolled in the Académie Julian, where he found himself studying from plaster casts again. The physical journey from Chicago had gained him little, after all, and he soon realized that his skills as an academic draftsman were, at best, indifferent. However, during the eight months he studied at the Julian, he became acquainted with the recent art movements and began the other journey traveled by American artists in Paris. Starting with Impressionism, he explored the history of modern art by studying the works of successive groups of painters, working his way gradually to Cubism and the art of the moment.

Here was material to jolt any artist and give pause to even the most adventurous. For a few years Benton painted in both traditional and modernist styles simultaneously, even during the same day. This fracturing of purpose carried over into his private life as well. Whatever diversions he could find in Paris—café life, bohemian friendships—were vitiated by his insecurities in intellectual give-and-take and by his anxieties concerning his talents. A doer rather than a talker, he was ill at ease in café discussions and did not easily join in convivial camaraderie with other young artists.

In the winter of 1909, while still a student at the Julian, Benton undertook his first experiments with Impressionist techniques, helped by the American painter John Thompson. Benton was particularly attracted to Pissarro's work because of the sense of structure it imparted to him. He learned to alter the tonal palette he had used at the Julian, substituting variations of color, based on the spectrum, for the gradations of lightness and darkness called for in traditional academic painting.

From this point, he moved on to Cézanne and to the Renaissance and Baroque painters, whose works he began to study in the Louvre. From the old masters he learned compositional devices and types of color harmonies, but from Cézanne he absorbed little. Already a draftsman confirmed in his perception of form by means of contour, he resisted Cézanne's breaking up of form by areas of color and dissolving of large shapes into separate, though interlocking, planes.

However, Benton responded very favorably to the exhibition he saw in 1910 of the work of the Neo-Impressionist Paul Signac. He was quick to realize that while colors in a Neo-Impressionist painting were broken up, forms remained whole and integral.

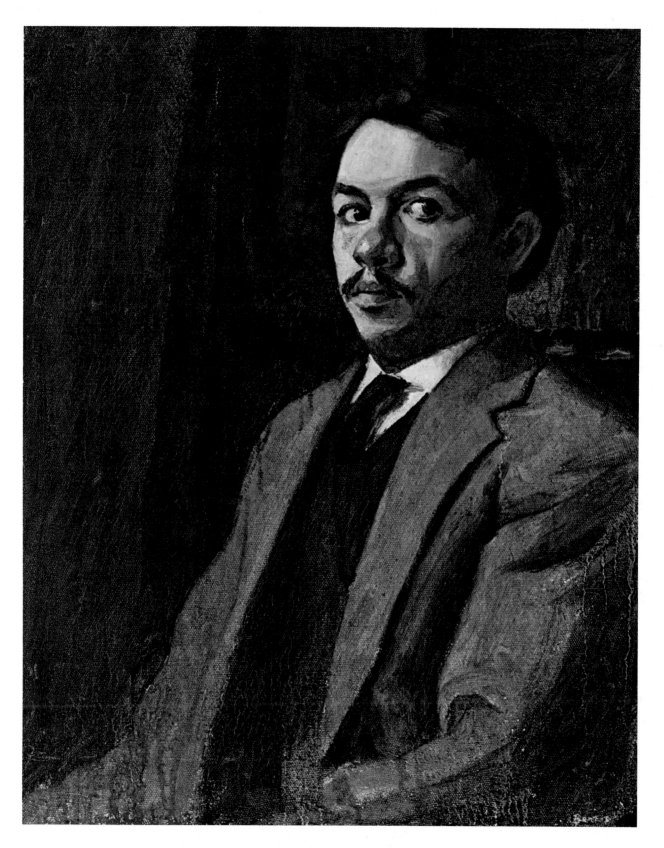

4. *Self-Portrait*. 1909. Oil on canvas, 20 1/4 × 16 1/4″. Collection the artist

For him, Neo-Impressionism might well have qualified as the ideal modern style—modern devices of coloration combined with a traditional sense of form.

Developing further his Impressionist-derived studies, he now began to model more obviously with different colors than with tones of the same color. Warm colors, such as yellow, served as the light tones: cooler colors, such as blue, served as darker tones. Roundness and bulk were suggested by variations in intensity of a particular color, rather than by tonal modeling.

Unfortunately, Benton's growth as a modernist painter in Paris can be followed only through his reminiscences, for almost all the paintings of this period perished in the blaze that destroyed the family home in Neosho in 1917. One of the few surviving works, *Chestnut Tree—Contre Soleil,* offers only a very imperfect idea of his concerns (plate 5). Painted during the summer of 1910 in the south of France, where he was attempting to synthesize the techniques he had recently learned with the skills he had earlier acquired, the work is a mixture of stylistic motifs, combining a Neo-Impressionist stipple technique with highlights and shadows indicated by traditional tonal means. As the effort of a twenty-one-year-old, its indecisive qualities—neither entirely modern nor completely old-fashioned—metaphorically describe Benton's entire European experience. In it, one perceives his desire both to learn the new and to maintain the old.

In later years, after he had renounced modernism, he minimized the effect of his experiences abroad, stating that an introduction to art history, a love of French literature, and an ability to think in a foreign language were the most valuable mementos he was able to bring home. Although he would admit the modernist need to reexamine form and meaning in the face of academic literalism, he seemed always amazed that he had ever found modern art as attractive as he had.

FIRST NEW YORK EXPERIENCE

Benton returned home in July 1911, and after an aimless interval, spent partly in Neosho and partly in Kansas City, went to New York City late the following spring. Here, living the picaresque life of a young painter who has not yet found his supportive public, he held a variety of jobs, working as a commercial artist, as a decorator of ceramics, and, in 1914, as a set designer for motion-picture studios then located across the Hudson River in Fort Lee, New Jersey. Occasionally he painted portraits of popular motion-picture stars that were as traditional as his other portraits of the time (plate 6).

Whatever his wariness of Left Bank intellectuals, or his problems with discussions of

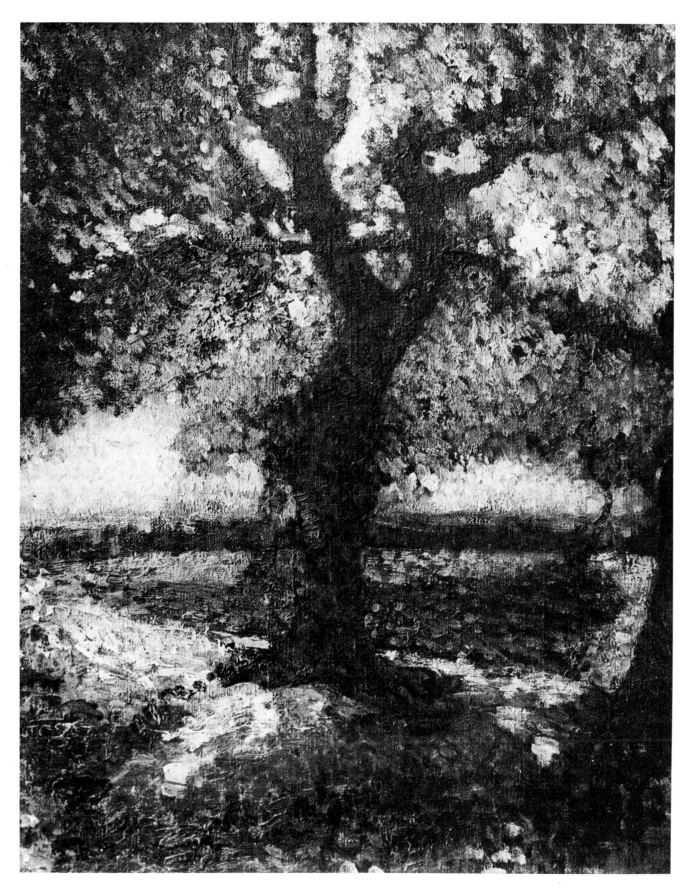

5. *Chestnut Tree—Contre Soleil.* 1910. Oil on canvas, 20 1/4 × 16 1/4″. Collection the artist

abstract theories, Benton did not reject modernism in the years immediately after he returned to America but continued to experiment with various styles until World War I. His experiments might better be termed forays, since he tried now one, now another manner while continuing to produce realistic paintings. With the course of his later career in mind, it is easy to understand his radical swings of taste. In effect, he had posed for himself the wrong set of problems. Adhering to the modernist respect for two-dimensionality, Benton fought down his impulses to manipulate forms in depth. Also yielding to the modern trend toward neutralization of subject matter, he slighted his innate gifts as a storyteller (which are evident in his writing as well as his art). He felt compelled to paint in modern styles both because they were regarded as the most progressive modes in the Paris he had recently left and because they advertised a progressive posture on his own part. He has admitted that he, like other young Americans at the time, could not think of art, modern or traditional, apart from the styles promoted in Paris.

The painting *Girl in Park,* which survived the Neosho fire, provides some idea of Benton's modernist phase (plate 7). Painted shortly after he returned home, it is fresh with memories of his stay abroad. Large areas of Fauve color jostle sections of small Neo-Impressionist strokes, a combination not uncommon in painting of the period. Benton's ambivalence in regard to means of suggesting form—flattened patterns of color versus tonal modeling—can also be discerned. The pinks in the tree at the left represent the former technique, while the brown and green trees behind reflect the latter. Again, such combinations were not uncommon then. That Benton was aware of them and the problems they engendered attests his understanding of modern composition.

Certain features, however, already signal the authentic Benton. Edges are heavily emphasized and darker colors act as bounding planes. He wanted both to suggest depth and, at the same time, to allow his forms to cling to the picture surface as flat patterns. Consequently, the girl's hat in the foreground is echoed by a similar curve in the middle ground and a green curve toward the distance. Also, the eye can follow a sequence of coinciding edges running from the yellow bush in the lower left to the green bushes in the farther distance and then back down the long branch of the tree. One sees a flat, triangular pattern as well as a series of forms in recession similar to those in his subsequent paintings.

Another early work, *Still Life with Fruit and Vegetables* (plate 8), probably reflects a brief period of attraction to Cézanne. After arriving in New York, he was befriended by Samuel Halpert, also recently returned from Europe, who introduced Benton once again to the intricacies of Cézanne's flattened planes and color areas. Again, however, Benton soon lost interest (he never followed the example so far as to loosen up the

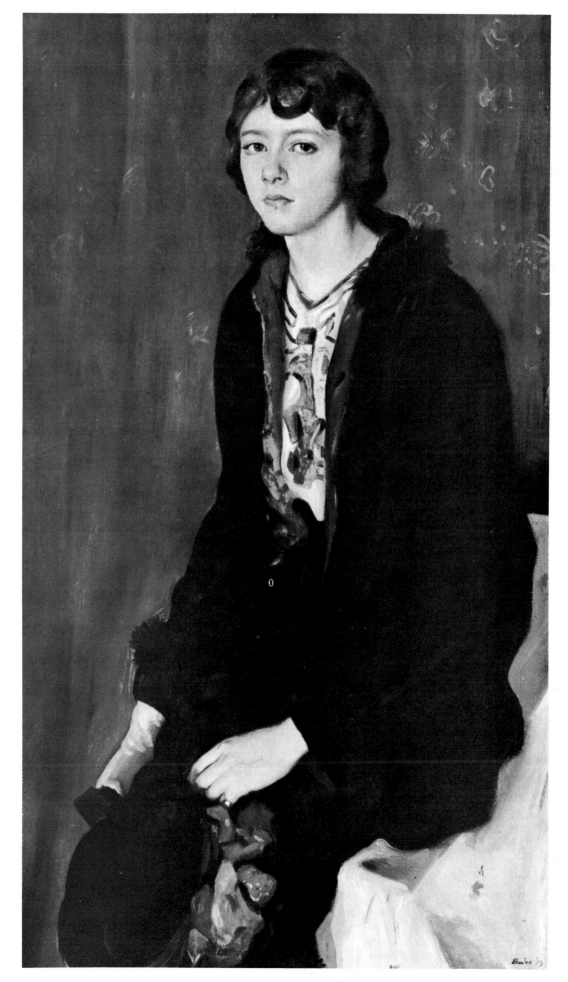

Portrait of the Artist's Sister. 1913.
Oil on canvas, 48 1/2 × 27 1/2″.
New Britain Museum of American Art,
New Britain, Connecticut.
On loan from Mrs. Mildred Small

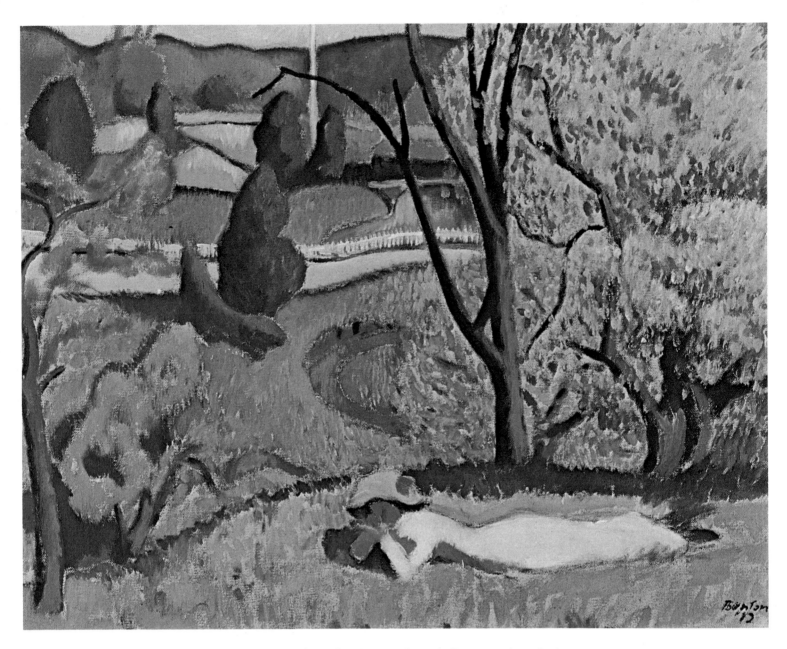

7. *Girl in Park*. 1913. Oil on canvas, 18 5/8 × 23 5/8″. Collection Mr. and Mrs. William N. Bush, Burbank

edges of his forms), only to fall momentarily under the influence of Braque. Benton would have been familiar with most of the European styles exhibited in the Armory Show in 1913 (which he unfortunately missed because he had been called back to Neosho owing to his mother's illness). He undoubtedly lost a good opportunity to compare them and sort out their influences on his own work.

In 1914 he began to explore yet another style. Stanton Macdonald-Wright, one of his closest friends in Paris, arrived in New York and soon thereafter he and the co-founder of the Synchromist movement, Morgan Russell, exhibited their Synchromist

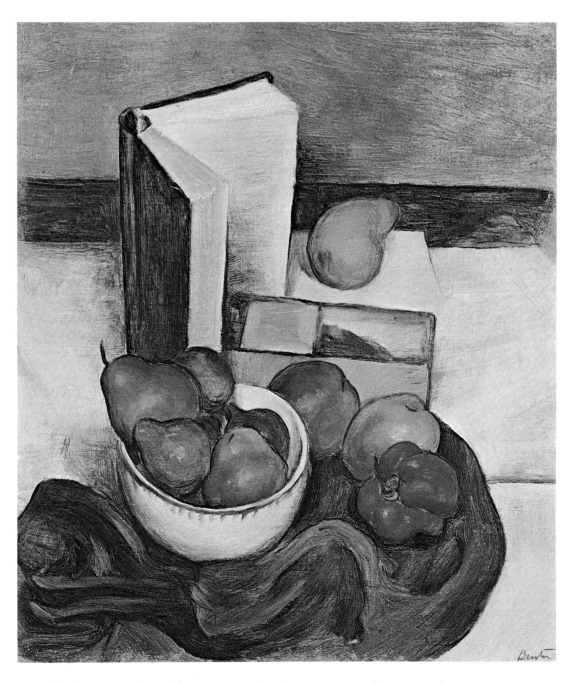

8. *Still Life with Fruit and Vegetables*. c. 1912–14. Oil on canvas, 20 × 18″. Collection Mr. and Mrs. William N. Bush, Burbank

paintings. Benton, who had returned to America before the first Synchromist exhibition, in Paris, began to experiment with the color effects of this style. He was drawn to it not simply for reasons of friendship but also because he enjoyed its surging rhythms, which were partially derived from Michelangelo's sculptures and thus provided a logical connection between the orderly forms of past styles and the color experiments of current art. In the Synchromist style he found something of the kind of pictorial form he sought—a combination of active contours and brightly colored areas which held suggestions of depth.

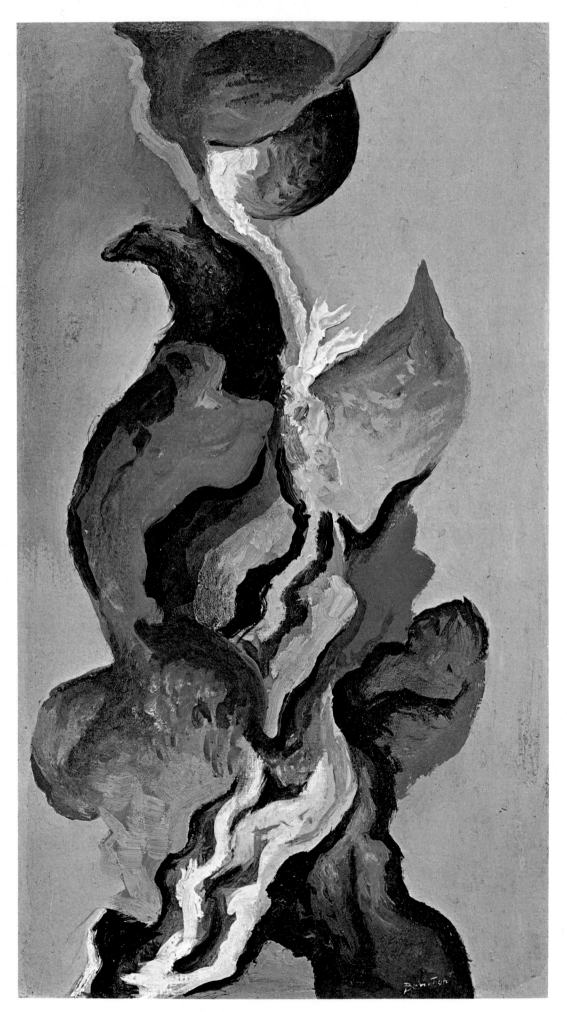

9. *Autumn Leaves.* c. 1920.
Oil on panel, 15 1/2 × 8 3/4″.
Graham Gallery, New York

10. *Constructivist Still Life.* c. 1918
Egg tempera on panel, 14 × 8 1/2″.
Graham Gallery, New York

Unhappily, all Benton's purely Synchromist studies have been lost, and the chronology of his work for the next four years, 1914 to 1918, has grown indistinct. Thus the impact of Synchromism on his work cannot now be fully assessed. However, at least three distinct manners emerged in his painting in this period.

In one manner color manipulations dominated tonal gradations. Modeling was often indicated by intensities of color rather than by lights and darks. In interesting displays of technical virtuosity, Benton arranged dark-valued reds or blues near lighter-valued colors, causing the latter to pale into the background. By emphasizing the darker-colored objects in this way he could create passages that looked like photographic negatives, thus focusing the viewer's attention on the formal rhythms of a piece (plate 9). Highly sophisticated, despite Benton's later disclaimers, these works indicate his familiarity with Parisian modernism and a facility with some of the various means developed by its chief exponents.

In the second manner Benton explored what sometimes look like abstract city and landscape scenes but in actuality were studies made from pieces of colored paper set on sticks and wired together (plate 10). In these works there is a greater emphasis on spatial interactions. Edges are firmer, so that the forms are more clearly defined and more forcefully positioned in space. The use of dark and light passages varies considerably. In some cases, a dark or a light red is so abruptly stated that it does not suggest rounded volumes. In others, the changes from dark to light are graduated, so that actual modeling and spatial penetration of forms are suggested. As a result, spaces appear ambiguous even when the forms are arranged in coherent two-dimensional patterns. Filled with interesting possibilities for development, this style could have evolved into an abstract counterpart of Benton's later realistic manner had he remained a modernist painter.

The third manner that Benton developed in these early years was much more realistic than the first two. In the works in question, based on Michelangelo's sculpture (especially the relief of the *Battle of the Lapiths and the Centaurs*), Benton attempted to project recognizable figural motion by means of Synchromist color techniques (plate 11). Begun in the winter of 1915–16, the paintings were exhibited in the Forum Exhibition of Modern American Painters in March 1916, an important first gathering of young American modernists and, incidentally, Benton's first showing in New York City.

These figure studies, highly prophetic for his subsequent development, were virtually impossible to realize successfully because of the means Benton chose. Sculptural forms in painting had usually been rendered by tonal gradations; Synchromist paintings depended to a greater extent on color contrasts. The paintings were, indeed, bright-colored. Each figure was given "what amounted to a solid 'local color'—red, orange, green, or yellow—just as I might have painted a red apple, an orange orange, a green

pepper. . . . The interstices between the figures—the recessive parts of my designs—were painted with blues, deep violets, and blue greens. The effect was colorful, but tended to flatten my pictures." Furthermore, Benton's concern for linear definition complicated his realization of the figures. These contours became so insistent that they established surface patterns independent of the human figures they were supposed to delineate.

The works shown in the Forum Exhibition, as well as other paintings of the period, reflect yet another dilemma that Benton faced. Should pictures have recognizable subject matter, and if so, should the imagery be meaningful or simply a departure point for abstract manipulation? Benton had written for the exhibition catalogue a statement ending with this paragraph: "In conclusion I wish to say that I make no distinctions as

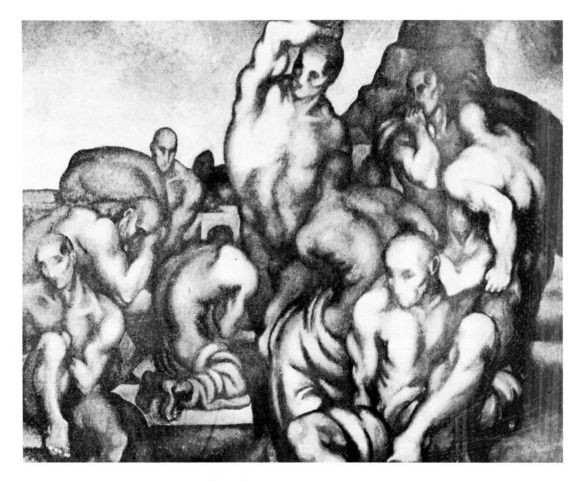

11. *Figure Organization No. 3.* c. 1916. Whereabouts unknown

to the value of subject matter. I believe the representation of objective forms and the presentation of abstract ideas of form to be of equal artistic value." In later years Benton often said that he subsequently changed his opinion, but in 1971 he admitted that these words were "suggested by Willard Wright [Willard Huntington Wright, organizer of the exhibition] so that it would appear that I was 'in harmony' with the thinking of my fellow exhibitors even though my pictures didn't seem to be so."

Clearly, the third group of Benton's paintings of this period reveals, more than the others, strenuous tensions between abstract patterning and figural representation and between flattened shapes and spatial modeling. The artist was not only caught on the horns of a dilemma; he had a number of options available and could conceivably have chosen those offering the easiest solutions—and perhaps, in the process, have become a minor modernist master capable of deftly manipulating patterns and colors. Instead he tried to form a style that could combine his interest in earlier art, Michelangelo's sculpture in particular, with various modernist devices he had learned abroad. In short, he was anticipating a kind of art that would have relevance to both the present and the past. His theater of operation at this time was still within the world of art (combining methods gleaned in museums and in modern ateliers), rather than the world of American reality, but these paintings with their realistic and monumental figures suggest the terrain Benton would finally choose as his own.

Following the Forum Exhibition, Benton dropped, for the most part, the Synchromist palette and his experiments with nonobjective forms to concentrate on the problems of arranging single figures and multifigured groups in three-dimensional settings (plate 12). He strove to create an illusory pictorial space of his own invention, not exclusively dependent either on Renaissance precedent or on actual observation. Three-dimensionality, with a tactile quality, would be recognized, but so would contour, in a two-dimensional context. What he tried to create, then, was traditional figural groups in the modernist idiom with a subject matter that would be recognizable, though not necessarily literal.

Benton's almost compulsive need to rethink the problems of putting paint to surface was not based only on aesthetic considerations. His political heritage could not easily be reconciled with the thought of the elitist artistic circles he frequented. In addition, he read avidly and responded actively to authors and their ideas. Over the years the arguments of various writers were to influence the turn of his own thought. In France, for example, Benton explored widely in nineteenth-century French literature and was especially impressed by Hippolyte Taine's *Philosophie de l'art,* the first theoretical treatise on art that he had read. Its environmentalist theories impressed him profoundly and permanently. Taine put forth the theory that art is determined by race, time, and

12. *The Bather*. c. 1917. Oil on canvas, 29 1/2 × 28 1/2″. Private collection

13. *Self-Portrait.* 1912. Oil and tempera on canvas, 31 1/2 × 22 3/4″. Collection the artist

environment—by the people who make it, the period in which it is made, and the place in which it is created. He located the genesis of art in a stationary community, not in transitory studios. Art, he held, derived from a people and was intended for that group, without regard for any shifting international intelligentsia. To fathom "a work of art, an artist or a group of artists, we must," said Taine, "clearly comprehend the general social and intellectual condition of the times to which they belong."

Benton accepted Taine's argument and felt, therefore, that modern art was wandering off on a false trail. Nevertheless, rather than attempt to reconcile the two antithetical positions at that time, he allowed them to coexist in his mind and thereby prolonged his indecision concerning the viability of Parisian modernism.

The impress of both family tradition and Taine's writings may have provoked Benton's irritation with Alfred Stieglitz, which, as early as 1918, was already felt, if not openly expressed. Initially a frequent visitor to Stieglitz's gallery at 291 Fifth Avenue, New York, Benton never became a member of the inner circle; he found the conversations there as intimidating and as alien to him as those he had heard in Paris.

With another important figure in the New York art world of the period before 1917, Dr. John Weichsel, Benton formed a warm friendship. He met Weichsel in the winter of 1914–15. A man of socialist leanings whose aim was to reestablish art's purposeful place in society, Weichsel founded the People's Art Guild in 1915; as a means of bringing art to the working class, he strove to encourage an interest in art among the labor unions. The Guild did not survive World War I, but Benton's friendship with Weichsel continued until about 1926, when the artist's Americanist direction became very pronounced.

Weichsel arranged exhibitions and lectures and classes in settlement houses and community centers. Through the connection of the Guild with the Chelsea Neighborhood Association, on the lower West Side, Benton in 1917 obtained a position as director of the Association's gallery; he also taught drawing in their adult classes in the public schools. One of his students was Rita Piacenza, whom he married in 1922.

Weichsel, who was superbly grounded in history and social theory, guided Benton through a vast intellectual landscape. The artist read William James, John Dewey, Freud, Marx, and Proudhon, among others, and, in the course of attending regular weekly meetings of the Guild his political interests moved considerably left of center. Or, perhaps, Benton's Middle Western Populism found a common ground with the radical politics of Weichsel and his circle. (Populism, based on ideas that were spreading through the Midwest after the Civil War, was the first important modern American political movement to insist upon governmental responsibility for the public's welfare. Its programs included public control of the railroads, direct presidential elections, and

14. *Constructivist Still Life.* 1917. Oil on paper, 17 1/2 × 13 5/8″.
The Columbus Gallery of Fine Arts, Columbus, Ohio. Gift of Carl Magnuson

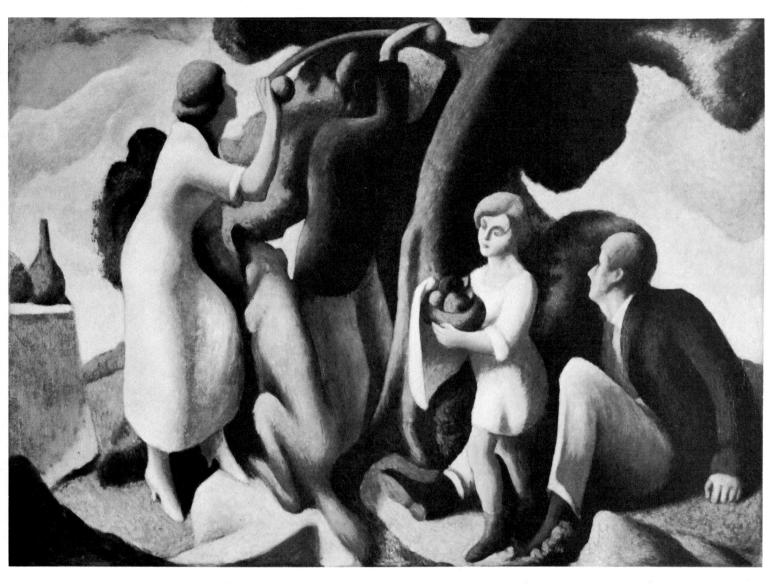

15. *Garden Scene (Figure Composition)*. 1919. Oil on canvas, 42 × 60″. Collection Mr. and Mrs. Thomas S. Kelly, New York

the development of means to protect the interests of the common man against Eastern monopoly capitalism.)

Like a number of others in New York City's left-wing circles, Benton felt that World War I was little more than a struggle among capitalists for control of the world's resources. After the war, he remained favorably impressed by the Russian Revolution because he believed that life could be given a decent order only by means of a socialist system. During the 1920s he was friendly with a number of Communists, and at one time, as he once said, "conspired with Bob [Robert Minor, the cartoonist and organizer] to provide secret meeting places for the persecuted members of the Communist Party, one of which included my own apartment in New York."

31

No wonder Benton could not accept Parisian modernism unconditionally! Although his paintings did not yet show it, art had become for him something more than a set of problems based on color theories or a way of manipulating spatial relationships. He felt that art should reflect a social basis as well. Still, the gap between his political orientation and his aesthetic position was wide, and it remained for his experiences during the war to bring them closer together.

By 1918, then, Benton had traveled from Neosho to Chicago to Paris to New York and had felt comfortable in none of these places. He could neither fully accept nor reject modern art, nor could he evolve a particular style out of the many influences operating upon him. He seemed to lean toward a social rather than an aesthetic justification for art, but he had not yet transferred his beliefs into practice. And there was no special reason why he should. After all, when he enlisted in the Navy in 1918, he was still a young man in his twenties, exploring.

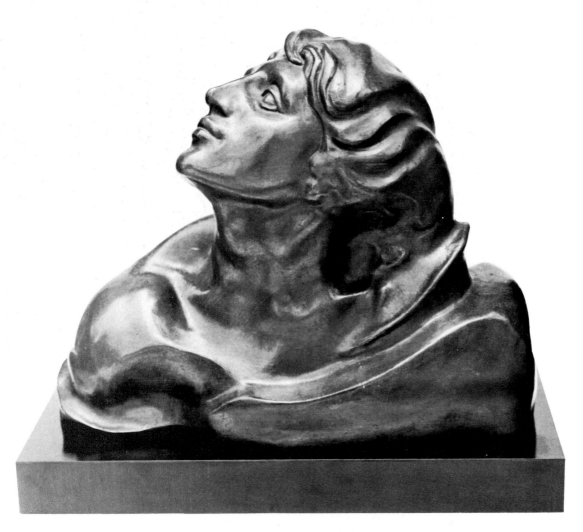

16. *Head of Rita.* 1918 (cast in 1969). Bronze, 14 1/2 × 17″. Collection the artist

PART II

WORLD WAR I AND THE POSTWAR ADJUSTMENT

THE AMERICAN HISTORICAL EPIC

WORLD WAR I
and the POSTWAR ADJUSTMENT

One can only guess how Benton might have worked through the problems of pictorial design and thematic content, had not the events of World War I intervened. The artist dates the beginning of his departure from the School of Paris to the period immediately after the Forum Exhibition and the final separation to the time he served at the Norfolk Naval Base in 1918.

Benton may well have enlisted in the Navy to flee New York City as much as to avoid serving in the army: he may actually have been glad to leave behind the personal and artistic problems he had encountered there. In any case, unlike other members of his generation, he was not disillusioned by military service; rather, it provided a fruitful period of relief to the young would-be modernist. It was then that he came to recognize, perhaps for the first time, the importance for him of the easy relationship that he had experienced with farmers and other people from rural areas, of his psychological closeness to their life-styles and reactions, and to set up his barriers against what he would later describe as the ego-ridden, urban, international intelligentsia of New York City. In Norfolk he began to see that he had entered upon the long road back to his roots.

Assigned to work as an architectural draftsman, Benton also made studies of the activities he observed (plate 17), and these new experiences began to transcend a host of concepts based on his earlier interests. In all the years he had been painting this marked his first significant artistic contact (after the architectural impressions of Chicago) with the technological objects of the modern world. He later explained the effect on him in the following way:

> My interests became, in a flash, of an objective nature. The mechanical contrivances of building, the new airplanes, the blimps, the dredges, the ships of the base, because they were so interesting in themselves, tore me away from all my grooved habits, from my play with colored cubes and classic attenuations, from my aesthetic drivelings and morbid self-concerns. I left for good the art-for-art's-sake world in which I had hitherto lived. Although my technical habits clung for a while, I abandoned the attitudes which generated them and opened thereby a way to a world which, though always around me, I had not seen. That was the world of America.

33

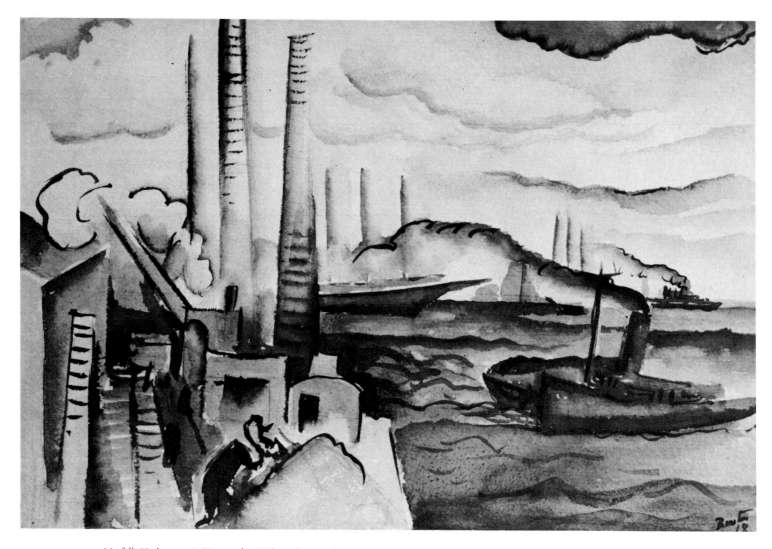

17. *Norfolk Harbor.* 1918. Watercolor. Whereabouts unknown

This passage, written in the fervid phrasing of the 1930s, augurs the contempt Benton later came to hold for the kind of paintings he had been making; but in 1919 the break was not so apparent. When he returned to New York City from Norfolk, he took up with many of his old friends, some of whom were more socially than aesthetically motivated. Once again Benton resumed his studies of Renaissance art in the hope of finding a means to reconcile his conflicting attitudes toward space, pattern, and subject matter. He read about Tintoretto's use of sculptured figurines as models in creating the *Last Supper* for Santa Maria della Salute, Venice. Benton then turned to sculpture as one of the preliminary methods of establishing spatial relationships between forms, a device that has served him ever since. He also made many drawings based on those of the sixteenth-century Italian Mannerist Luca Cambiaso, subjecting the forms and directional movements to geometric analyses. In these studies Benton did not atomize

or dissolve space in a Cubist manner but tried to find ways of reconstructing it in pictorial terms of his own invention.

If his more finished studies of the initial postwar years are an indication, it was then that he began to create a space inhabited by broadly sculptured forms whose modeled parts suggested roundness but whose profiles could still be read as flat shapes. His figures existed on different planes in depth and at the same time formed two-dimensional patterns by means of the repetition of rhythmic sequences from one figure to the next. His colors and textures remained entirely unrealistic. By these means, Benton tried to honor both art and life, or, as he indicated, to develop an artistic construction parallel to reality but not in imitation of it (plate 18).

Benton's aesthetic quests were modified and ultimately given direction by his increasing concern for relevant subject matter, and by the beginning of the 1920s he had found a way to bring together his art, his political beliefs, and his environmental ideas. He began to focus more precisely on American themes.

When in the Navy, he had read J. A. Spencer's three-volume history of the United States, whose mid-nineteenth-century illustrations suggested possibilities for giving art a greater social relevance and providing it with a content that Benton considered worth communicating and comprehensible to people outside the artistic elite. The idea of concentrating on specifically American paintings was reinforced by Benton's decision in 1920 to spend summers in Martha's Vineyard, in New England. There he met down-Easters in their own environment and began to make studies of them, suggesting by near-caricatures their quirky ways (plate 19).

The major vehicle by which Benton hoped to convey his coalescing environmentalist and Americanist points of view was a projected history of America conceived as a series of murals. Ultimately called the *American Historical Epic,* it was to comprise some sixty panels, of which careful studies for ten were completed. Four additional panels describing the history of New York City, planned for the New York Public Library, were painted in 1925 but never installed.

By 1921, then, the Benton that people later grew to love or hate began to emerge from his apprenticeship years, not yet entirely certain of his direction but knowing that his sphere would be circumscribed by realistic subject matter based on American experiences of the past and present.

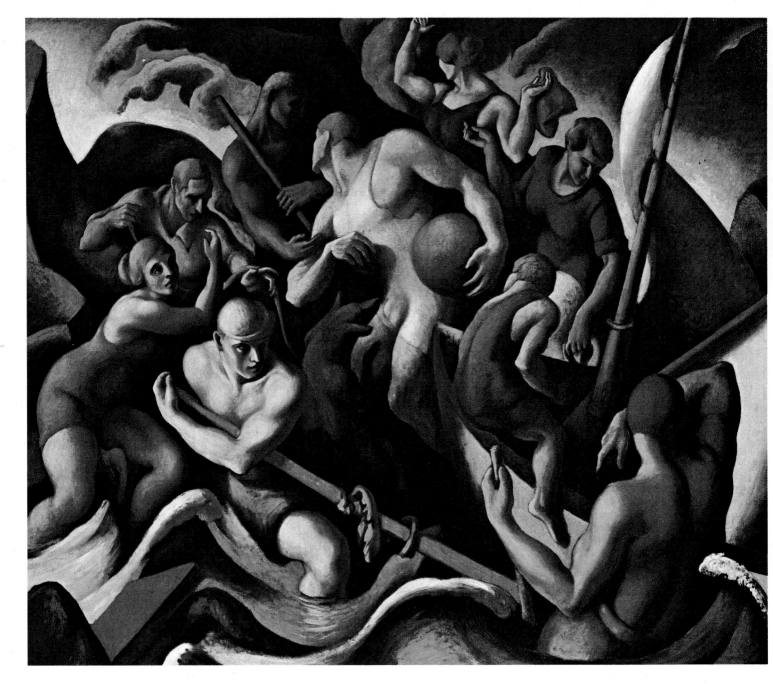

18. *People of Chilmark (Essay in Composition).* c. 1922.
Oil on canvas, 66 × 78″. Hirshhorn Museum and Sculpture Garden, Smithsonian Institution, Washington, D.C.

19. *Portrait of Josie West.* c. 1920. Oil and tempera on canvas mounted on panel, 16 3/4 × 13″.
Collection Rita Benton, Kansas City

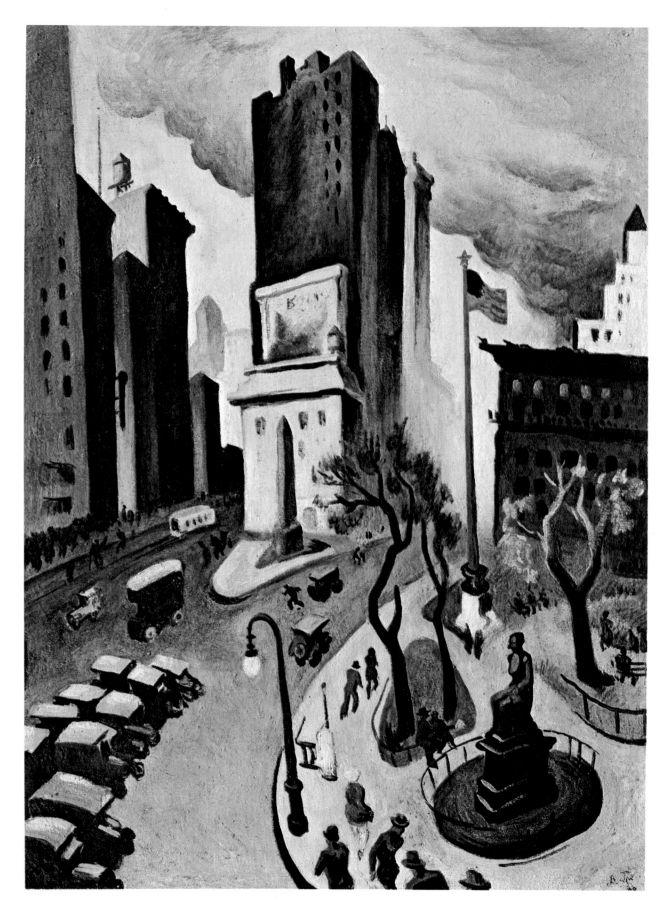

20. *New York, Early Twenties.* 1920. Oil on canvas, 34 × 25″. Graham Gallery, New York

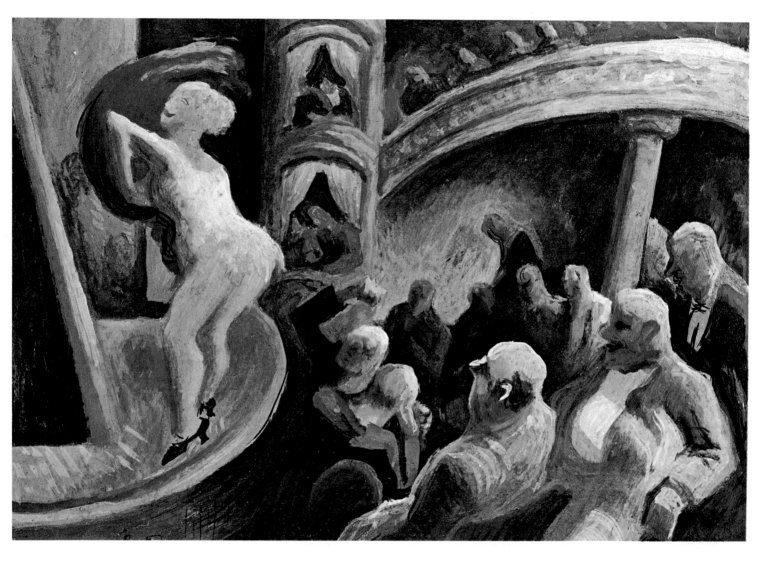

21. *Burlesque*. c. 1922. Egg tempera on panel, 9 1/2 × 12 1/2″. Collection Edward Suckle, Culver City, California

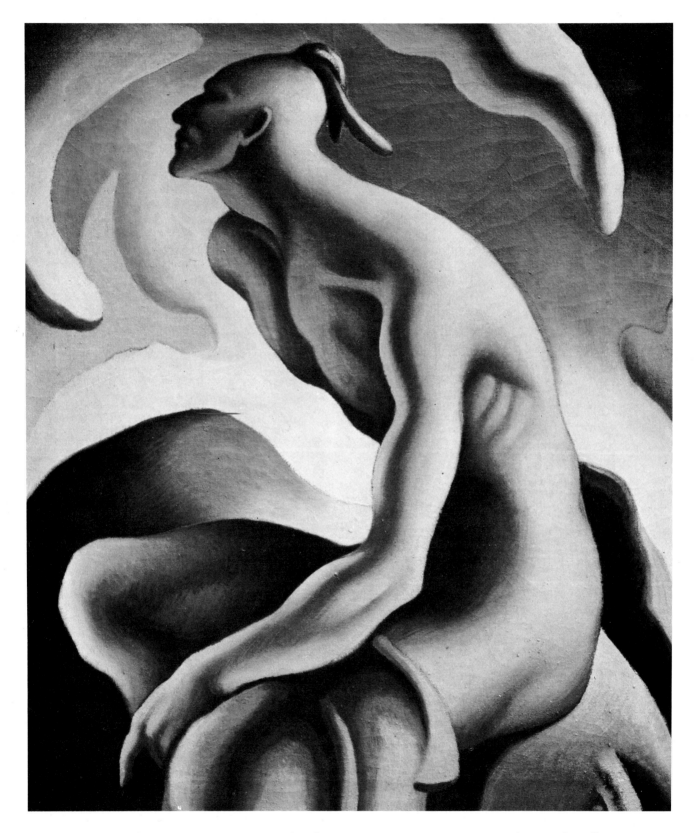

22. *King Philip*. 1922. Oil on canvas, 30 × 25″. Saint Joseph College, West Hartford, Connecticut. Rev. Andrew J. Kelly Collection

THE AMERICAN HISTORICAL EPIC

Before examining the mural series that constituted Benton's most ambitious effort of the 1920s, it is well to consider some of the ideas that were in the air at the time. Certainly his decision to adopt American subjects, historical as well as contemporary, was intensely personal, but his interests were by no means unique. Historians, writers, critics, and artists were beginning to explore seriously the pertinence of America's past to its present. This fertile field of inquiry brought forth an intensive two-decade discussion about the values worth maintaining in an era of rapid change, ways of sustaining such values, and the relative merits of American and European culture. For many this study was a means to self-discovery. It was not simply a matter of national self-consciousness but was infused with environmentalist thought and theories.

Benton may have been reading *The Dial* magazine as early as 1920 (his friend Thomas Craven was writing for it) and could have come upon an article by John Dewey, published in June of that year, which extolled the exploration of forces, not just colors and characters, in this country. "We are discovering that the locality is the only universal . . . ," Dewey said. "When the discovery sinks a little deeper, the novelist and dramatist will discover the localities of America as they are, and no one will need to worry about the future of American art."

Whether or not he read this particular article, Benton was conversant with Dewey's ideas. Some of the attitudes that the artist began to express with increasing conviction during the 1920s were stated clearly by Dewey in his *Art as Experience,* published in 1934. Dewey found in the art of modern times the serious problem of "the continuity of esthetic experience with normal processes of living." He further observed, and Benton often concurred in his own writings, that objects which had held validity and significance in the past because of their place in a community now existed in isolation from the conditions of their origin. By the 1930s Benton's attitudes were predicated on the reintegration of such objects with the conditions of their origin, and thus his ideas bear an important relation to Dewey's aesthetic philosophy.

A related environmentalism can be found in the writings of the historian Frederick Jackson Turner, whose influence was strong in the 1920s, even though he had postulated his theories about the turn of the century. The existence of free land, its continuous recession, and the advancing westward settlements, seemed to him crucial to the development of American democracy. The unique qualities of American life, he felt, lay in those elements created by the westward migration, because the settlers and their descendants relied less upon European ways and institutions to fashion their lives and more upon pragmatic decisions required for survival.

Turner implied that the interaction of persons with their environment must be recognized and that cultures are born and flourish as a product of that interaction. He felt that the most typical American culture would bloom in the Middle West—the economic, cultural, and geographic crossroads between the European-influenced East and the still primitive West. By the late 1920s Benton, who had begun to read Turner about 1927, would have heartily agreed.

A number of literary figures were exploring that typical American culture in the 1920s—among them Sherwood Anderson, Sinclair Lewis, William Carlos Williams, Van Wyck Brooks, and H. L. Mencken—and many of them were disillusioned by it, if not outright hostile to its attitudes and institutions. However, whereas they pointed out fallacies, shortcomings, and inadequacies in American life, Benton was discovering original and unique qualities. Instead of a culturally barren America for which the misunderstood Puritan was held largely responsible, Benton saw a country full of incident and excitement, local color, and potential for intellectual growth.

Other painters, too, were turning toward an examination of America. Their realistic images described the Eastern coastline, Eastern and Middle Western cities, industrial sections, and the countryside. The state of the American psyche was reflected in various ways in the images of such artists as Charles Demuth, Charles Burchfield, Charles Sheeler, and Edward Hopper, though without Benton's aggressive optimism.

He saw insufficiencies, but instead of returning to Paris, where so many artistic Middle Westerners had gone to write about their blighted childhoods or to dwell on the ways in which their native environment numbed the creative spirit, Benton tried to refind his past and induce it to function positively in terms of the needs of the present. In 1925 he began to drive and hitchhike through hundreds of small towns all over the southeastern, Middle Western, and south-central regions of the country, savoring the local legends, characteristics, habits, and ways of life. The kind of alienation that characterized, say, Harold Stearns's indictment of American life, *Civilization in America* (1922), or Hopper's visual probes did not touch Benton. He did not want to abandon the country or comment on its shortcomings but hoped to find a civilization emerging from the native set of ideals, aspirations, and realities. He found the seeds of this civilization among the nonintellectual, hard-working, pragmatic yeomen who settled the country. That particular America which Mencken saw as the paradise of the third-rate, Benton saw as the country's saving grace.

In 1921 Benton's environmentalist and Americanist sentiments were still offset by his Marxist political beliefs and his interest in earlier art styles. Although concerned with American themes, he was inhibited by his attraction to Renaissance forms from creating an American style of his own. Furthermore, he still equated American demo-

cratic ideals with those proclaimed by Soviet Russia and saw Communism as an extension of democracy, perhaps its final fulfillment.

He thus came to formulate the *American Historical Epic* as a people's history rather than one glorifying great men and political or military events or representing abstract symbols such as Liberty Personified. "I wanted to show," he later said, "that the people's behaviors, their *action* on the opening land, was the primary reality of American life." More interested in operations and processes than in ideas or specific events, he intended to show how the people became increasingly separated by advancing civilization and technology from the benefits of their settlements. Although Benton believed in the American dream, good Middle Western Populist that he was, he saw no part of it in Wall Street buccaneering and economic exploitation of common people. On the contrary, his mural cycle was to show the embezzlement of the American dream by predatory capitalism—an ambitious project at any time, let alone in the early 1920s.

The first set of five panels, showing the periods of discovery and settlement, was completed in 1924. A second set of five, concerned with colonial expansion, was finished in 1926. Each is stylistically distinct from the other.

For the first group he borrowed figural attitudes and formal sequences from Renaissance models and, as usual, generated tensions by two- and three-dimensional patterns (plates 23–26). Although he sought a space that "had become the very core of my dream of an art that might.be inclusive of all the conditions of reality," he knew that he was not fully achieving it. Conditioned by earlier habits of patternmaking, he was still a student of art rather than of life.

In the *Discovery* panel, for example, the space that exists between the Indian woman in the foreground and the European boatmen appears to be arbitrary, obviously circumscribed within a large oval of figures. Inside that oval, curving forms echo and parallel one another, and light and dark areas alternate. Edges of one form glide into those of others or simply share a common contour. All these relationships, in turn, extend outward to encompass the forms of the entire panel.

Although realistic, the first set of panels indicates that Benton had not yet begun to "Americanize" his subject matter, for the episodes are generalized. Even so, there are environmentalist overtones pointing to those aspects of the period of settlement that have influenced subsequent American character—confrontation between races, the significance of religious figures from the start, and the need to build and to fortify immediately.

About 1925 Benton realized that his proper direction as an artist lay in abandoning the devices used in the murals for those used in the smaller paintings. In the easel paintings of the middle and late twenties—and in the second set of the *American Historical*

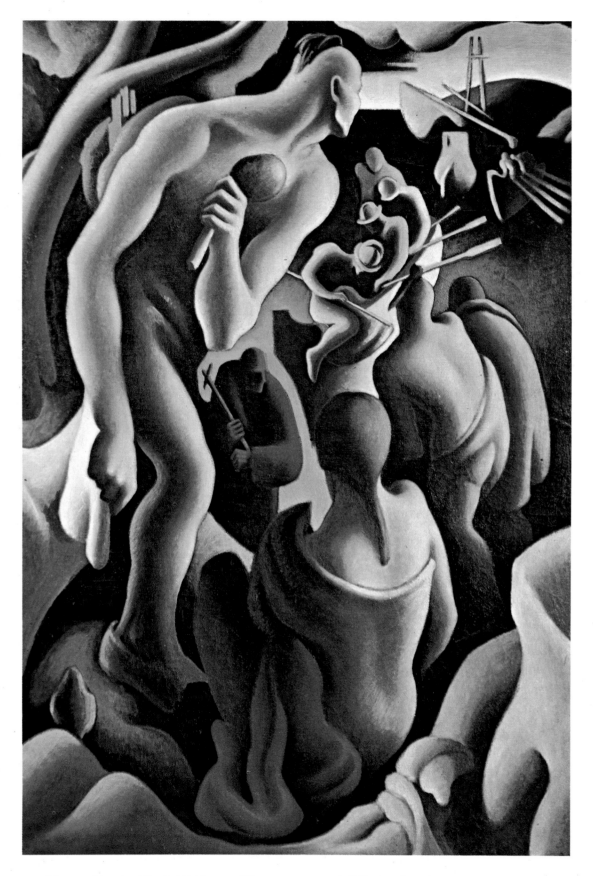

23.　*Discovery (American Historical Epic).* 1920. Oil on canvas, 60 × 48″. Collection the artist

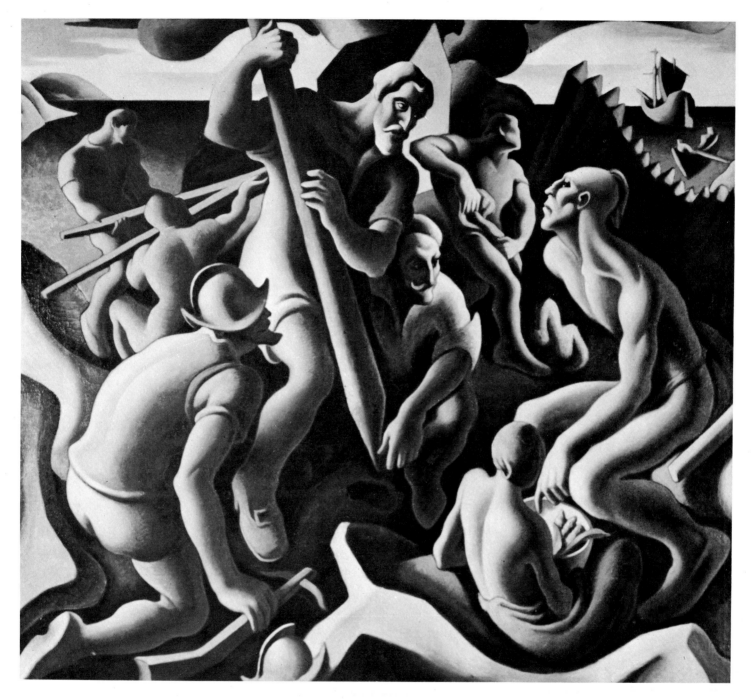

24. *Palisades (American Historical Epic)*. 1919–24. Oil on canvas, 72 × 84″. Collection the artist

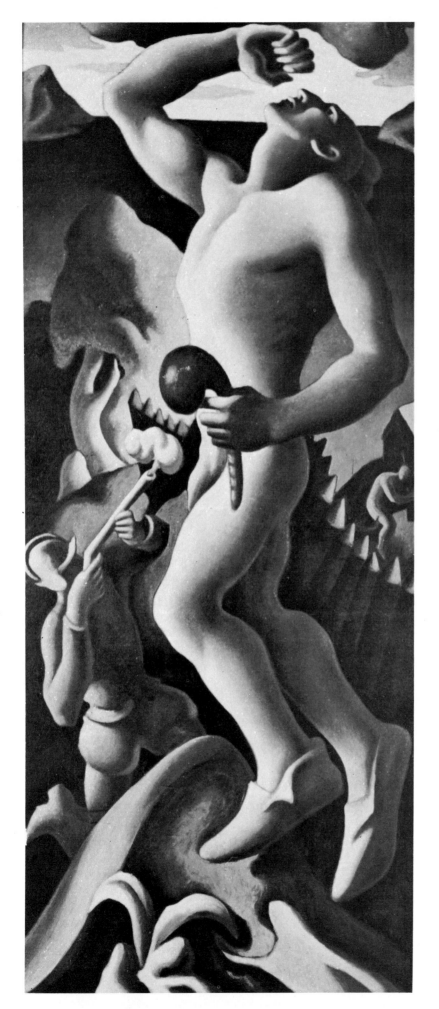

25. *Aggression*
(American Historical Epic). 1919–24.
Oil on canvas, 72 × 36″. Collection the artist

Epic panels—he resolved many of the problems besetting his work and finally evolved a style and an attitude toward subject matter with which he could feel comfortable.

The easel paintings, based on more immediate observation, indicate more clearly the kind of subject and spatial solutions he was seeking. It is illuminating to compare two works that deal with the same theme, *Prayer* (1919–24; plate 28), from the first set of *American Historical Epic* panels, and the easel painting *The Lord Is My Shepherd* (1926; plate 29). In both pictures Benton is plainly stating that Americans are religious, or at least practice religious observances, yet the differences are quite apparent. In *Prayer* no specific locale is suggested, nor do the people react to one another in any special way that would differentiate them or even reveal who they are. By contrast, the couple in *The Lord Is My Shepherd* appear to be the spiritual descendants of the first settlers of the West. The interior is bare and frugal, the only decoration being the framed sampler with the opening words of the Twenty-third Psalm on the wall. The reflective look on the man's face suggests that he has just said grace, and his wife seems to be waiting for the cue to begin eating. Plain without being dowdy, appealing without being prettified, they represent the kind of lower-middle-class life that Benton viewed as the backbone of America. The sense of duty and devotion apparent in their faces describes an essential aspect that he sensed in the nation's character.

Another and entirely different aspect of that character is intimated in the modeling of the figures. Compared to the tonal changes in the mural panels, those in the easel paintings are quicker, more abrupt, and at times more arbitrary. This quality, seen clearly in *New York, Early Twenties* (plate 20), suggests a Fauvist influence, but Benton's concerns were not with Parisian-inspired forms. Rather, he painted jagged silhouettes and strongly contrasting tones and colors because he was beginning to express his feeling that America means turmoil and energy. He was after an image of a city on the move. Its tumultuous qualities he perceived as characteristic of American life, and the sharpening of tonal contrasts was a way of suggesting this excitement. Furthermore, these abrupt tonal changes indicate that Benton was using a more pictorial attack for his easel paintings than for his mural panels, in which the tonal transitions are certainly more gradual. It is possible that his use of Plastilene models for the murals caused him to invest them with a more sculptural feeling; in any event, his basic approach was different.

The growth of this phase of Benton's career involved not only artistic change but also a reevaluation of his political, environmentalist, and Americanist ideas. In brief, his Americanist notions began to subsume the others; that is to say, he began to follow to its logical conclusion his idea that to be an artist in America one had to develop an

American style based on American experiences common enough to be shared by a majority of one's fellow countrymen.

In 1928, only a few years after he had altered his approach, he recounted a specific experience that symbolized the change. He had returned to Missouri in 1924 to aid and comfort his dying father.

> I cannot honestly say what happened to me while I watched my father die and listened to the voices of his friends, but I know that when, after his death, I went back East I was moved by a great desire to know more of the America which I had glimpsed in the suggestive words of his old cronies. . . . I was moved by a desire to pick up again the threads of my childhood.

Very likely, this responsiveness to the demands of the past was accentuated by Benton's association with his friend Thomas Craven, a poet and classical scholar whom he had known since 1912 (they were even roommates for a time). By the early 1920s, Craven, possibly inspired in his turn by association with Benton, had begun writing art reviews and in them had developed an environmentalist point of view as well as an extraordinary distaste for modern European art. He felt that the Europeans substituted an interest in textures, arbitrary color combinations, and decoration for the actual world. He believed, as did Benton, that art based on these abstract concerns was not so appropriate for American painters as one derived from practical and pragmatic considerations. American artists, he held, did not think so theoretically, nor were they so intellectual, as European artists. Through the middle years of the decade his tone became more strident as he argued for the development of an American art based on American experiences. Essentially he played a role in the development of the American Scene movement analogous to that of critics Harold Rosenberg and Clement Greenberg vis-à-vis Abstract Expressionism.

Benton's political posture also changed through the middle of the decade. Although he did not finally break all connections with his left-wing friends until about 1930, he no longer believed so firmly that an ideal American democracy could be equated with Marxist thought or with the policies of the Soviet government. Economic determinism, he felt, did not fully illuminate America's development; it was too theoretical. Being sympathetic to Dewey's pragmatic philosophy, he began to look for explanations of America's growth in practical experiences and improvised responses. He was no longer enticed by grand speculative constructions. History, he decided, was local and specific, dependent on unique environmental factors, not on closed philosophical or political concepts. Increasingly, he felt that an artist should find meaning in the

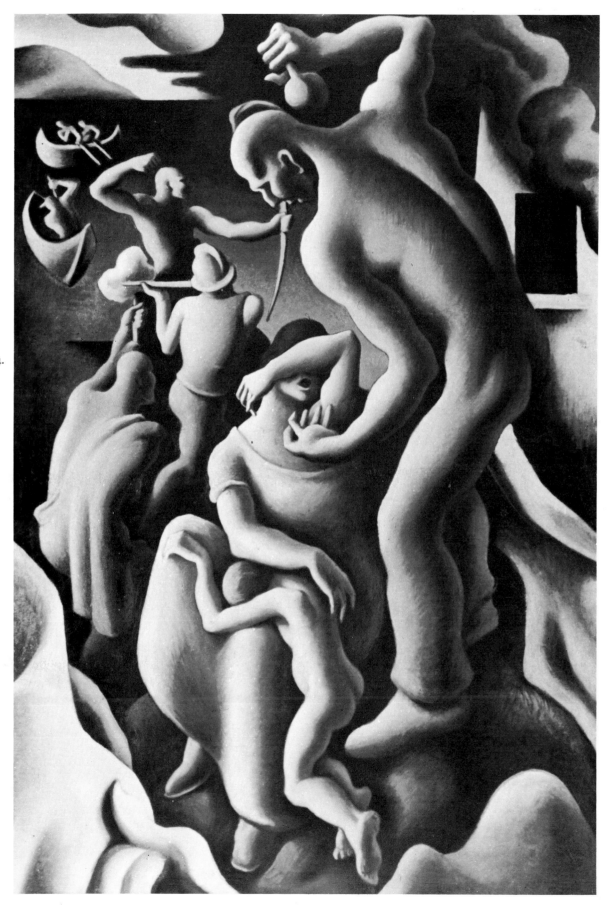

26. *Retribution*
(American Historical Epic). 1919–24.
Oil on canvas, 60 × 48".
Collection
the artist

forms of life as it is lived. For Benton this was the American life of ordinary Americans, in which he could easily participate.

Of course there were many kinds of ordinary Americans—rural, urban, blue-collar, white-collar. Although he claimed to know the city as well as the backwoods (aside from his war service, he lived in New York City from 1912 until 1935), he identified himself more with rural America and began to enshrine the people of this America, the agrarian myth, and the special values of the rural life that was fast slipping away. He viewed with sorrow the destruction of this life, blaming it on financial interests which tricked people, gutted the land, stripped forests, and ravaged the earth for minerals. He wrote in 1934 that city life and modern America in general were embarked on a "chartless journey," borne along by "mass production, the movie, the radio, and the paved road." Benton sought an America in which the flavor of the pioneer was still present despite modern abuse. Perhaps it was the only America he could really understand—his father's America. "Traditions and the old ways fight still the entrance of the modern world in this country, but in a little while they will break down and the very last of our father's America will be gone."

In 1924, after his father's death, Benton continued working on his mural cycle in New York (plates 27-30). He stopped painting stock types responding to stock situations, Renaissance- or Marxist-inspired, and began instead to collect individual and characteristic poses from life. These he intended to use with as little alteration as possible, because the space he sought to describe had to conform to the modern world as he interpreted it. In addition, he began to bring his content closer to the present, believing that more contemporary subject matter might help to define his sense of form and therefore his manipulation of pattern and space. His new content, he reasoned, would dictate his form; form would become a function of subject matter.

Benton also began to exaggerate certain features of his subjects. Such caricature, at the very heart of his newly developing style, was the result of two factors. First, sharp contours and varying tonalities created patterns that fulfilled his sense of responsibility to art. Second, the spastic contours and quickened spatial dislocations that he adopted set up a "turmoil of rhythmic sequences" which, he hoped, would reflect and symbolize the turmoil of America's energetic growth.

The Pathfinder reflects the new approach. The subject appears to be more jerky than sinuous. A greater measure of space is provided for all the figures, and even though abstract patterns abound, as in early paintings, they interfere less with the story being presented (plate 30).

Within the next few years Benton would eliminate many more abstract devices. The cubistic rock in the foreground of *The Pathfinder,* for example, an intrinsic part of the

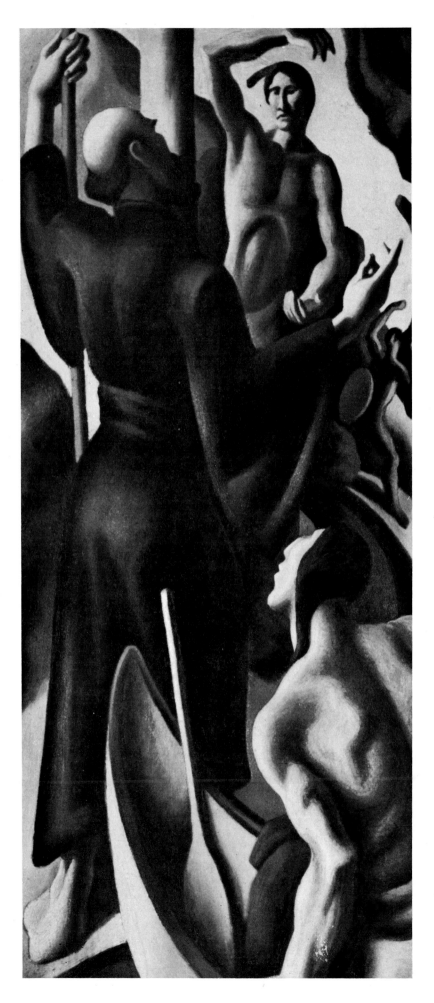

27. *Jesuit Missioners (American Historical Epic)*. 1924–26.
Oil on canvas, 72 × 36″. Collection the artist

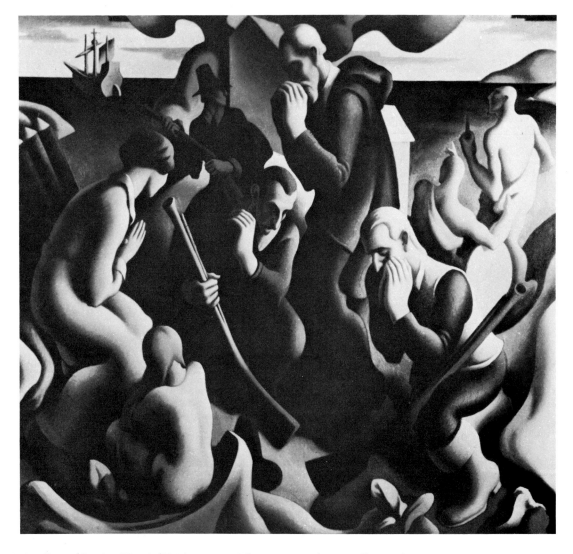

28. *Prayer (American Historical Epic).* 1919–24. Oil on canvas, 5 1/2 × 6′. Collection the artist

design, carried no American meanings at all. In paintings such as *Boomtown,* Benton found his American substitutes (plate 31). Here the black smoke from a carbon plant serves in the design to lead the eye back into space and is related to other dark shapes by its dark color, but at the same time it demonstrates the waste and pollution he has always deplored. The responsibilities to art are respected, but simultaneously an American quality of turmoil is communicated.

One may well ask: If Benton located himself psychologically in rural America, why, then, should he have evoked symbols of tumult to represent the country? These are more usually associated with urban life and industry. The artist might have answered that he sought an image of the entire country, not merely of one locale or a single geographic region. In his own lifetime he had seen Indian lands become in turn the white man's frontier, agricultural settlement, small town, industrial center, and modern

52

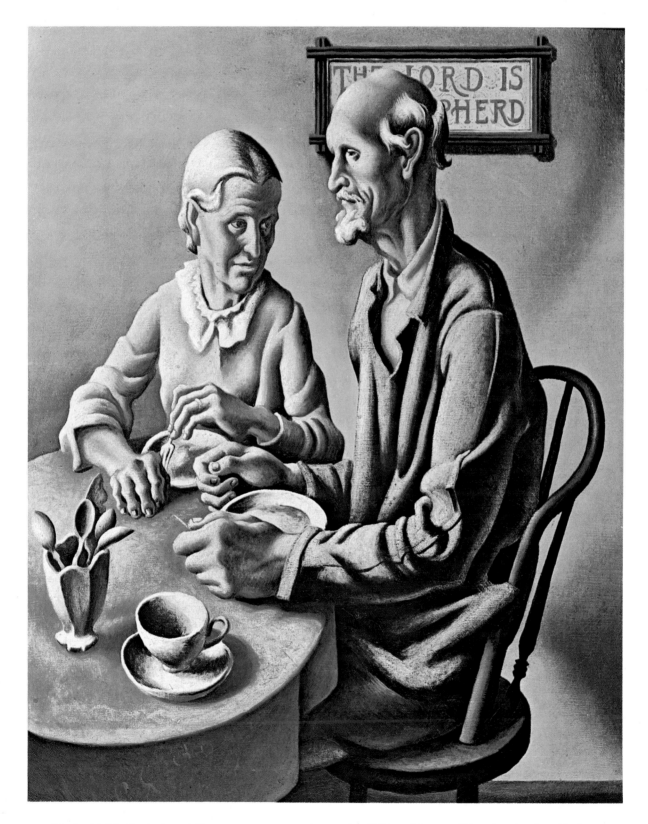

29. *The Lord Is My Shepherd.* 1926. Tempera on canvas, 33 1/4 × 27 3/8″. Whitney Museum of American Art, New York

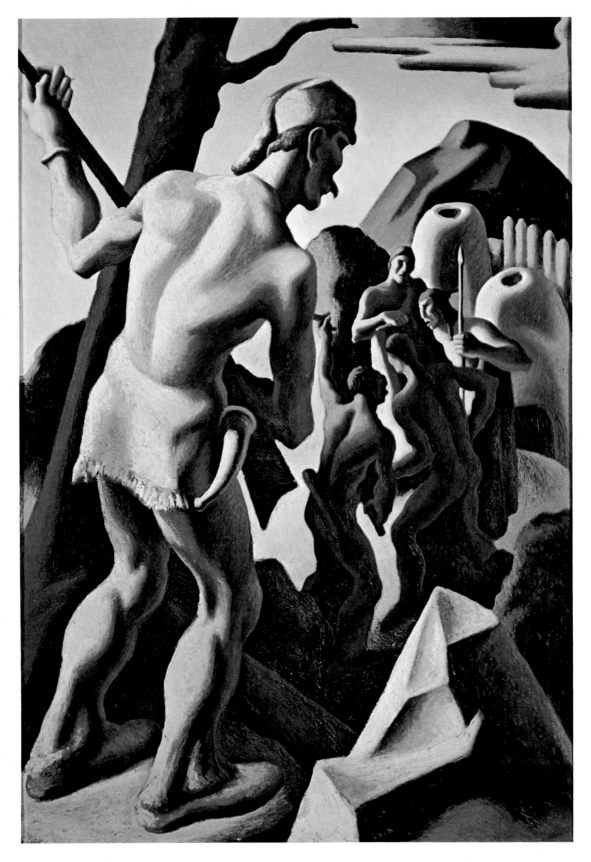

30. *The Pathfinder (American Historical Epic).* 1926. Oil on canvas, 60 × 48″. Collection the artist

city housing millions. This evolution was strenuous, certainly. Benton had already lived through a broad range of American experiences, and he sought to project them into a style of painting that would be rooted more in the agrarian past than in the urban present but would take into account all those experiences.

One might say also that he chose to explore the continuities between past and present, rural and urban, and to meld from this variety of chronological, geographic, and cultural sources a coherent style and subject matter. It was his belief that American cultural history, at least until the turn of the century, generally grew from rural pressures on urban centers. "Our basic cultural ideas, our beliefs as to what constitutes the 'American character,' our mythologies, had their origins in the earlier conditions." These he wanted to represent.

At least three observations can be made about the two sets of mural studies that were completed for the vast project of the *American Historical Epic*:

First, never before in the history of American art had an artist tried so intently to create through a series of related works a style that was specifically American in form and content, one based on those American experiences which the artist understood best. Just as writers of the time were searching for a usable past, so was Benton, and from that past he attempted to elaborate a specifically American art for the present.

Second, the plastic, turbulent surfaces of the mural studies departed radically from the mural styles in vogue at that time, which were typically executed with flattened forms, often pale in color, that would not disturb the architectural surfaces. Murals were considered to be decoration and little else. The preferred subject matter, even as late as the 1920s, had been restricted to the level of academic cliché. In his obstreperous way, however, Benton demanded equality for the murals with the architecture, as contemporary critics, notably Lewis Mumford, did not fail to notice.

Third, the mural studies must have had a profound influence on a younger generation of painters who would soon be receiving governmental commissions during the Depression. They were exhibited during the late 1920s in New York City, where Benton was teaching at the Art Students League (1926 to 1934). Certainly the paintings helped to prepare a climate of opinion receptive to mural innovations when, about 1930, the leaders of the Mexican renaissance, Diego Rivera, José Clemente Orozco, and David Siqueiros, visited and worked in the United States, creating, among them, thirteen sets of murals.

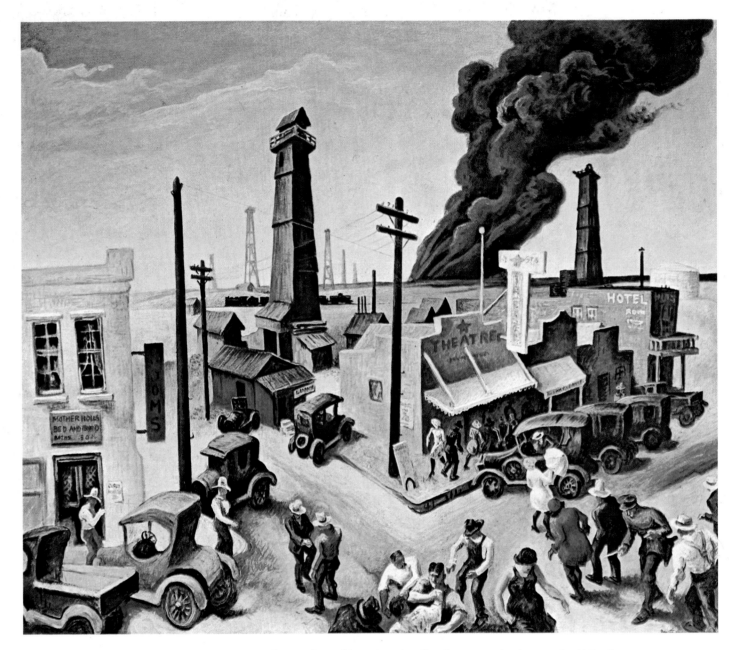

31. *Boomtown*. 1928. Oil on canvas, 45 × 54″. Memorial Art Gallery of the University of Rochester. Marion Stratton Gould Fund

PART III

THE "AMERICAN SCENE"

MURALS OF THE THIRTIES

BATTLES AND SKIRMISHES

THE RETURN TO THE
MIDDLE WEST

THE "AMERICAN SCENE"

Within the context of painting created during the 1920s and 1930s, works representing an American scene with specifically American connotations began to be called "American Scene painting." The nature of this category is indicated by the subject matter— American blacks rather than Balkan gypsies, Cape Cod cottages rather than Parisian walk-ups, flat expanses of the Great Plains rather than the hills of the Provencal countryside. In style the treatment was predominantly realistic. Any abstract elements that appeared would seem to have been imposed on an originally realistic conception. Unlike a typical contemporary European work, in which colors appear to exist just behind the picture plane, the colors of an American Scene painting seem to lie directly on the picture surface. Paintings by many artists of the time possessed these features in varying degrees, and there is no certain criterion for affixing the American Scene label.

Benton has stated that his first programed studies of the American Scene began in 1926. Earlier paintings had invoked this scene, but not until he had harmonized his ideas on the environment and on artistic content did such works appear with frequency. A comparison of two of his paintings suggests the sense in which the term may be applied. *Martha's Vineyard,* although of an American scene, is not really an American Scene painting (plate 33). Granted that the type of house and telephone pole are specifically American, the work as a whole does not suggest the quality of light or landscape characteristic of an American locale. It is a landscape painting primarily and not necessarily an American one. In contrast, *Lonesome Road* can only be a painting of an American subject in an American landscape (plate 34). The work is not so much painting for its own sake as it is a depiction of an aspect of America. The painting is subservient to the subject it records.

If this distinction applies to American Scene painting in general, then how can one characterize Benton's works in this vein more precisely? As one studies his paintings of this period, one realizes that he did not paint individually identifiable places, even when the subject is recognizably American. Questions of style and psychological attitude aside, this trait distinguishes his paintings from those of Demuth, Hopper, and Burchfield, whose buildings and landscapes often depended on specific models. Benton sought the typical rather than the particular, the behavior patterns representative of different types of people rather than the activities of individuals, the recognizable character of an area rather than an exact description of topography.

He clearly ran the risk of stereotyping behavior patterns, types of activity, and landscapes. His paintings could become a kind of impressionistic journalism, savoring the typical features of the subject being painted but not exploring the individual psychology,

motivation, or even context in which it occurred. As his image of America became increasingly certain, he began to create works to fit that image. Benton must have been aware of the dangers inherent in seeking a composite view of America, but he was evidently willing to risk them. *Lonesome Road,* then, becomes a typical rural scene of the South, and *Boomtown* fits everybody's conception of what a town that is booming looks like and of the frenzy of activity that takes place there.

Concerned with symbolizing everyday events and the lives of ordinary people, he sought the archetypal in the commonplace and tried to invest the average with mythic properties. "This is the American experience," he seemed to be saying, and his view could best be expressed by generalizing a subject from the specific. Years later, he well summarized this view in a single sentence. "I believe I have wanted, more than anything else, to make pictures, the imagery of which would carry unmistakably *American meanings* for Americans and for as many of them as possible."

Toward the end of the 1920s Benton's attitudes toward America, rural life, and the past had come to be shared by a greater number of people. The debunking of American institutions, which had been prevalent earlier in the decade, gave way to a desire to preserve and enlarge upon those values already existing. In magazine articles and books the search for roots and a growing pride in America's past became more insistent. Critics more often questioned the validity of using modern European masters as models for American artists. Increasingly it was held that the last significant advances in Paris had occurred before World War I. Furthermore, many artists who had painted in the modern European idioms began at this time to discover America and in their discovery to become critical of their former models. These included such figures as George Biddle, Ben Shahn, and Grant Wood.

To serious-minded people the American renaissance, upon the edge of which the country had been hovering for years, seemed imminent. Having expressed itself politically, administratively, and industrially, the country was now thought ready to express itself artistically. But rather than manifest its genius through individual titans such as Michelangelo, the American renaissance was expected to arrive through common, group effort and to uplift taste in general. Democratic and egalitarian, it would be for all people.

By 1931 the desire to find American roots for an American art culminated in a determined search. That year the term "The American Wave" was coined to describe both a movement and an attitude working toward an art which could express without foreign influence the spirit of the land. Arguments raged, of course, about the nesting places of that spirit. Among those who subscribed to the tenets of The American Wave, the metropolis was not one of those places. Indeed the city and all that it represented—

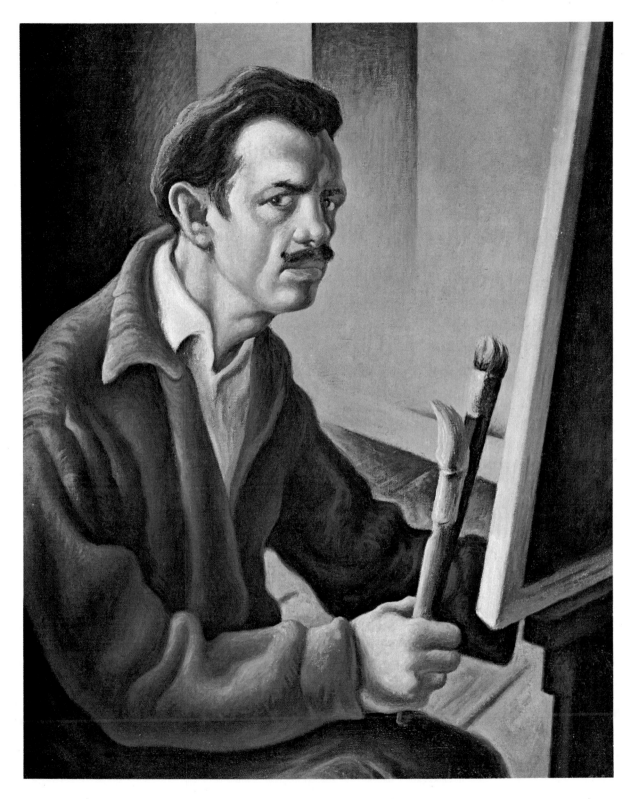

32. *Self-Portrait.* 1926. Oil on canvas, 30 × 24″. Collection Rita Benton, Kansas City

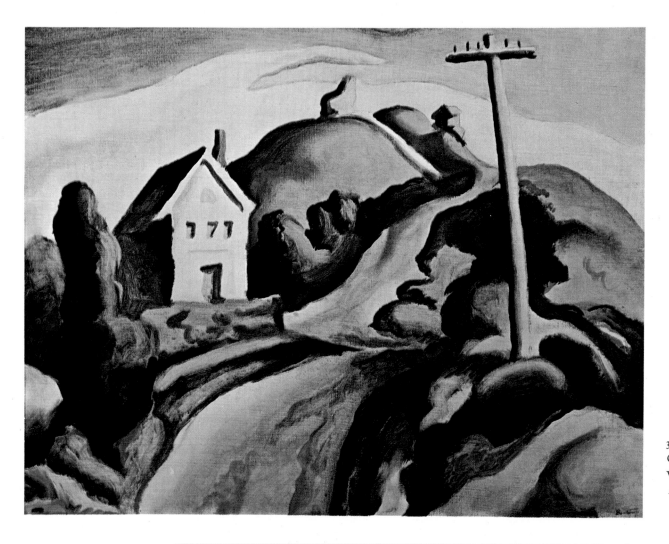

33. *Martha's Vineyard.* 192
Oil on canvas, 16 × 20".
Whitney Museum of Amer
Art, New York

34. *Lonesome Road.* 1927.
Tempera on panel, 25 × 34".
Nebraska Art Association,
Lincoln

big business, anonymity, parasitical living off the rest of the country—came under heavy attack, and not solely by troglodytes in rural legislatures and Ku Klux Klan klaverns.

Many social scientists became proponents of regionalism, or regionalization, in the country's geographic, social, and cultural resources. They hoped that such a regrouping of the nation's wealth would "bring about a new springtime in culture." At one center, the University of North Carolina, theorists argued for an understanding of all societies through regional studies because, they felt, all cultures grew from regional developments, an environmentalist attitude long held by Benton. At least one famous group of poets and critics, the *Fugitive* writers, clustered at Vanderbilt University, tried to revive and perpetuate a regional—in this case Southern—tradition in poetry.

For artists, too, many of whom were in revolt against the crushing maw of the machine age, symbolized by New York's dominance in cultural and business affairs, regional studies offered a subject matter, a sampling of techniques through folk modes of expression, and different points of view. One observer noted, turning Marshall McLuhan around well before the fact, that for the regionalist, "the life of his region is his medium of expression, not his message."

Although Benton was obviously sympathetic to all these ideas and efforts, to regional traditions and rural values, he was not truly a "Regionalist" painter. In fact, the term "Regionalism" as applied to art was the invention of critics and observers, rather than a concerted movement among sectional groups of artists. Throughout the late 1920s and the 1930s, no distinctly Southern, Middle Western, or Eastern style emerged in connection with a range of subject matter depicting the social, cultural, and religious values and aspirations of a restricted area as, say, Florentine and Sienese art did in those communities. That many American local scenes were painted by a great variety of artists is clear: that their approaches never coalesced into clearly defined sectional idioms suggests that no true "Regionalist" movement developed.

35. *Rita and T.P.* 1928. Oil and tempera on canvas mounted on panel, 33 × 25″. Collection Rita Benton, Kansas City

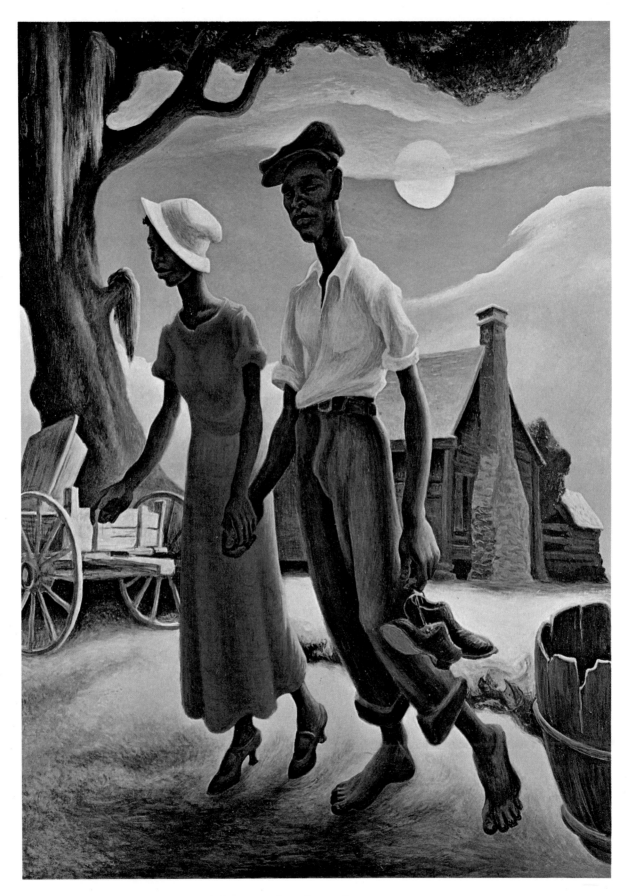

36. *Romance.* 1931–32. Tempera with oil glaze on panel, 45 1/4 × 33 1/8″.
The Michener Collection, University Art Museum, The University of Texas at Austin

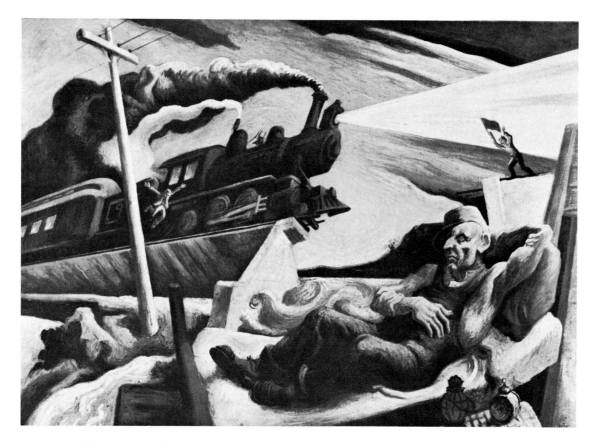

37. *Engineer's Dream.* 1930. Oil and tempera on canvas, 30 × 42″. Collection the artist

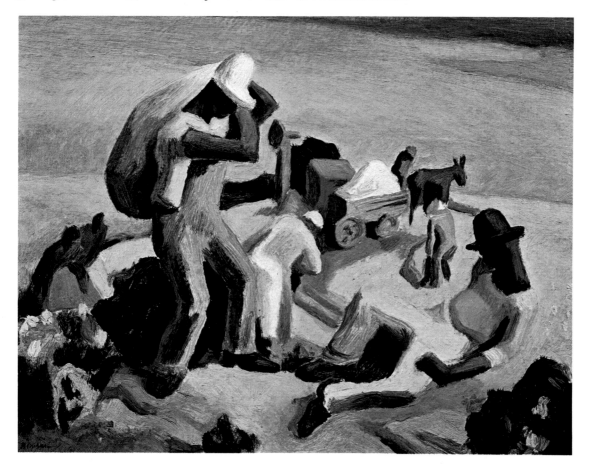

38. *Georgia Cotton Pickers.* 1931. Oil on panel, 11 1/2 × 15″. The Museum of Modern Art, New York.
Gift of Mrs. W. Murray Crane

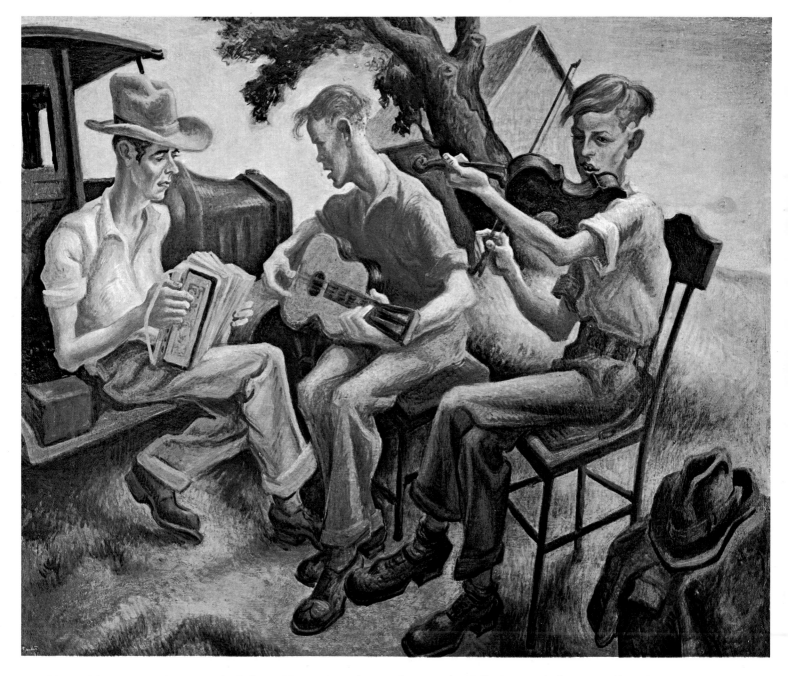

39. *Missouri Musicians.* 1931. Tempera with oil glaze on canvas mounted on panel, 29 × 34 3/4″. Collection Dr. Abraham Feingold, Sands Point, New York

40. *Homestead.* 1934. Oil and tempera on panel, 25 × 34″.
The Museum of Modern Art,
New York. Gift of Marshall Field

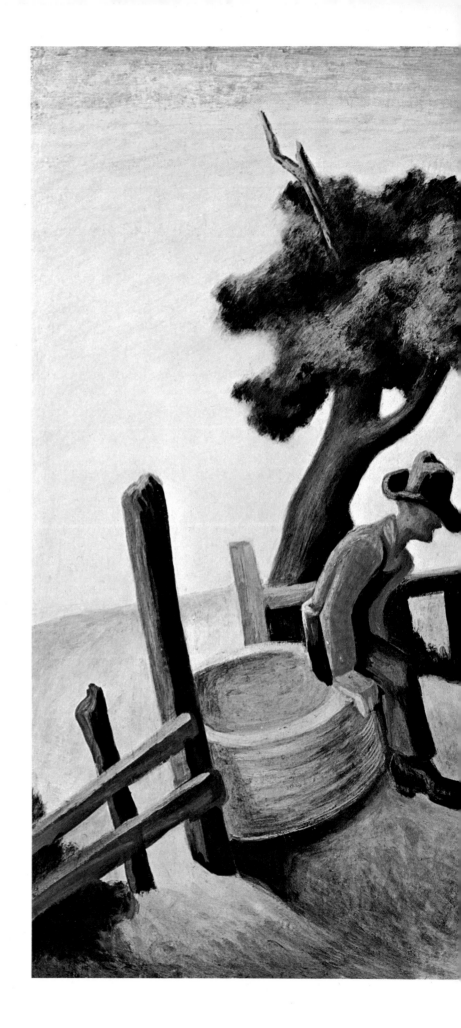

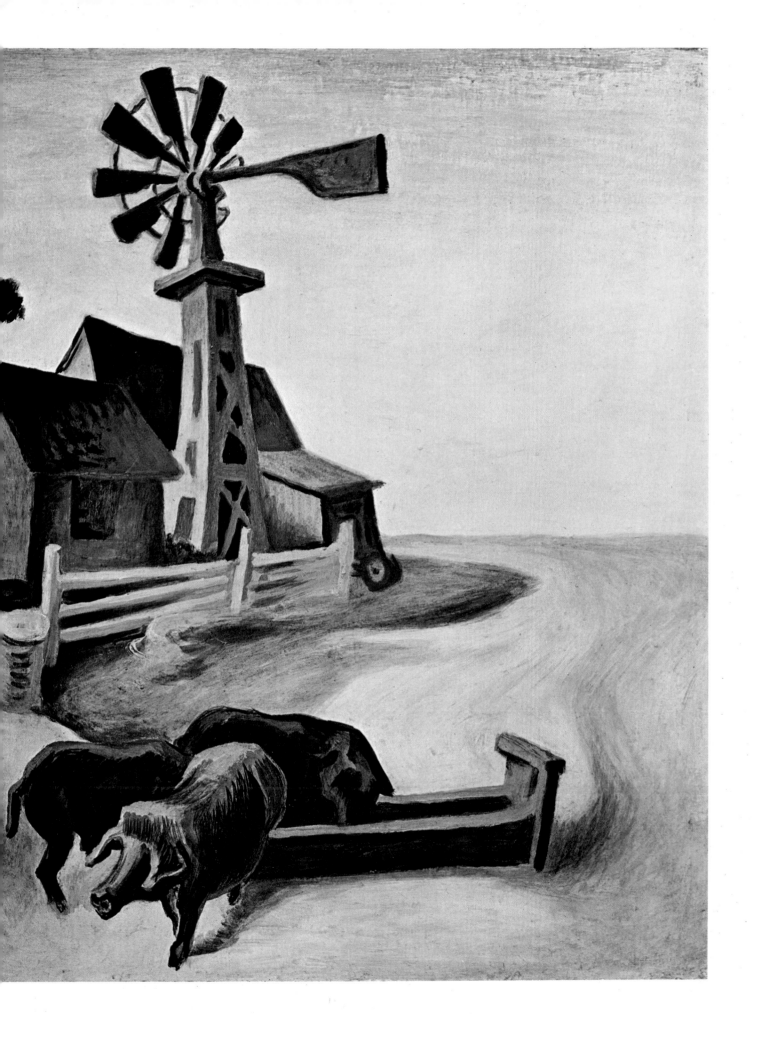

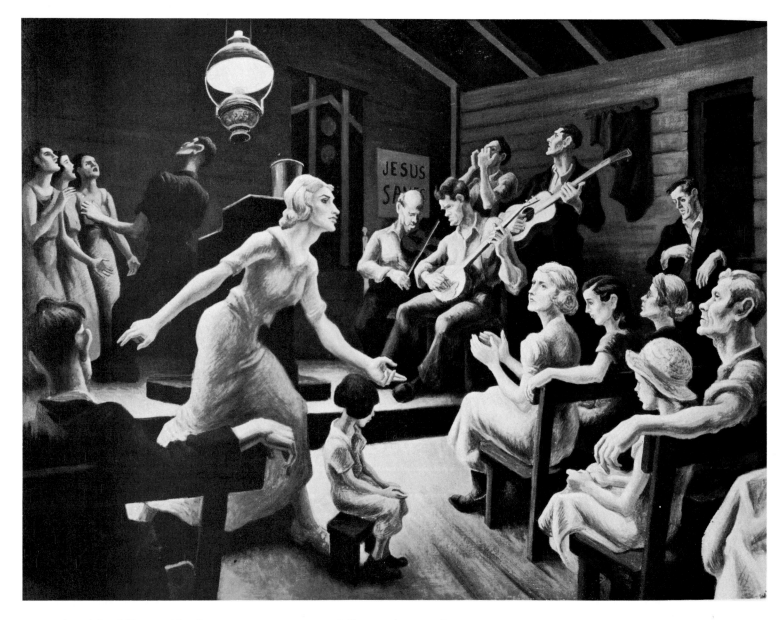

41. *Lord, Heal the Child*. 1934. Oil and tempera on canvas, 42 × 56″. Collection John W. Callison, Kansas City

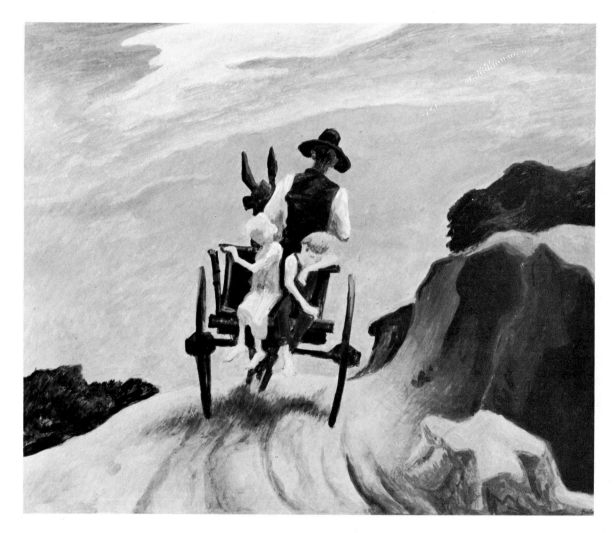

42. *Going Home*. 1934. Oil on panel, 17 × 21″. Collection Mr. and Mrs. Alexander Frohlich, New York

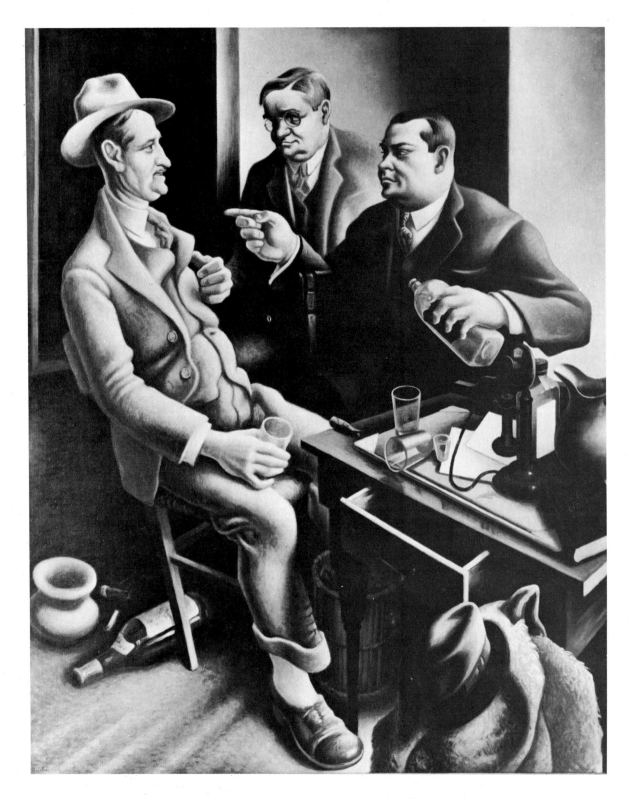

43. *Preparing the Bill.* 1934. Oil on canvas, 46 × 38″. Randolph-Macon Woman's College, Lynchburg, Virginia

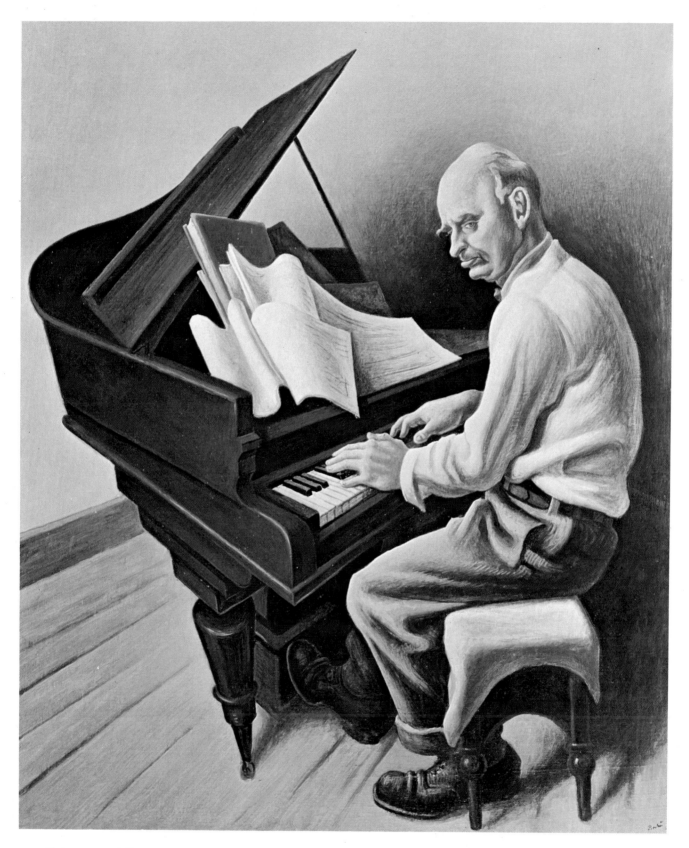

44. *"The Sun Treader"—Portrait of Carl Ruggles.* 1934. Tempera on canvas mounted on panel, 45 × 38″.
Nelson Gallery-Atkins Museum, Kansas City. Friends of Art Collection

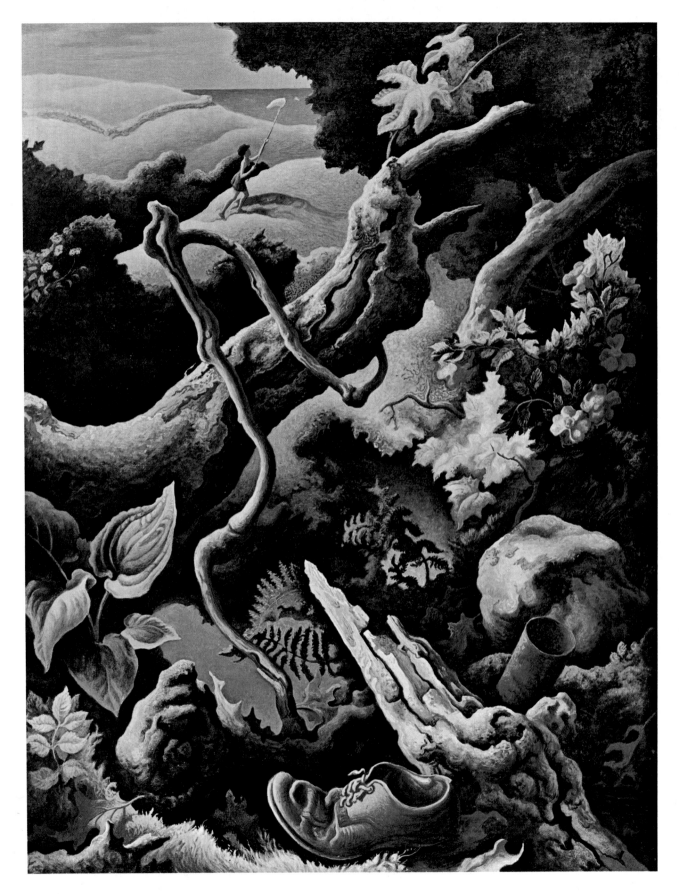

45. *Butterfly Chaser*. 1932. Oil and tempera on canvas mounted on panel, 40 × 30″. Collection Jessie Benton

MURALS OF THE THIRTIES

A major vehicle for developing an easily understandable American art at this time was mural painting. Although mural commissions were awarded through the 1920s, a shift in attitude toward the medium became apparent after 1927. Both critics and artists began to view it not merely as architectural decoration but as a distinct and perhaps saving category within American painting. John Sloan, who, like Benton, taught at the Art Students League, noted that many energetic and creative painters at that time were interested in turning to the mural form. Thomas Craven, in his acerbic manner, stated that a few good murals would provide American painting with a dignity and usefulness that it did not otherwise possess. Proponents of the American renaissance supported mural activity in emulation of the Italian Renaissance. Of greater importance was the increasing desire manifest in the art world to foster an art of easy communicability. Mural painting, a public art form, could well serve to implement such an art.

If one were to pick the single American artist who most effectively fostered an interest in mural painting, the choice would have to be Benton. Along with his teaching, he created three sets of murals between 1930 and 1933. The first two, painted for the New School for Social Research and the Whitney Museum of American Art, both in New York City, surveyed aspects of contemporary American life. The third set was commissioned for the State of Indiana Pavilion at the Century of Progress International Exposition held in Chicago in 1933 and 1934. In these last panels Benton presented the history of the state. All three sets received tremendous publicity, and together they provided numerous clues to future muralists who would soon be portraying histories of regions or scanning contemporary America.

The particular theme Benton selected for the New School murals was *America Today* (plates 46–52). He was especially pleased to obtain the commission because his interest in historical materials was beginning to fade. Not long before this he had painted the mural-sized study *Bootleggers,* his first large-scale contemporary scene (plate 56). Prophetic of his later work, it is different from the panels of the *American Historical Epic* in that the previous subordination of peripheral figures to a central dominant one is replaced by a more panoramic treatment of competing motifs. Benton's sense of American turmoil here invades all elements of the painting. Psychologically and stylistically attuned, he was ready for the New School commission.

In the nine panels of this cycle Benton reconnoitered contemporary America—its city activities, agricultural life in the South and the West, and its industrial growth as well —recording the kinds of activities he had observed in his recent travels around the country. He wanted to show the abundance of energy and the variety and confusion of

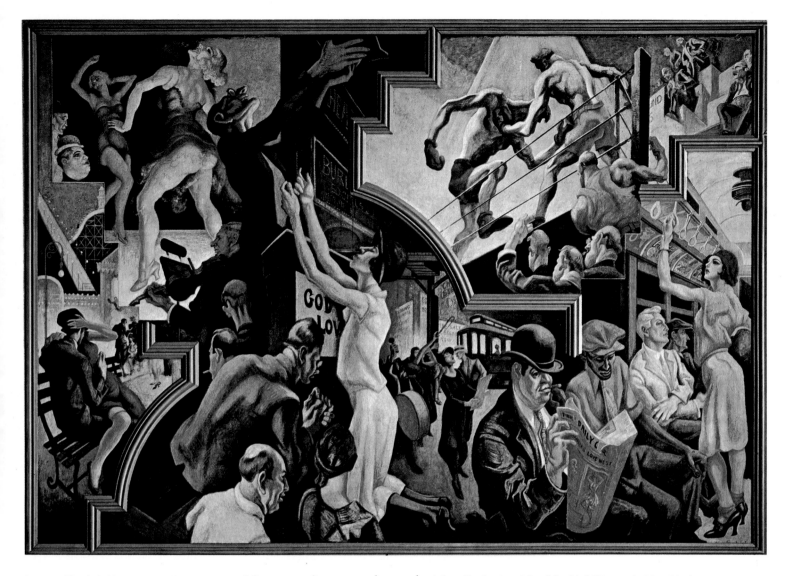

46–47. *City Activities.* 1930–31. Egg tempera and distemper on linen mounted on panels, 7′7″ × 26′10″. New School for Social Research, New York

everyday existence by presenting the uniquely American fusion of a rural and frontier psychology and an advanced technological system. No doubt he agreed with Thomas Craven's subsequent dictum that it was "the painter's business to provide an appropriate form for this curious condition."

In the New School cycle, oil wells jostle cows, and mine entrances block the path of large, ocean-going ships steering toward hilltop cabins. In place of the creeping standardization that many were finding in American life, Benton discovered a great diversity, calling for a robust and animated style. Many scenes are dominated by men whose gestures are theatrically exaggerated as if they were involved in ritual activity or in pantomime. Muscles bulge, hands clench, shoulders lean. A train rushes across the landscape. Smoke rises exuberantly. People gyrate as if they were giants engaged in gargantuan tasks; to Benton they *were* giants, since they represented the working people who in a few generations had made America the strongest country in the world, who

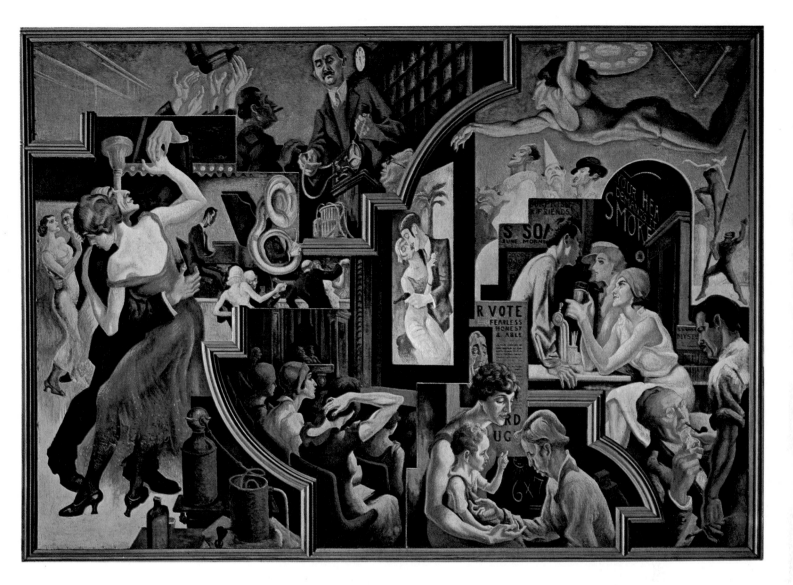

sometimes in a single generation had telescoped the development of frontiers from the most primitive to the most sophisticated of communities. The murals celebrate the life of those people whose actions upon the land created the character of the nation.

Those people—nonintellectual, perhaps endowed only with a tabloid mentality— were, for Benton, the paintable people. To ensure common American meanings, Benton devised a familiar tabloid format to present his images. He broke up the panels with straight and curved simulated architectural moldings. In addition to emphasizing spatial dislocations, these must have suggested to the contemporary viewer the illustrated pages in magazines and the rotogravure sections in Sunday newspaper supplements (plate 53). In effect, Benton conveyed the dynamism of the country in a form recognizable to most Americans, presenting pictures not simply of the week in review but of the country in review.

Shortly after he had completed the panels, Benton said that he did not know whether they qualified as art, nor did he care. Showing the "energy and rush and confusion" of

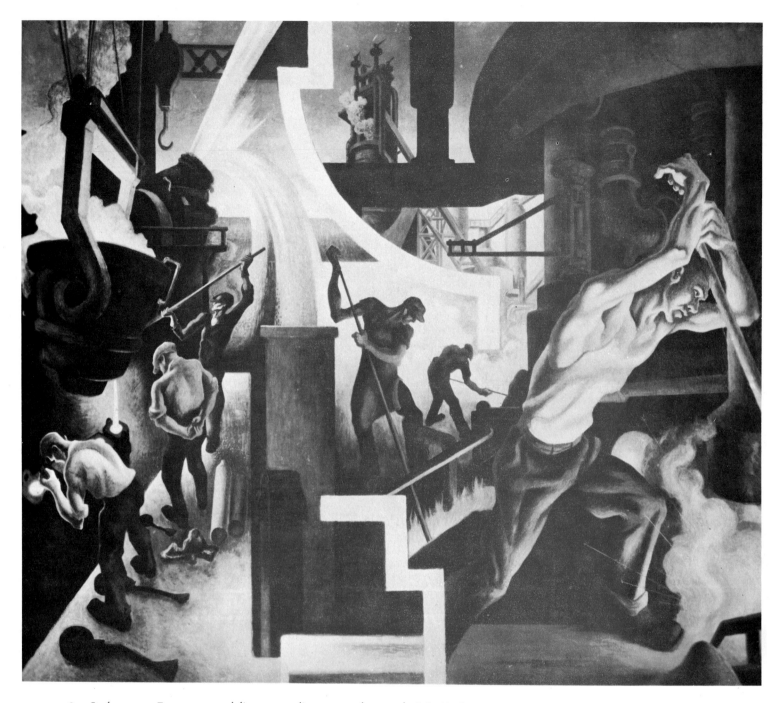

48. *Steel.* 1930–31. Egg tempera and distemper on linen mounted on panel, 7′7″ × 8′11″.
New School for Social Research, New York

American life was enough. The panels are hardly artless, however. If one disregards the subject matter and sees the forms and colors instead (as one had to do early in the 1960s, when Pop paintings were first exhibited), then one can clearly see a composition of underlying diagonals, X patterns, related verticals and horizontals, and fulcrums around which pivot associated shapes. Furthermore, he achieved a kind of pictorial space that parallels rather than imitates reality and symbolizes the American space— disjointed, interrupted, pulsating.

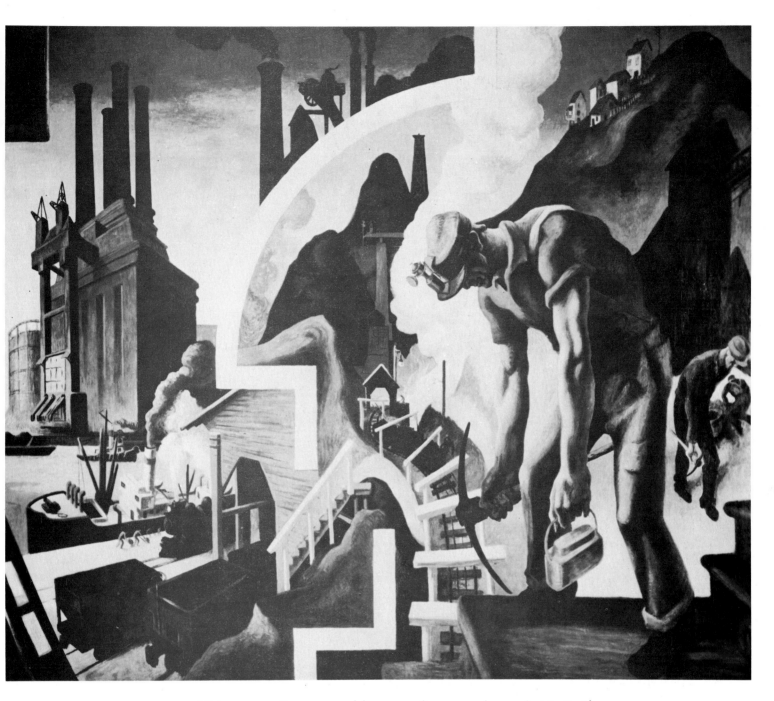

49. *Mining.* 1930–31. Egg tempera and distemper on linen mounted on panel, 7′7″ × 8′10″.
New School for Social Research, New York

For Benton, a ten-year search by way of easel paintings and mural studies had been fulfilled. For the burgeoning American Scene movement, a major monument had been created.

Benton's next set of murals, painted for the library of the Whitney Museum in 1932, marked a logical progression in theme. Instead of surveying work and leisure-time activities once again, he concentrated more especially on the popular arts, and called the new panels *The Arts of Life in America* (plates 55, 54). Four of the seven panels portrayed

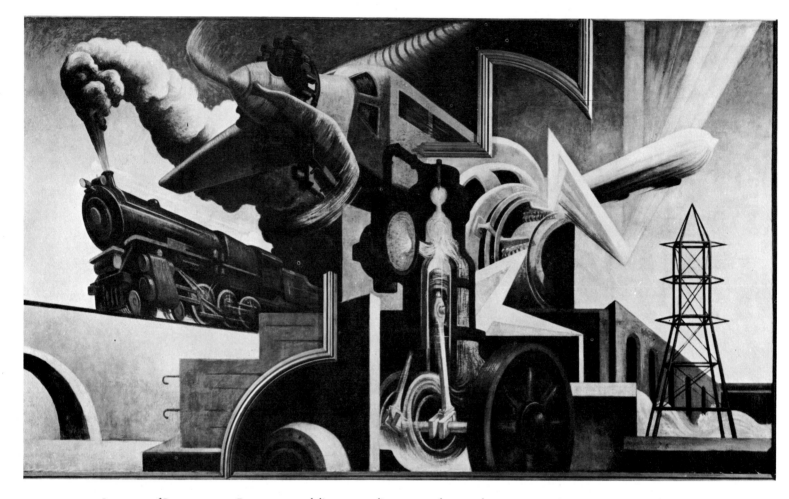

50. *Instruments of Power*. 1930–31. Egg tempera and distemper on linen mounted on panel, 7′7″ × 13′4″.
New School for Social Research, New York

the arts as they were produced by lower- and lower-middle-class Americans in the
South, the West, and the big city. Indian arts also were recorded, and two panels were
devoted to politics and to problems caused by the Depression.

As he stated, the real subject of the murals was "a conglomerate of things ex-
perienced in America," or, more specifically, those arts evolved as a refinement of
common activities. Purposely omitting the arts normally housed in museums or created
after special training and professional guidance, Benton chose instead to emphasize the
essentially unstudied and spontaneous character of popular crafts and pastimes and,
perhaps, their easy interchangeability. Shooting craps seems to require an animation
similar to that of gospel singing. Shooting rifles demands a coolness parallel to that of
playing cards.

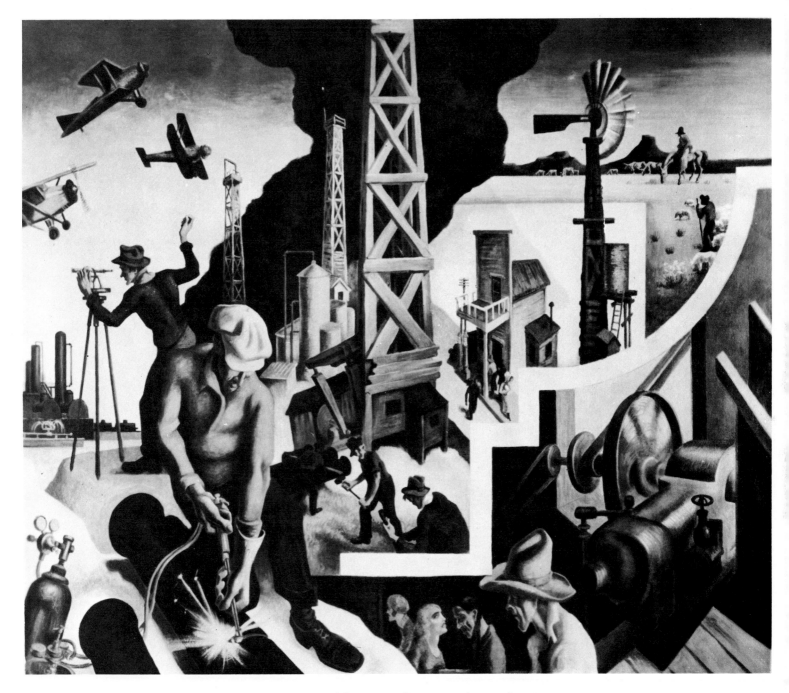

51. *The Changing West.* 1930–31. Egg tempera and distemper on linen mounted on panel, 7′7″ × 8′8″.
New School for Social Research, New York

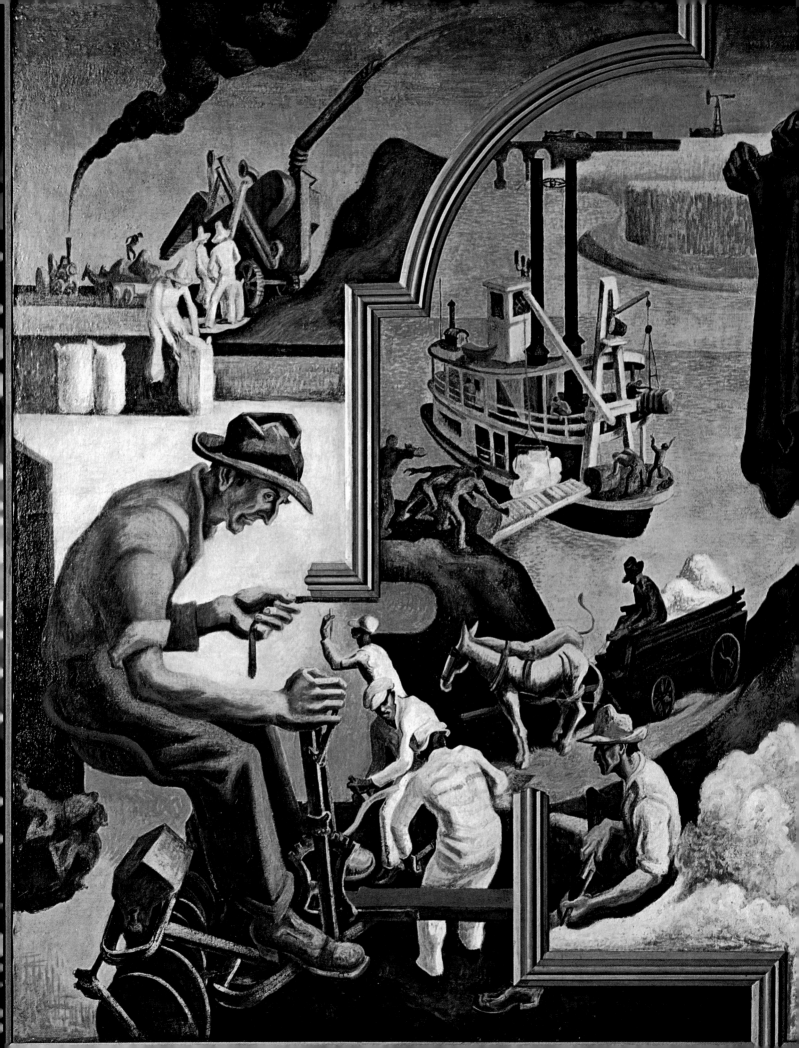

52. *The South*. 1930–31. Egg tempera and distemper on linen mounted on panel, 7′7″ × 8′10″. New School for Social Research, New York

One may disagree with Benton's thesis, as did the contemporaries who objected that the arts of life in America were not so gross as those depicted in the murals or that some of his cruder characters were not so centrally, dominantly American as, say, under-expressive Rotarians. Benton might have answered that Rotarians had probably capitulated to snobbery or at least repressed their own feelings in the face of elevated taste.

Using theatrically posed and stereotyped images, Benton programed his survey downward to a level of common understanding. For him, art did not necessarily aspire upward: it reached outward. Both in style and in subject matter his approach was, in a phrase Thomas Craven used in a slightly different context, "undefiled by cultural pretensions."

The panels were created, of course, after a considerable amount of thought and with definite social convictions. In the constant interaction of meaning and form, Benton manipulated the over-muscled and extra-jointed bodies to stress physical experiences, to symbolize American energy, and to construct a space that in pictorial terms would be the equivalent of real space.

As Benton's storytelling gifts were given freer rein, his sense of pattern grew less obtrusive. True, in the panels of the arts in the South, the West, and the city the central figures emerge as if at the apex of a triangle pointed at the viewer, and various elbows and knees may be arranged along imaginary diagonals; nevertheless, the close relationships of such forms are largely lost. Edges of figures rarely coincide, and tightly patterned shapes which earlier might have enclosed many persons are more open. Figures exist more easily in space. By contrast, the panel devoted to Indian arts is in the earlier style. Silhouettes of one figure run into the outlines of other forms, and the viewer is more impressed by large patterns than by individual features. In the main, however, the competition between form and meaning seems to have been won by meaning. In terms of Bentonian aesthetics, this was entirely appropriate.

A perceptive critic in 1932 might have predicted that sooner or later Benton would pursue his particular reading of the American spirit by recreating the development of a region rather than by glancing once again over the nation's activities, and that in the chronological layers of a single part of the country he could find insights into the whole. He was afforded such an opportunity late in 1932, when he was invited to paint the *Social History of the State of Indiana* for that state's exhibit at the Chicago Exposition. Within six months he toured the state, researched its history, visited many of its inhabitants, and completed twenty-two panels measuring 45,000 square feet altogether (plates 57, 58).

To some extent these panels fulfilled Benton's original ambitions for the *American Historical Epic,* in that he painted a history dramatizing the social and environmental

53. Page from the rotogravure picture section of *The New York Times*, January 4, 1931

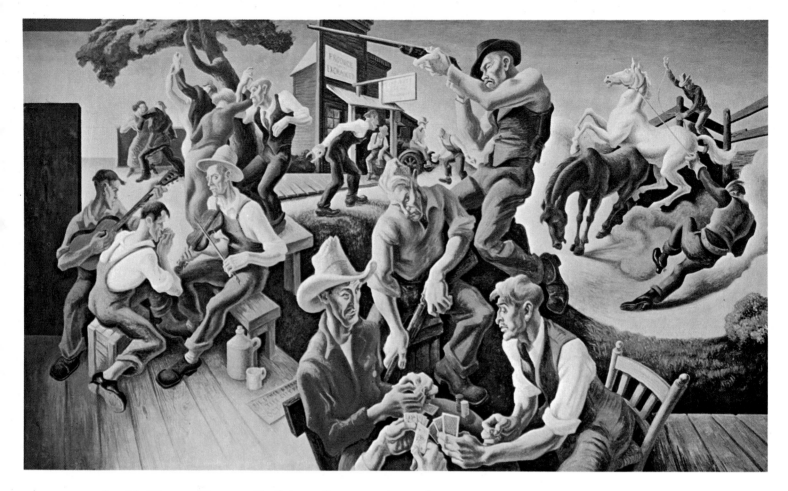

54. *Arts of the West.* 1932. Tempera with oil glaze on linen mounted on panel, 7′10″ × 13′3″.
New Britain Museum of American Art, New Britain, Connecticut, Harriet Russell Stanley Fund

changes, at least in one state, from the time of the Mound Builders to the machine age. Organizing his material into sections recording cultural and industrial progress, he depicted the early fur traders, the pioneers, and modern reform movements. (He also included a cross-burning by the Ku Klux Klan, much to the chagrin of Indiana's boosters and uplifters.) The panels summarized the activities, aspirations, explosive growth, and quickly developed traditions of one part of the country where, within a few generations, pioneer conditions had given way to modern industrial complexes. Here, certainly, was justification for an energetic style.

Benton might have worked out the idea of a progression of frontiers—social, cultural, industrial—simply on the basis of chronology, as he had done in the *American Historical Epic.* However, the development of themes and images in the Indiana murals also reflects the artist's close reading of the works of Frederick Jackson Turner, of whom he had been aware since roughly 1927. Benton may easily have accepted Turner's ideas concerning the practical, and even coarse, nature of the American mind as well as the

importance of the frontier. By the time Benton painted these panels, he had evidently grown extremely familiar with Turner's thoughts, so much so that certain passages from the historian's essays seem to lie behind the pictures.

In his famous essay "The Significance of the Frontier in American History" (1899) Turner said:

> The United States lies like a huge page in the history of society. Line by line as we read this continental page from West to East we find the record of social evolution. It begins with the Indian and the hunter; it goes on to tell of the disintegration of savagery by the entrance of the trader, the pathfinder of civilization; we read the annals of the pastoral stage in ranch life; the exploitation of the soil by the raising of unrotated crops. . . ; and finally the manufacturing organization with city and factory system.

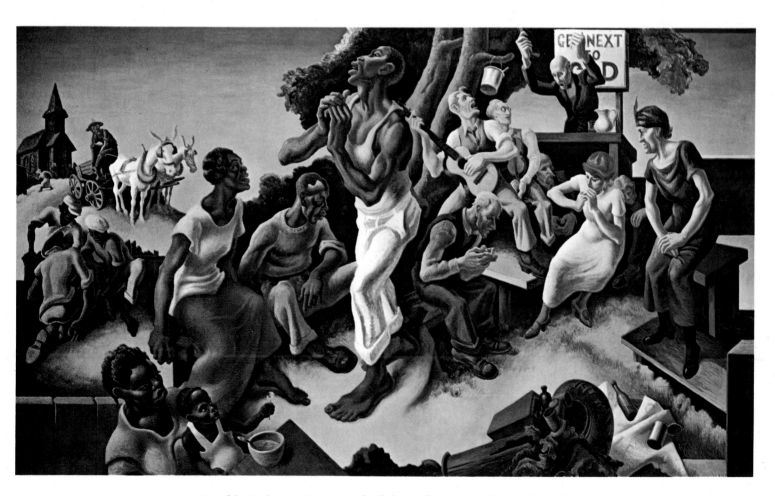

55. *Arts of the South.* 1932. Tempera with oil glaze on linen mounted on panel, 8 × 13'.
New Britain Museum of American Art, New Britain, Connecticut. Harriet Russell Stanley Fund

Another such passage is from "Contributions of the West to American Democracy" (1903):

> [The idealistic influence of the democratic experience of the West] gave to the pioneer farmer and city builder a restless energy, a quick capacity for judgment and action, a belief in liberty, freedom of opportunity, and a resistance to the domination of class which infused a vitality and power into the individual atoms of this democratic mass. Even as he dwelt among the stumps of his newly-cut clearing, the pioneer had the creative vision of a new order of society. In imagination he pushed back the forest boundary to the confines of a mighty Commonwealth; he willed that log cabins should become the lofty buildings of great cities. He decreed that his children should enter into a heritage of education, comfort, and social welfare, and for this ideal he bore the scars of the wilderness.

Benton tried to capture the epic grandeur of settlement, growth, and education suggested by words such as these. As he had done before, he broadened specific historical facts into generalized situations. Occasionally, recognizable figures appear, including Abraham Lincoln in the panel entitled *Early Schools and Communities* and Civil War Governor Morton in *Civil War,* but otherwise Benton did not paint particular events in the lives of famous people from Indiana. Rather, he focused on characteristic activities; everyone, known or unknown, is engaged in some kind of enterprise.

One searches in vain for an overriding theme that might give coherence to the panels. Clearly, no Marxist subtleties appear, nor is the gist of the work a hymn to capitalism or American idealism. The series is a people's history, an account of the more recent developments easily shared and confirmed by the public, and, as Benton had intended in the *American Historical Epic,* it shows how their restless energies changed the land. It is a work in praise of the anonymous American.

When exhibited, the panels were for the most part contiguous. Elements of one section spilled over into another, making the seams invisible. At regular intervals, strong verticals formed by figures, parts of buildings, trees, or tornado-like shapes provided moments of stability and points of rest in the unfolding panorama. In nervous counterpoint, figures cut by the base line of the murals seem to fall into the viewer's space, while, immediately behind them and to the sides, quick recessions carry the viewer's eyes to distant vistas. Few forms appear calm, and Benton's always animated contours seem to throw his figures into muscular spasms or force a building's roof line to swoop off into space. The sudden shifts of perspective and the agitated stances of the figures are

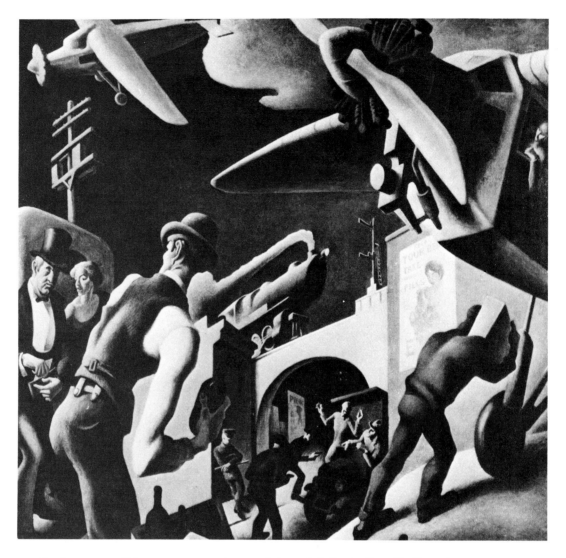

56. *Bootleggers*. 1927. Oil on canvas mounted on panel, 65 × 72″. Collection Reynolda House, Inc., Winston-Salem, North Carolina

capable of evoking equivalent kinesthetic responses in a sensitive viewer.

The three sets of murals, major documents of American Scene painting, assured Benton's popularity, as well as notoriety, for the remainder of the decade, and they established the standpoint from which he attacked artists and writers who disagreed with his aesthetics and politics and who, in their turn, assailed him. In a fiercely polemical decade, the murals provided ample ammunition for virtually everybody.

Not surprisingly, Benton's opinions were solicited in 1933 when the artist George Biddle tried to interest the federal government—or, more specifically, his friend President Roosevelt—in developing a mural program as a way to support artists impoverished by the Depression. Responding both as an artist and as a Middle Western Populist, Benton expressed the opinion that public administrators would become meddlesome and probably would not allow realistic treatments of modern American life.

Nevertheless, a strong mural program did become the backbone of the first federally sponsored art project, the Public Works of Art Project, begun late in 1933. A temporary program, it lasted six months. In the following year, Benton agreed to help the government promote public art projects. For Audrey McMahon, who worked with Harry Hopkins, then director of the Federal Emergency Relief Administration, Benton toured Eastern, Southern, and Middle Western states to encourage public interest in American art. He spoke mainly to political leaders and lay audiences to allay their suspicions about art and artists, a skill he had developed when in Indiana. His conversations helped to form a supportive public of politicians when the Federal Art Project of the Works Progress Administration was initiated in 1935.

Shortly after Benton returned to New York City in 1934, Forbes Watson, Edward Rowan, and Edward Bruce, who supervised yet another governmental program, the newly established Section of Painting and Sculpture in the Department of the Treasury, asked Benton to paint a mural for the new Post Office Building in Washington, D.C. The first artist approached, he was instructed to be conservative in taste. Even though the mural study would be screened by a committee, and there was no guarantee of acceptance, he agreed to work up designs. The theme was to be postal transportation. The designs were approved by the building's architects, but the committee asked for many changes. Benton might have bowed to its wishes had he not been invited just then to paint a set of murals in the Missouri State Capitol in Jefferson City and to become director of painting at the Kansas City Art Institute. Abandoning the Post Office Building project, and abandoning New York City as well, Benton left in 1935 for the Middle West, where he lived ever since. Ironically, the American artist who was so instrumental in creating an interest in mural painting never completed a single panel for any of the governmental programs.

BATTLES AND SKIRMISHES

Benton's decision to return to the surroundings of his formative years was taken in response to other conflicts as well as those of the bureaucratic handling of his designs for the Post Office Building. His departure also climaxed the growing hostility between himself and certain other artists, who either painted in School of Paris styles or were as devoted to the American Scene as he was but painted it from a left-wing point of view. So vicious were the attacks, counterattacks, and recriminations that artists active in the 1930s still bristle when Benton's name is mentioned. Benton himself never understood why he aroused such hostility. He surmised that his success caused some jealousy, and that his association with the increasingly xenophobic Thomas Craven may have led people to transfer to him some of their antagonism to Craven.

Other reasons for the antipathy toward Benton may be offered as well. Clearly, he was a "visible" artist who obtained good commissions and was treated very favorably in Craven's art columns and in the pages of the *Art Digest,* a magazine that strenuously promoted the American Scene. Furthermore, he was and remained vigorously articulate. He wrote articles and gave many speeches in which he set forth his position unequivocally. His tone could be abrasive, and sometimes, in the heat of argument, his "antiforeign" stand was interpreted as being anti-Semitic, an interpretation that he believes was used maliciously against him. At a time when Hitler's power was rising (Nazi artistic policies were carefully recorded in the *Art Digest*), Benton became associated in people's minds with nationalist, rightist, and, therefore, fascist thought. He was tagged as the painter of isolationism.

In any case, his battles with both modernists and Social Realists helped to polarize artistic thought during the Depression and forced people to choose sides. Occasionally, in the art press of the day, chronicles of the verbal and even chair-throwing battles competed with the usual art criticism.

By 1926, Benton's friendship with Dr. John Weichsel ended, as has been mentioned, because of the Americanist direction the artist began to take. After the completion of the New School murals, friends and critics who had approved (or at least had not disapproved) of the earlier mural studies began to desert him. Politically radical friends such as author Leo Huberman, whose book *We, the People* Benton illustrated as late as 1931, and Boardman Robinson found his growing chauvinism distasteful, as did acquaintances, like Lewis Mumford and E. E. Cummings. Their disagreement with Benton's aims only served to heighten his suspicions of Easterners and intellectuals, and his growing reluctance to accept their positions increased his alienation. By the

The Fur Traders; Pioneers (Industrial Progress). 1933 *Home Industry; Internal Improvements (Industrial Progress).* 1933

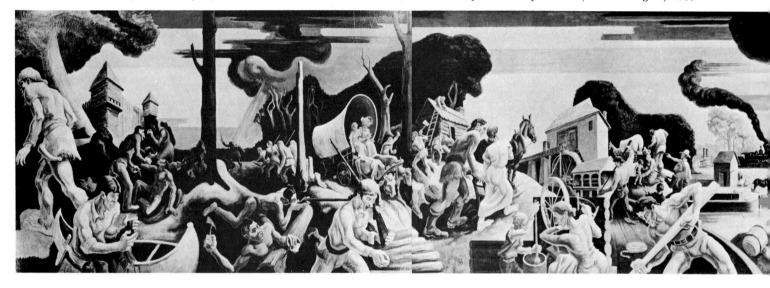

57. *Industrial Progress.* Panels from State of Indiana Exhibit at Century of Progress International Exposition, Chicago. 1933. Egg tempera on canvas mounted on pane
each panel 20 × 12′. Indiana University Auditorium, Bloomington, Indiana

Colleges and City Life; Leisure and Literature (Cultural Progress). 1933 *Woman's Place; The Old-Time Doctor and the Grange (Cultural Progress).* 1933

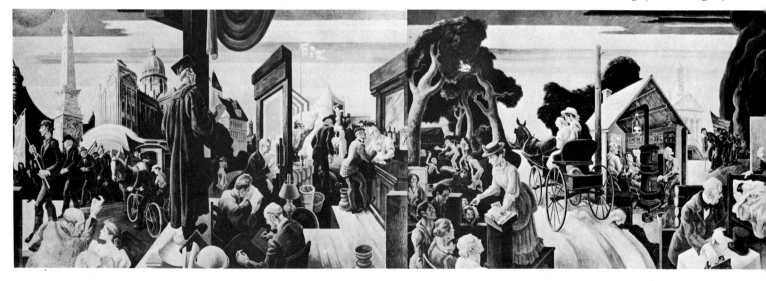

58. *Cultural Progress.* Panels from State of Indiana Exhibit at Century of Progress International Exposition, Chicago. 1933. Egg tempera on canvas mounted on panels
each panel 20 × 12′. Indiana University Auditorium, Bloomington, Indiana

Civil War; Expansion (Industrial Progress). 1933

The Farmer; Coal, Gas, Oil, Brick (Industrial Progress). 1933

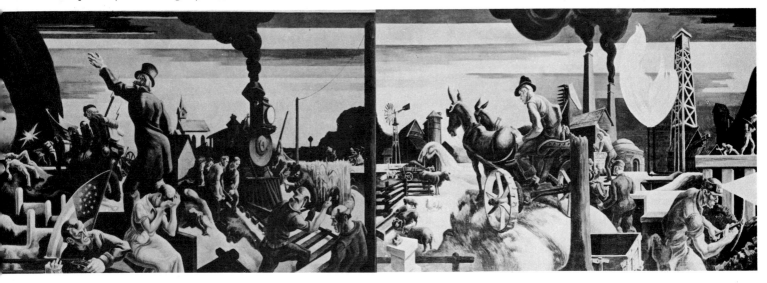

Reformers and Squatters; Early Schools and Communities (Cultural Progress). 1933

Frontier Life; The French (Cultural Progress). 1933

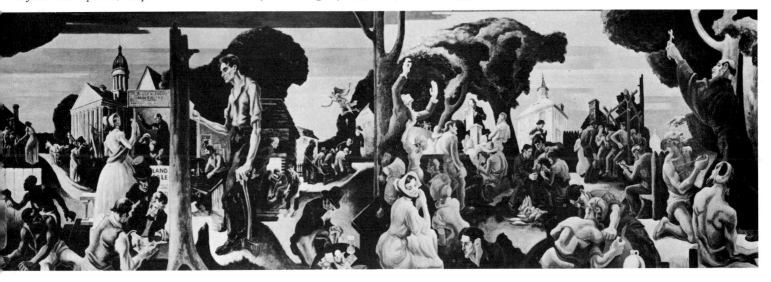

time the Whitney Museum murals were completed and the Depression had enveloped the country, reasonably clear lines had been drawn between those who painted the American Scene from the point of view of Main Street and those who viewed it from Union Square.

Benton (like Craven) acknowledged a debt to Communism for bringing artists into direct contact with life and the living, and he even considered its effect to be the most important since "the lords and dukes of the High Renaissance took [art] away from the service of religion and made it an accessory of vanity." But in the early thirties Benton saw left-wing artists as strait-jacketed by theories that did not apply to America. He began to equate Communism with Fascism, in a pox-on-both-your-houses attitude, finding both systems typically Central European in thought, politically and aesthetically absolutist, and based on an internal logic that ignored pragmatic American concerns. In comparison with the Social Realists, Benton felt that his art was socially more realistic than theirs, since it depended not on particular doctrines but on American experiences gathered beyond the confines of New York City.

Immersed in notions of free enterprise and individualism, Benton could find acceptable only minimal governmental controls to ensure economic success. He would not have painted the sights described by writers such as Theodore Dreiser and Edmund Wilson, who in 1931 traveled to the Appalachian coal fields to witness repression and poverty at first hand. Nor would he have painted the blacks of the Scottsboro Case to illustrate how American justice tried to railroad nine men into the electric chair in Alabama Instead of the downtrodden proletarian, ill-fed sharecropper, or beleaguered black, he painted people capable of enjoying life. His subjects seemingly accepted their fate. Rather than grim reminders of their oppression, he painted the sense of energy and lust for living that helped sustain them. His characters seemed to gain strength from contact with the land, whether they were shiftless or hard-working blacks, hard-drinking or amiable whites. The behavior patterns that he stereotyped were different from those recorded by left-wing artists and writers, who often reduced to cartoon simplicity life in the South and in the mountainous regions.

The skirmishes with the Social Realists were the more spectacular of the two running feuds Benton conducted during the 1930s. The other revolved around his contempt for modern art and for those Americans who followed School of Paris styles. As revulsion from recent European styles expanded in the 1930s, Benton's remarks grew correspondingly vitriolic. He thumbed his nose at museum curators who, he felt, bought the works only of dead artists or who staged exhibitions of esoteric art incomprehensible to the general public. Not content merely with painting or with letting his paintings speak for his attitudes, he played both the bully and the young David slaying any opposing

giant in sight—all in behalf of meaningful subject matter based on American experience.

Although Benton may have enjoyed the professional and public attention, the emotional costs of the fight must have been enormous. Ostracized by former friends, rejected by many students, baited and booed at public appearances, physically drained by painting three sets of murals in three years, he found New York City an increasingly joyless place to live and work. Even before the crisis years of 1934 and 1935, when he was most reviled, he may have begun to think about returning to the Middle West. When preparing the Indiana murals, in 1933, he relived aspects of his own Missouri childhood and adjusted easily to the people he met, feeling, in a mood reminiscent of his Norfolk days, as if a close kinship had always existed with them. Although he had taken trips through back-country areas, he had never stayed long enough in one place for these feelings to crystallize and to be reinforced by daily contacts. His years in New York City seemed increasingly like a sojourn, a visit, a temporary interlude in his life. The time he had spent in large cities, he realized, had not seriously altered his small-town values.

Early in 1934, perhaps when he was touring the country for Audrey McMahon, he expressed the desire to paint a mural of the life of Huckleberry Finn, a fellow Missourian. This suggests that Benton was then ready to leave the East, perhaps permanently, in order to revisit a place and a period closer to those of his own youth, before America had traveled so far on that "chartless journey" he had written about.

Thus the opportunity offered him in the following year, to paint the historical murals in Jefferson City and to work at the Kansas City Art Institute, was thoroughly welcome. His departure from New York produced, in addition to a rash of articles in the daily press and the art journals, one of the classic anti-urban statements of the decade, an essay, admittedly disjointed but profoundly felt, which Benton included in his earlier autobiography. In it the artist intimated that one could go home again, particularly at this time in the history of American art and culture. Since localism played such an important role at that point, he hoped to find the old ways, not embalmed but giving rise to new cultural practices based on native (rather than imported) models.

Finding people increasingly distrustful of large cities, especially after the stock-market crash of 1929, Benton said that he wanted to escape from narrow metropolitan intellectualism. On his tours he had noticed a growing cultural consciousness in smaller cities and, as a Middle Western artist, he wanted to be closer to and take part in their developing concern for art. In the outlying areas, he felt, few aesthetic orthodoxies, cults, or conformist principles would inhibit the cultivation of new forms and subjects. By comparison, New York City, worn out and no longer able to provide its inhabitants with humane living conditions, seemed to him a parochial appendage off the eastern coast,

93

absorbed in its own life if not serving as a colonial outpost of European culture. The future of American art, he held, was not to be found in a place offering only coffins for the living and the thinking.

THE RETURN TO THE MIDDLE WEST

He left New York City, then, not simply driven out by hostility but also believing that he was headed for the mainland of America. In time he found Missourians as much constrained by urban evolution as the inhabitants of New York. The pleasant, relaxed atmosphere he had envisaged really existed only in extremely rural sections. Even so, the change must have been, for a time, utterly delightful, for the murals in Jefferson City, entitled *A Social History of the State of Missouri,* were the best he had yet completed and, very likely, the most satisfying of his entire career. The subjects included early accounts of the regions, subsequent events that took place in Benton's own lifetime, and legends associated with the state (plates 59–64). The murals combined local history with autobiography, known facts with stories remembered from childhood. They made possible the integration of the artist with his environment, his subject matter with his means of depiction. As an American Scenist, Benton could hardly have asked for anything more.

The mural space includes three walls, each cut by a door. The historical panels represent a vigilante lynching, horse trading, primitive agriculture, and an old-fashioned political meeting run by Benton's father. The parts devoted to family life, the farm, and the law show modern agriculture, grain elevators, a domestic scene, a court in session, and the mining industry. Over the doors are episodes from the lives of Jesse James, Frankie and Johnny, and Huck Finn and Jim. Architectural frames, reminiscent of those in the New School murals but not nearly so obtrusive, set off the subjects.

Benton's sometimes wry observations of life in the popular American culture indicate that his over-all view fell somewhat short of total admiration. In one vignette a lynching and the beating of a slave are shown, as well as the tarring of a white man. On one of the walls a scene shows the destructive use of whisky as a bargaining weapon with the Indians. On another appears a slaughterhouse with an integrated group of workers. Interestingly, two of the three legendary scenes feature black subjects, and in the section illustrating the political meeting a black businessman or politician can be seen in the assembled crowd.

Although the artist seems to have doted on homespun anecdotes, glorified democratic

94

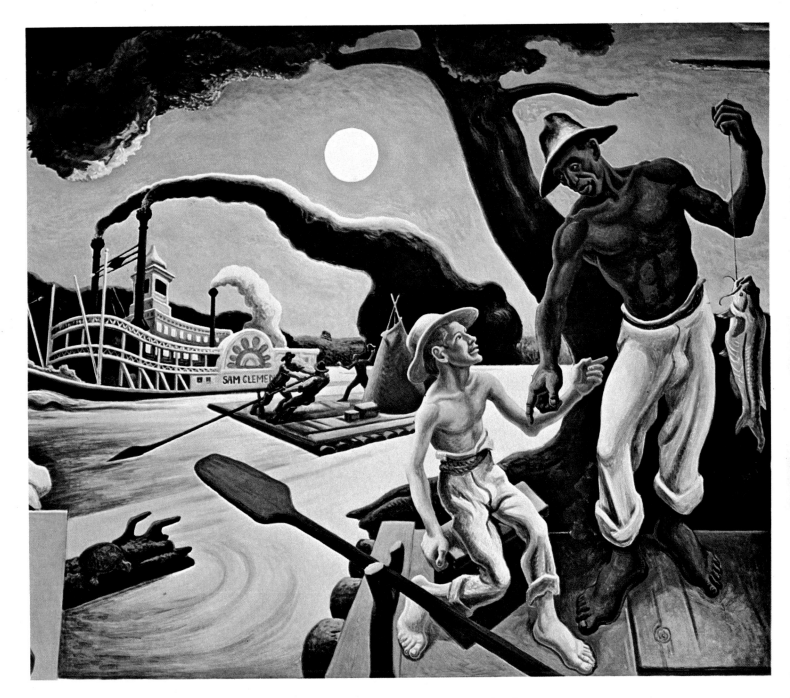

59. *Huck Finn*. 1936. Oil and egg tempera on linen mounted on panel, 7 × 12′. Missouri State Capitol, Jefferson City

processes, and rejoiced over the productivity of the people and the land, the seamier aspects of Missouri's history are admitted to an exceptional degree in a set of murals designed for a state capitol. It is undeniable that national theories of art may feed into fascist, racial, and religious theories, but an artist totally wrapped up in the American flag or completely committed to Main Street boosterism would not have added these elements to the panels. Such contrasts, surely, were inserted by one who recognized both the merits and the faults of the system but was committed to working within it.

Compositionally the Jefferson City murals differ from the earlier ones. In the section devoted to the family, the farm, and the law, Benton used vertical props similar to those in the Indiana murals, but by opening up more ample vistas and using a deeper perspective, he achieved less crowded spaces. Perhaps because of this greater expansiveness, Benton took pains to organize his figures within broad circular areas or to place them within a carefully studied diagonal grid. As never before, he reconciled his conflicting desires to create spaces parallel to reality and to organize patterns flatly on the picture plane. A similar adjustment of two- and three-dimensional treatment appears in the bodies of the heavily muscled men.

Contrasting with the turbulent forces Benton felt impelled to project in his earlier work, broad, stately rhythms dominate the Missouri panels. This change of mood may be more than a matter of stylistic evolution, perhaps depending on both geographic and psychological factors. His earlier scenes, both rural and urban, tended toward a compositional agitation which reflected, in Benton's eyes, American dynamism. But here similar views are calmer. Possibly the tempo of life in New York City had affected Benton more than he knew, so that he carried over into all his work a frenzied quality derived from the cosmopolitan environment. Because he obviously fought against this environment, he increased the intensity of his attack when painting.

In slower-moving Missouri, at home at last, the natural pace of the surroundings, in addition to the artist's greater psychological rapport with that pace, may have led him to decrease the quick flow of activity and to round the sharpness of edges. The jagged grew smooth, the crowded sections became less dense, the clutter began to disappear.

His easel paintings revealed similar changes during the years just after his return to Missouri. Figures moved less violently and were less angular. Their proportions more nearly approximated normal measurements. Curvilinear elements encompassing groups of figures or objects were less obtrusive, occasionally absent. In some paintings a compromise seems to have been attempted in his description of forms, so that silhouettes of clouds, the horizon line, and the contours of the earth, although each distinct, all responded to the same broad, rhythmic sweeps of Benton's hand (plate 65). As a result

the pulse of his pictures was slowed down. One's eyes are not forced along sequences of

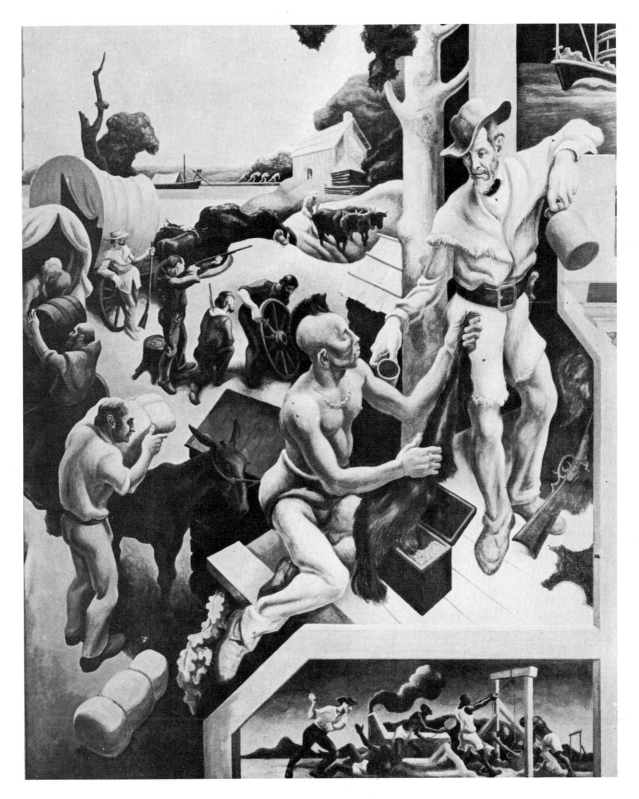

60. *Early History*. 1936. Oil and egg tempera on linen mounted on panel, 14′ × 9′3″.
Missouri State Capitol, Jefferson City

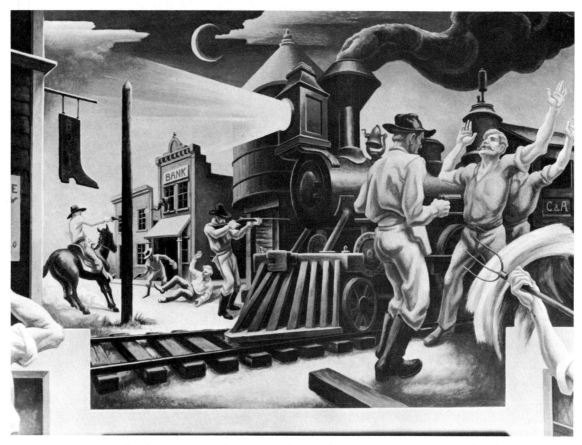

61. *Jesse James.* 1936. Oil and egg tempera on linen mounted on panel, 7 × 12′. Missouri State Capitol, Jefferson City

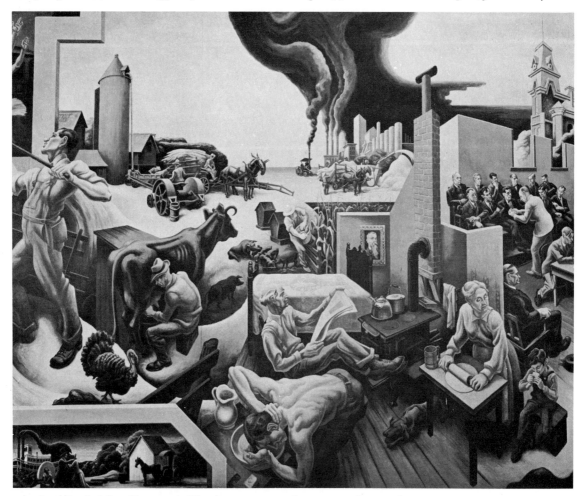

62. *Rural Family Life and Law.* 1936. Oil and egg tempera on linen mounted on panel, 14 × 23′.
Missouri State Capitol, Jefferson City

edges but are allowed to linger over particular passages. An occasional elegiac note appears, an element not easily found in previous works.

The new paintings certainly reflect Benton's warm feeling for the local land and its people, but geographical factors are also involved. For example, *Cradling Wheat* is a study, plainly and simply, of the distinctive Missouri landscape (plate 66). The peculiar character of that state's softly rolling hills (a striking change for the artist from New York City's tall buildings) is easily recognizable, and the cloud formations are of a type often seen in that part of the country. Relying less upon ideas concerning a general American style and subject matter, Benton increasingly allowed the look of the land itself to dictate his compositions and the life sustained by the land to provide his subject matter. He tended less to stereotype the region in picturesque scenes or typical views. These pictures possess, therefore, an intimacy and a sympathetic understanding that Benton had previously reserved for his family portraits. In great measure these too were family paintings. By contrast, other works of this period, showing activities common to other parts of America, retained a greater degree of angularity and recall the earlier manner.

It would seem that in his paintings of the New York period Benton had fallen victim, ironically, to the same assumption he had found false in many city-based artists—that from one city, New York, it was possible to understand the entire United States. When he returned to the Middle West, he circumscribed his wide-ranging vision and began to concentrate on representing a specific region—as if only now trying to apply John Dewey's admonition, offered many years before, about capturing universal essences through an appreciation of the local.

Perhaps because their focus is narrower, the new works seem more profound, certainly more profoundly felt. Less synthetic, they evoke a greater understanding of rural life, in at least one part of the United States, and therefore project to near-mythic proportions the lives of the people they represent. By concentrating on the particular, Benton achieved in greater measure his Americanist aims. Although describing a single area, these are his most American and, very likely, his best works.

Once having accomplished the successful return to his origins, what could he do next? The pressures he had faced in New York were eliminated, and he no longer had to demonstrate the Americanism of his art or his identity as an American artist. The deteriorating situation in Europe began to impose itself on people's minds and to compromise the position of American Scenists. Ten years before, one could have argued the case for supporting an American art in opposition to the envelopment of American taste by foreign movements and for seeking a usable native past. By the late 1930s such nationalistic and antiquarian concerns became suspect because of the mounting world

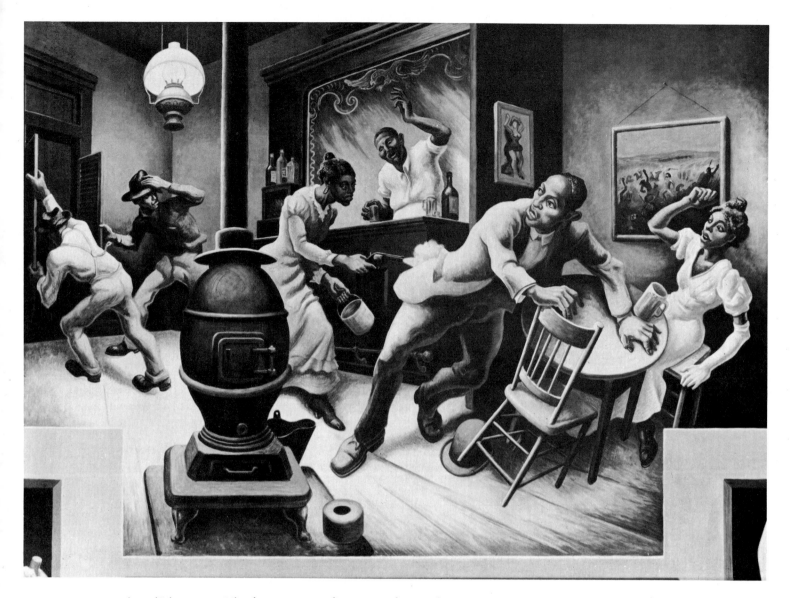

63. *Frankie and Johnny*. 1936. Oil and egg tempera on linen mounted on panel, 7 × 12′. Missouri State Capitol, Jefferson City

tension. Furthermore, the general drift of realistic American painting through the last years of the decade turned toward a greater reliance on imagination and fantasy and toward concern for the manipulation of color, as well as of texture, and pattern.

Like so many other artists who had matured in the thirties, Benton seemed to sense the great divide that would loom over American art with the approaching war. Still, firmly committed to a realistic art easily accessible to the average person, rather than to one exploring the intimacies of the imagination, he severely limited his options for change and development. Modifications and shifts did occur, nevertheless.

He began to paint more still lifes, studies from the nude, and landscapes that celebrated nature itself perhaps more than the specifically American scene. Less concerned with pattern than in the past, he treated surface effects with greater regard, manipulating

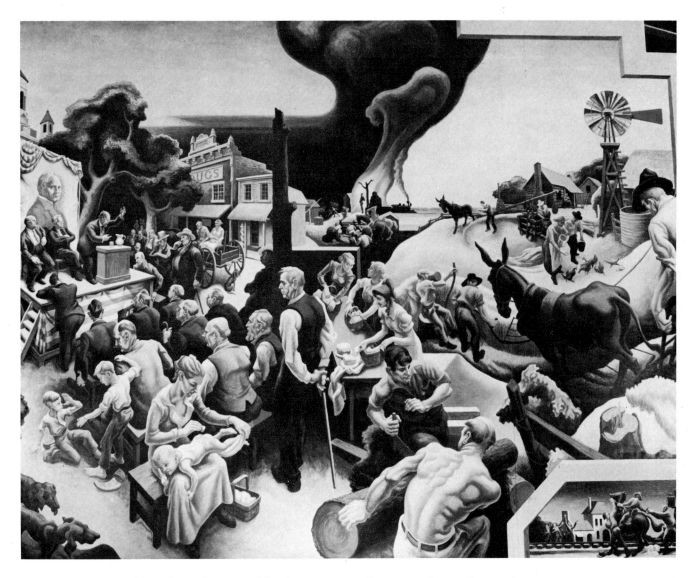

64. *Politics and Agriculture*. 1936. Oil and egg tempera on linen mounted on panel, 14 × 23′.
Missouri State Capitol, Jefferson City

texture and color in ways that were new to him. Altogether, he became more of a studio painter than at any time since World War I.

At times the sharpness of his vision and his insistent concern for detail carried Surrealist overtones. Occasionally when he was inserting a realistic nude into a lush, over-developed landscape, the results could be disconcerting, especially when he tried to domesticate mythological or biblical figures in the American environment (plates 67–69). Yet, using the same sharp-focus style and selective magnification of motifs, he created what must be one of the most eerie confrontations between a child and a butterfly ever painted. This work suggests not so much magical presences as hallucinatory ones (plate 72).

Some of Benton's most successful paintings combined his new interests with older ones. In *July Hay* earlier stylisms abound—long contour lines, angular movements of the figures, telescoped perspectives, and surging land—but to these he added magnified detail and enriched textures that substitute a measure of fantasy for what would earlier have been an old-fashioned celebration of the wheat harvest (plate 70).

Only rarely has the American soil been able to nurture an art of fantasy, and Benton soon gave up serious explorations of the unreal. Instead, he returned to the manner he

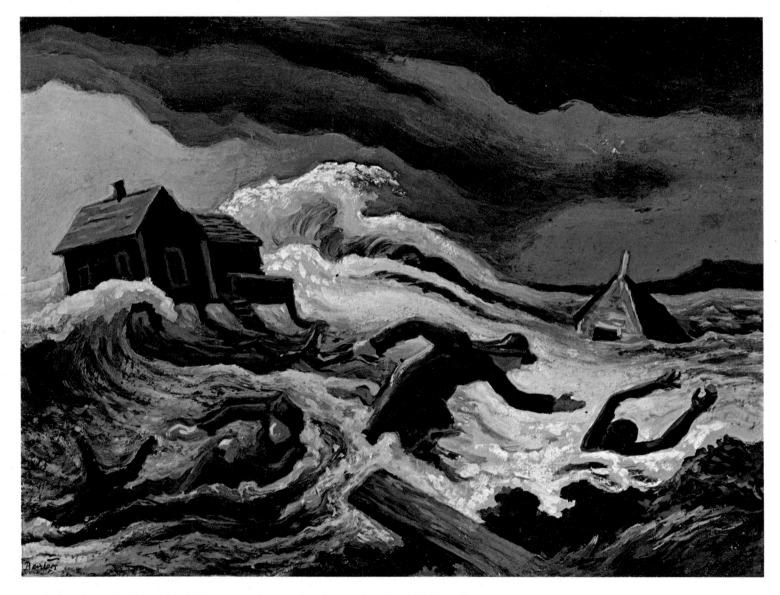

65. *The Flight of the Thielens.* 1938. Oil on panel, 8 1/2 × 11 1/2″. The Hollander Gallery, St. Louis

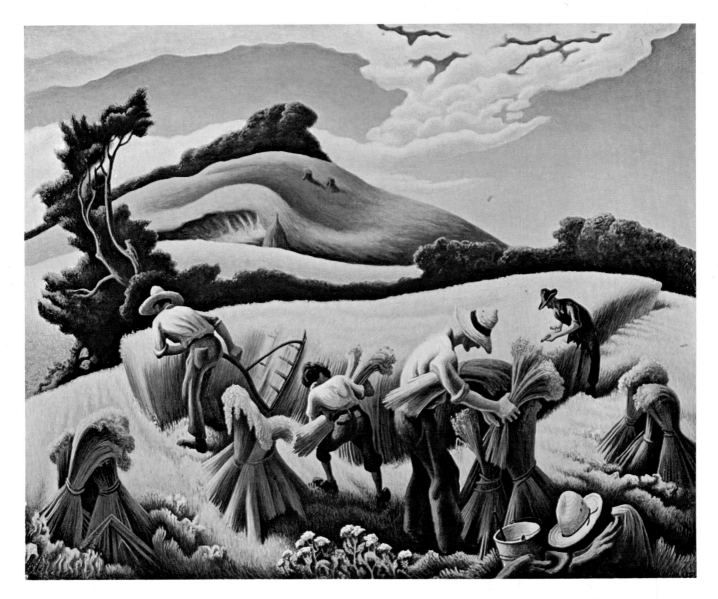

66. *Cradling Wheat.* 1938. Oil and tempera on canvas mounted on panel, 31 × 38". The St. Louis Art Museum

had developed soon after his arrival in the Middle West, controlling rather carefully the multiplication and enlargement of certain detailed forms. These, limited primarily to individualized grain shoots at the base lines of his paintings, established the broad contour rhythms for the ridges of the earth and the curves of the clouds (plate 71). In these works the routine activities of daily labor are enacted, as well as such untoward events—a fire in a barnyard, for instance—as might have been remembered and recounted for years at the fireside.

67. *Studies of Nude.* 1939. ▶
Pencil, 20 × 14″.
Collection Rita Benton,
Kansas City

68. *Persephone.* 1938–39. ▶ ▶
Oil and tempera on canvas, 71 × 52 1/2″.
Collection Rita Benton, Kansas City

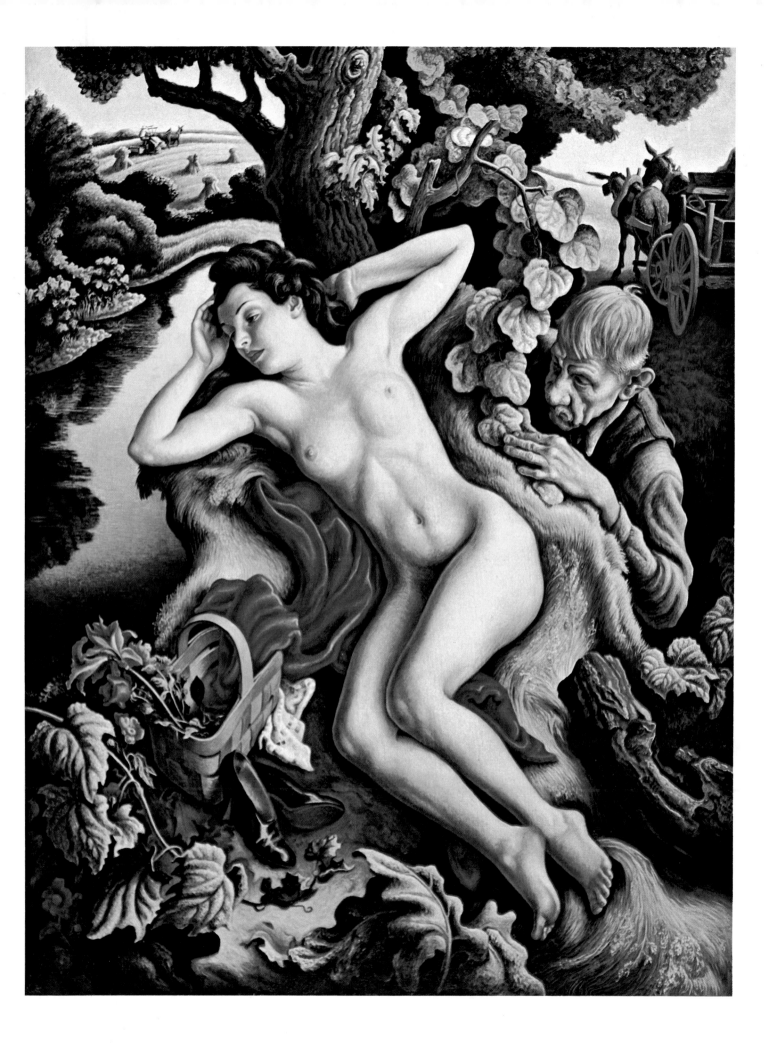

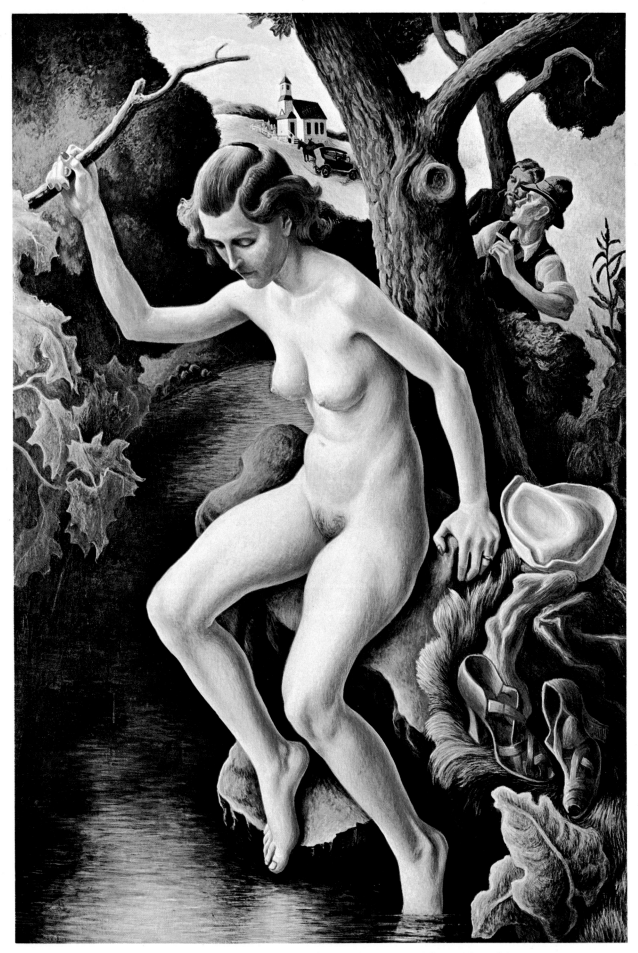

69. *Susannah and the Elders.* 1938. Egg tempera on canvas mounted on panel, 60 × 42″. California Palace of the Legion of Honor, San Francisco. Anonymous gift

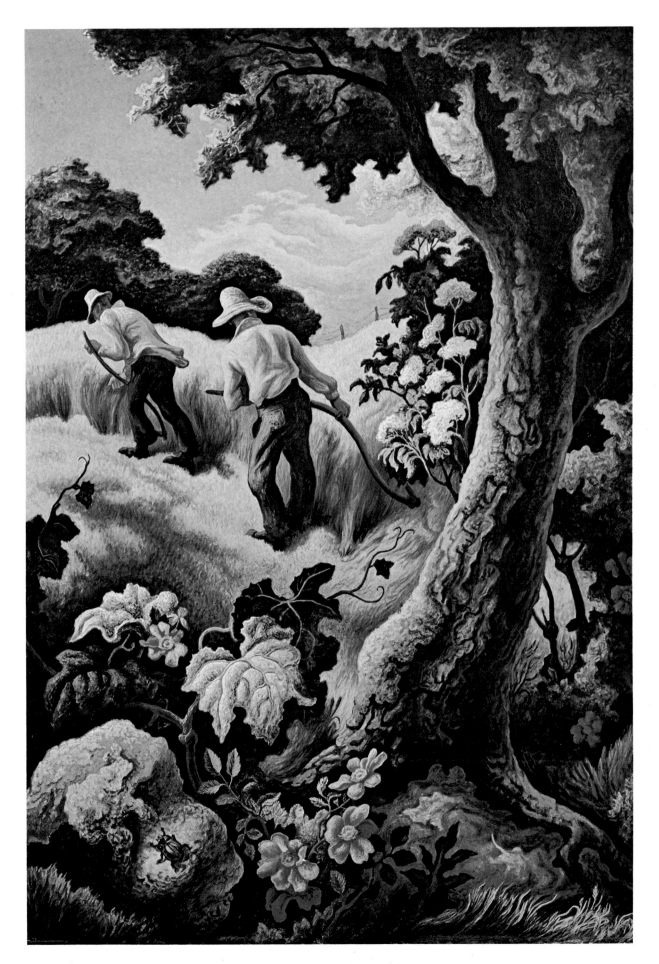

70. *July Hay.* 1942. Oil and egg tempera on canvas mounted on panel, 38 × 26 3/4″.
The Metropolitan Museum of Art, New York. George A. Hearn Fund

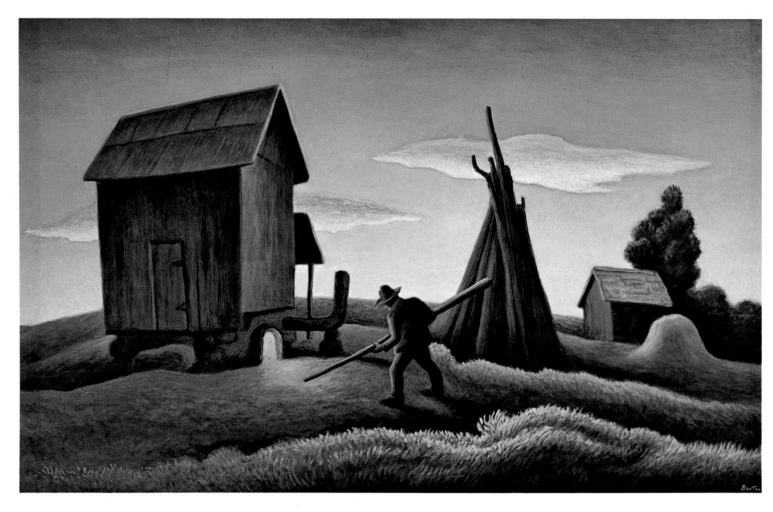

71. *Night Firing of Tobacco*. 1943. Oil and tempera on canvas mounted on panel, 20 × 31″. Collection Mr. and Mrs. Lelon M. Constable, Kansas City

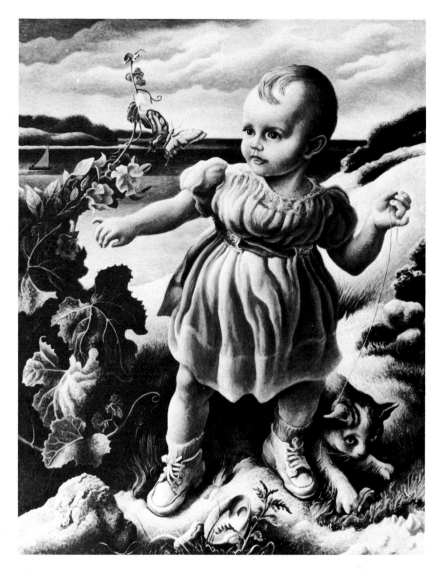

72. *Jessie, One Year Old.* 1940. Oil and
tempera on canvas mounted on panel, 28 × 39″.
Collection Jessie Benton

73. *The Woodchopper.* c. 1936.
Tempera on panel, 13 1/2 × 17 1/8″.
Collection Mr. and Mrs. Vernon
L. Newell, Tucson, Arizona

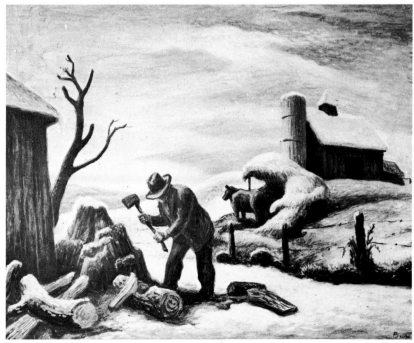

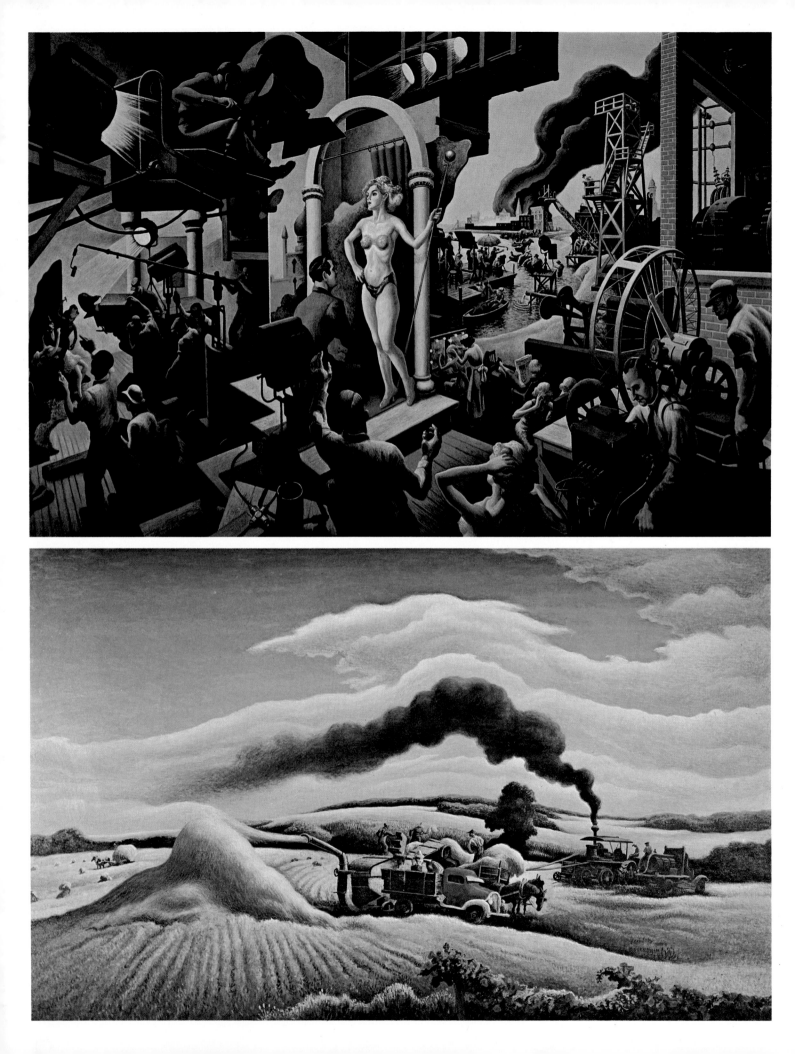

◄ 74. *Hollywood.* 1937. Oil and tempera on canvas mounted on panel, 53 1/2 × 81″. Collection the artist

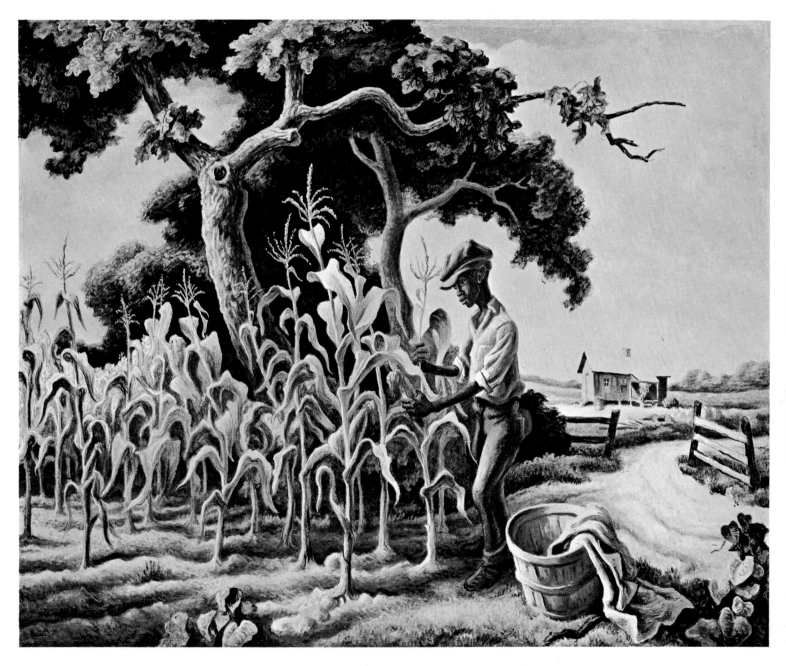

76. *Roasting Ears.* 1938–39. Egg tempera with oil glaze on canvas, 32 × 39 1/4″. The Metropolitan Museum of Art, New York. Arthur H. Hearn Fund, 1939

◄ 75. *Threshing Wheat.* 1938–39. Oil and tempera on canvas mounted on panel, 26 × 42″. The Sheldon Swope Art Gallery, Terre Haute, Indiana

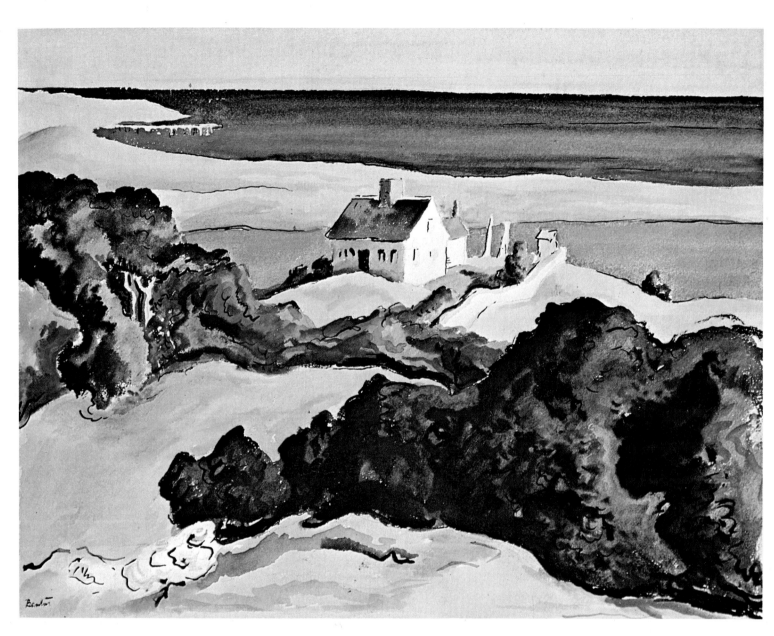

77. *Chilmark*. 1938. Watercolor, 13 × 17″. Butler Institute of American Art, Youngstown, Ohio

PART IV

WORLD WAR II AND THE POSTWAR WORKS

WORLD WAR II and the POSTWAR WORKS

Although settled in Kansas City, Benton still commanded attention from the national art press. An immensely popular figure in some areas, he could hardly be ignored; also, his outspoken attacks on the museum as a cultural institution and upon the type of mentality attracted to its curatorial staffs could not be overlooked. At the same time the worsening international situation had begun to preempt his usual subject matter, to empty him of painting ideas, as he said, and to diminish the size of his audience.

The attack on Pearl Harbor and Benton's response to it ensured an extraordinary, if momentary, increase in that audience. On a speaking tour when the news was received, he immediately returned home and created ten large paintings for the purpose of arousing Middle Westerners and all other Americans to the perils of the new war (plates 78, 79). Deliberately propagandistic, these pictures were designed with exaggerated effects in order to awaken in Americans "the kind of hard ferocity that men must have to beat down the evil that is now upon us." Published in magazines, newspapers, and pamphlets, fifty-five million individual reproductions are thought to have been circulated in the early 1940s, undoubtedly one of the widest distributions ever achieved by a single set of paintings.

Although finished rapidly and, as Benton said, formulated as cartoons in paint, they manifest yet another stylistic trait that became common in his work after 1940, and can be seen in incipient form in the Missouri murals: in his figurative paintings, profiles of shapes began to grow increasingly taut and sharp. The action of the figures appeared frozen, immobilized by their carefully defined edges.

This aspect of Benton's art was abetted by another factor that also began to appear after 1940 and can be detected in the Missouri murals as well. When not relating forms to the swelling curves of the Missouri landscape, or when not studying carefully particular details, he began to emphasize storytelling elements rather than formal patterns. Where he had once carefully contrived continuities of gesture and of tone and shape related to background forms, he now detached his figures from the surrounding field. He began to individualize a house in the landscape, a human form, or a table, so that each object became sealed within its own borders. The space that at one time paralleled reality now came to serve as a backdrop for the story of the painting.

This development, like others in Benton's art, perhaps depended upon external causes as much as upon the internal evolution of his style. The American style he had sought some twenty years earlier was based on at least two principal factors: first, his belief in the need to develop an American art and, second, his own ability to meet people and communicate with them during his wanderings. However, by the 1940s, the

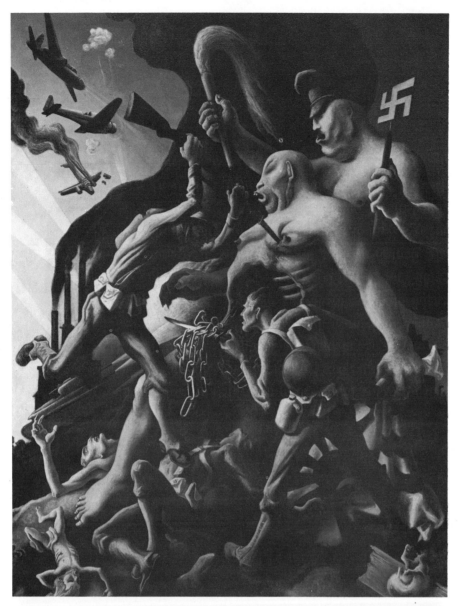

78. *Exterminate! (The Year of Peril)*. 1941.
Oil and tempera on canvas mounted
on panel, 8 × 6′. The State Historical Society of
Missouri, Columbia

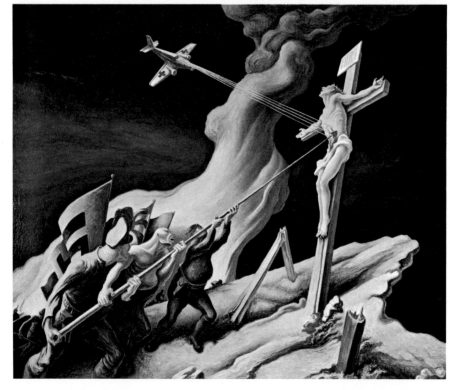

79. *Again (The Year of Peril)*. 1941.
Oil and tempera on canvas mounted
on panel, 47 × 56″. The State Historical Society of
Missouri,·Columbia

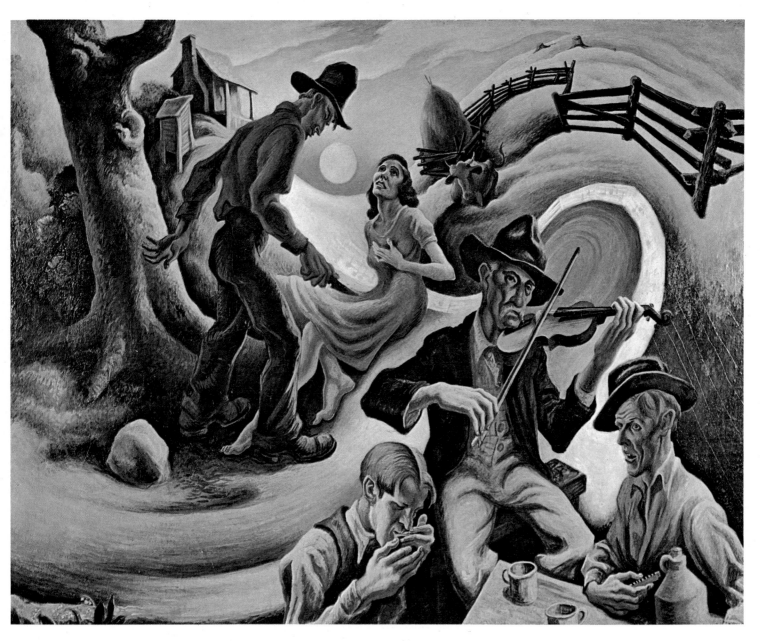

80. *The Ballad of the Jealous Lover of Lone Green Valley.* 1934. Oil and tempera on canvas mounted on panel, 41 1/4 × 52 1/2″.
The University of Kansas Museum of Art, Lawrence. Elizabeth M. Watkins Fund

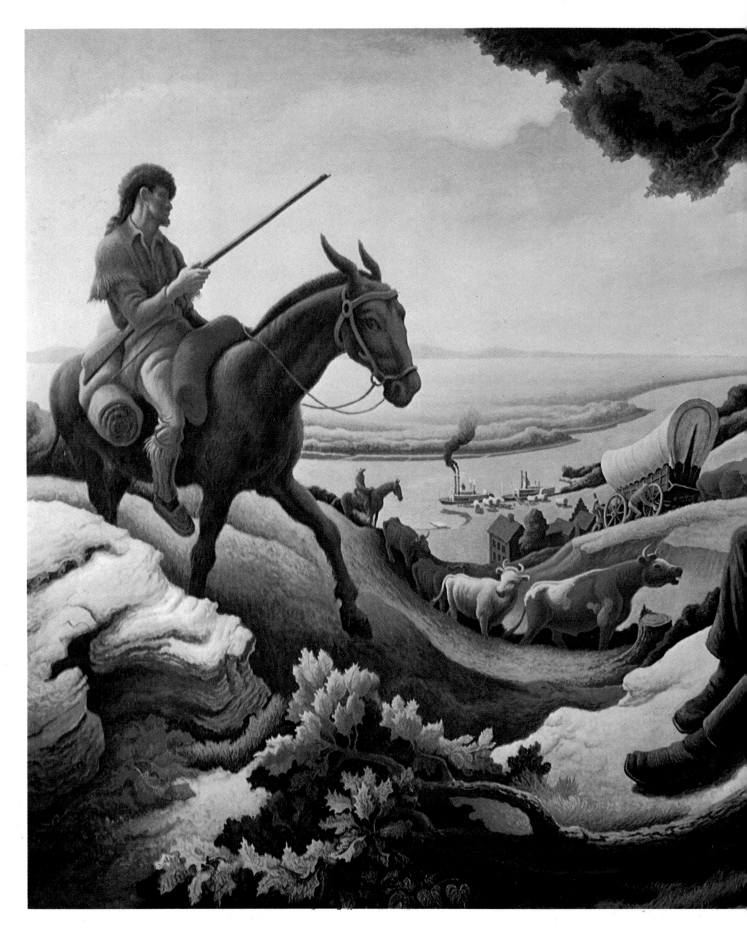

81. *Old Kansas City* (also known as *Trading at Westport Landing*). 1956. Egg tempera on canvas mounted on panel, 50 × 89″. The River Club, Kansas City

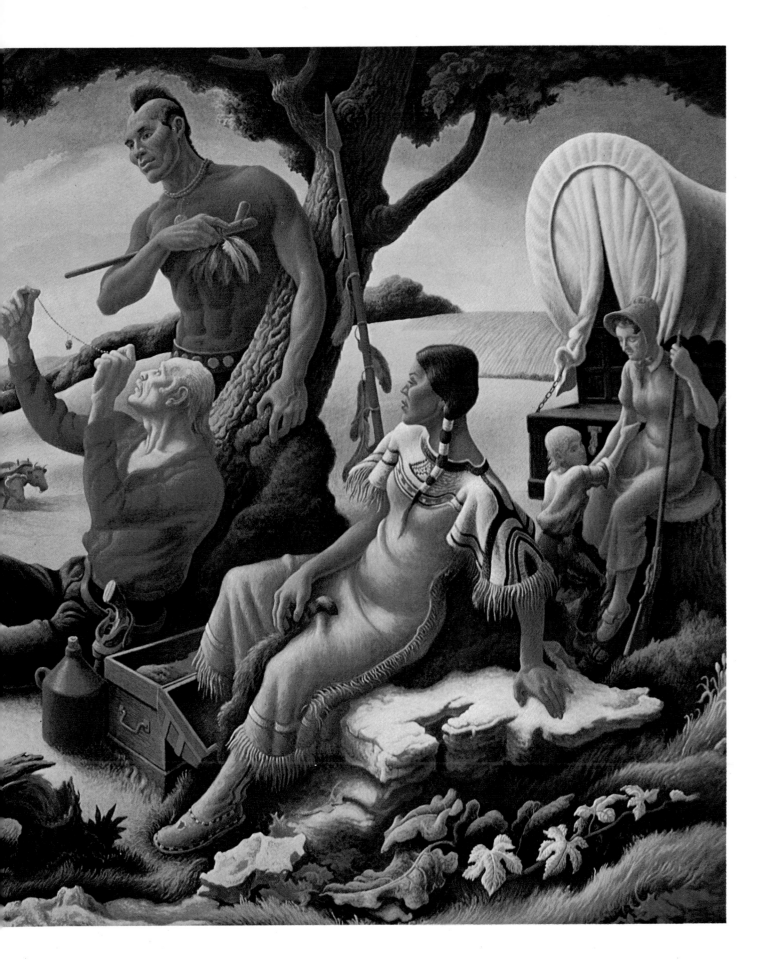

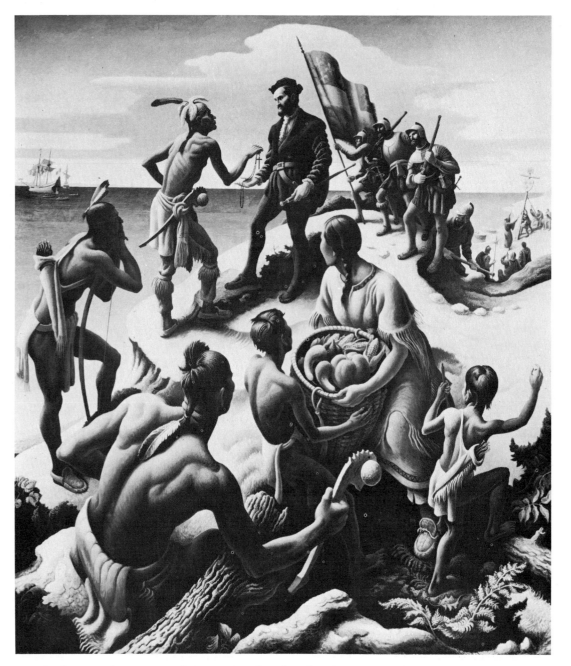

82. *Jacques Cartier Discovers the Indians.* 1956–57. Egg tempera on canvas mounted on panel, 90 × 78″. Power Authority of the State of New York, Massena

war had severely restricted priorities for the development of an American art, and Benton's ability to mix easily with people declined as he grew older. The American scene he had envisioned began to pass him by. For example, although he tried to paint scenes of World War II (not necessarily battle scenes), he found that this type of subject matter eluded him.

No doubt for Army and Navy professional men of my age [fifty-three in 1942], the technical aspects of the business were absorbing, but these meant nothing to me. I had to find my interest in life, not as it was instrumentally planned or directed from above, not as strategy or tactic, but as it was actually lived. When I began to discover I could not really participate in the youthful, and most essential and also pictorially significant part of this life, I began losing interest in it.

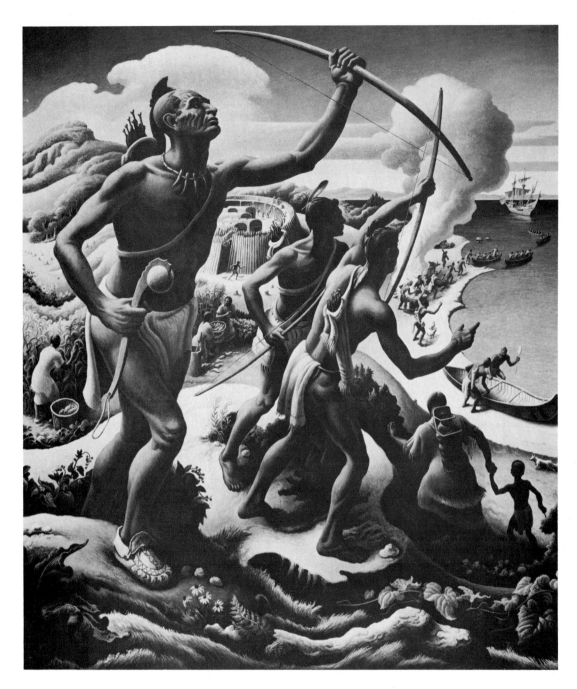

83. *The Seneca Discover the French.* 1956–57. Egg tempera on canvas mounted on panel, 90 × 78″. Power Authority of the State of New York, Massena

Finding it difficult to locate himself in the American reality of the 1940s, he could project neither a meaningful space parallel to that reality nor one consistent from painting to painting. America had changed, and so his image of it faltered.

America's image of Benton also changed. By the end of the war, he had been relegated by the art establishment to the history of American art. In one of the most abrupt turnabouts of public and critical taste, interest in realistic images was replaced by a delight in abstract art. Benton was not "kicked upstairs" to become an elder statesman; he was used, instead, as a symbol of the provincialism and jingoism for which a later generation condemned the art of the 1930s.

In part, Jackson Pollock's famous statement, "My work with Benton was important as something against which to react very strongly, later on. . . ," helped to set the

119

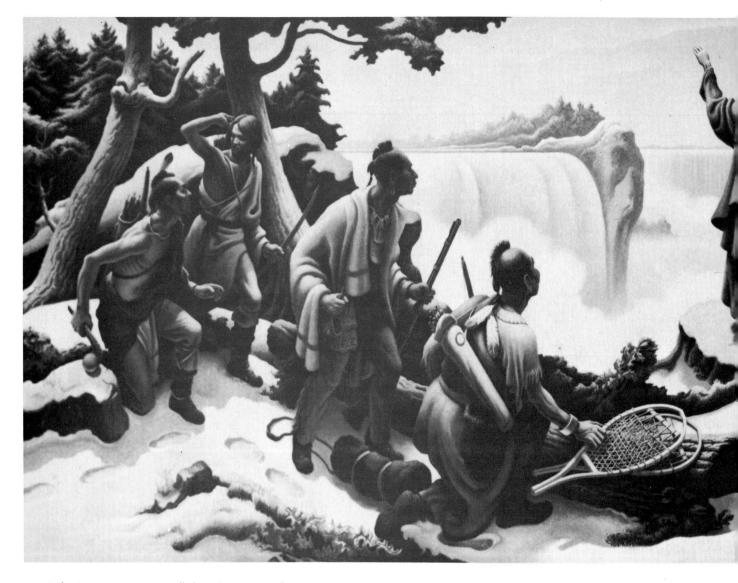

84. *Father Hennepin at Niagara Falls (1678)*. 1959–61. Oil on canvas, 7 × 20′. Power Authority of the State of New York, Niagara

tone. Important artists did not develop from Benton's example; they reacted against it, or simply ignored it.

The personal relationship between Benton and Pollock always remained cordial, evidently. The younger artist had studied with Benton at the Art Students League from 1930 to 1933, had remained a close friend of the family for about ten years, and virtually until his death, in 1956, maintained contact with Benton. On Pollock's principal contributions to the redirection of American art, Benton has rightfully denied any influence. Although both emphasized linear rhythms, Benton's were usually molded within circumscribed patterns, whereas Pollock's tended to thrust outward, or at least to suggest continuities of emphasis across a picture's surface.

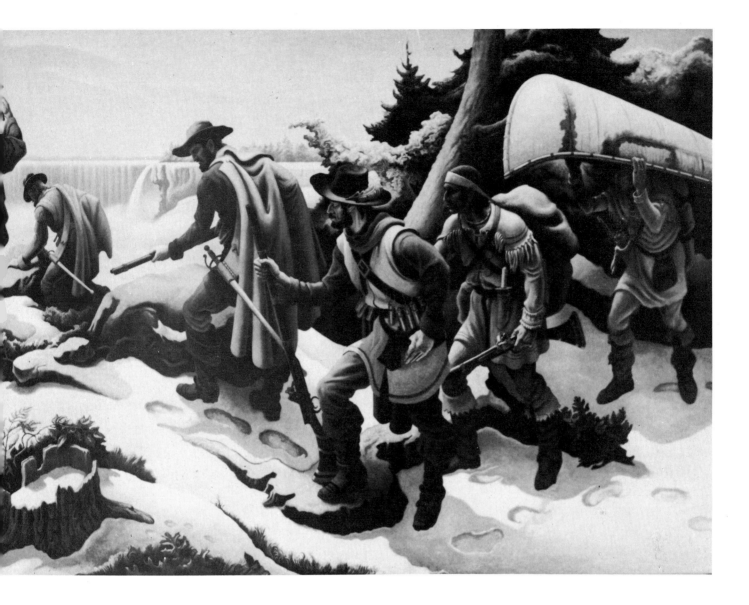

Although pleased by Pollock's success, Benton was not optimistic about its implications, finding in his work a further dehumanization of art in favor of sheer manipulation of pattern and color. Committed to cultural localism and environmental references, he questioned the willingness of so many artists from other countries to imitate Pollock, thus forcing a conformity on contemporary art while denying their own unique experiences. Finally, Benton felt, and still feels, that restlessness in the art world of today, where movement succeeds movement in such rapid succession, is attributable to the contemporary artist's dependence, for the renewal of his art, on personal impulses or the lessons of preceding styles, rather than on direct observations and encounters—that, in a word, art is renewed from life, not from art.

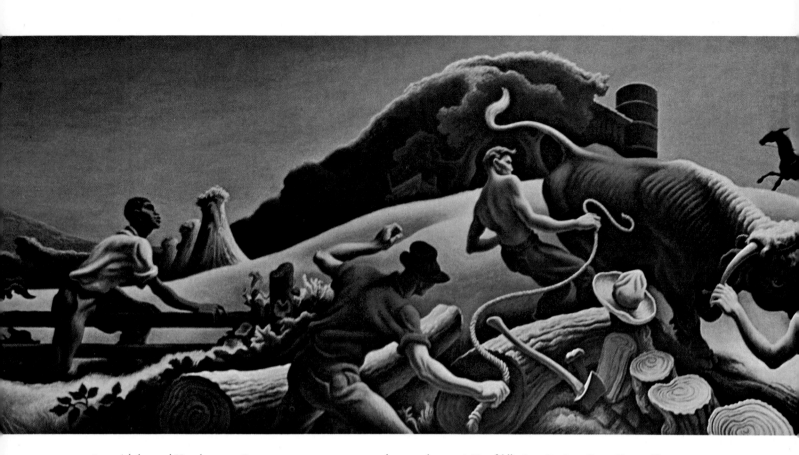

85. *Achelous and Hercules.* 1947. Egg tempera on canvas mounted on panel, 7 × 24′. Harzfeld's, Inc., Petticoat Lane, Kansas City

Benton rarely departed from this precept after World War II, and then chiefly in the five sets of murals he subsequently painted. He domesticated the Achelous and Hercules legend in his panel for Harzfeld's, a department store in Kansas City. (As in *Susannah and the Elders* and *Persephone,* he suggested American versions of archetypal themes, thus linking American experiences to those of other peoples.) In the other murals (for Lincoln University, Jefferson City, 1953–54; the Kansas City River Club, 1955–56; the Harry S. Truman Library, 1959–62; and the Power Authority of the State of New York at Massena, 1956–57, and at Niagara Falls, 1959–61), he explored American historical themes.

If American experiences can be interpreted through ancient legends, then the story of Achelous and Hercules is appropriate for the settlement of the Middle West (plate 85). The river god Achelous fought Hercules for the hand of Dejanira. Finding himself no match for Hercules's power, Achelous transformed himself successively into a serpent and a bull, but in the end was defeated. In the final struggle Hercules tore a horn from Achelous's head, and this became the cornucopia, or horn of plenty. As an allegory of the Middle West this hero tale may be explained as follows: Achelous was a river that overflowed its banks in the rainy season. It was thought of as a snake because of its

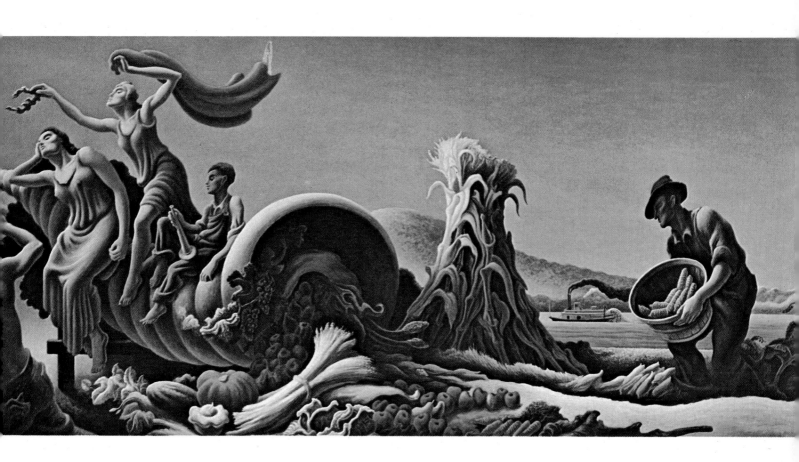

winding and a bull because of its force. In vanquishing the river god, and tearing off a horn, Hercules had halted the floods (by embankments and canals). The lands, now reclaimed and fertile, were symbolized by the horn of plenty. Under this guise Benton referred to the Mississippi and Missouri rivers, the floods and their control, the richness of the land, the cattle industry, and the strength of the settlers.

When he painted *Old Kansas City* (also known as *Trading at Westport Landing*) for the River Club nine years later, he used imagery more evocative of the American past (plate 81). In fact the mural was somewhat reminiscent of his *American Historical Epic* panels of the 1920s, because in it he brought together a number of episodes and telescoped a broad chronological sequence into a single composition. As in the earlier works, the actions stressed are those of anonymous persons rather than honored individuals. Developments on the land, rather than remembered events, still formed Benton's subject matter. The figures of a scout and an Indian trading with a pioneer frame a vista that includes a cattle drive, early buildings, and steamboat traffic on the river. The panel would have been a model of its kind had it been painted years earlier for one of the federal art programs.

Comparison with *The Ballad of the Jealous Lover of Lone Green Valley* reveals stylistic

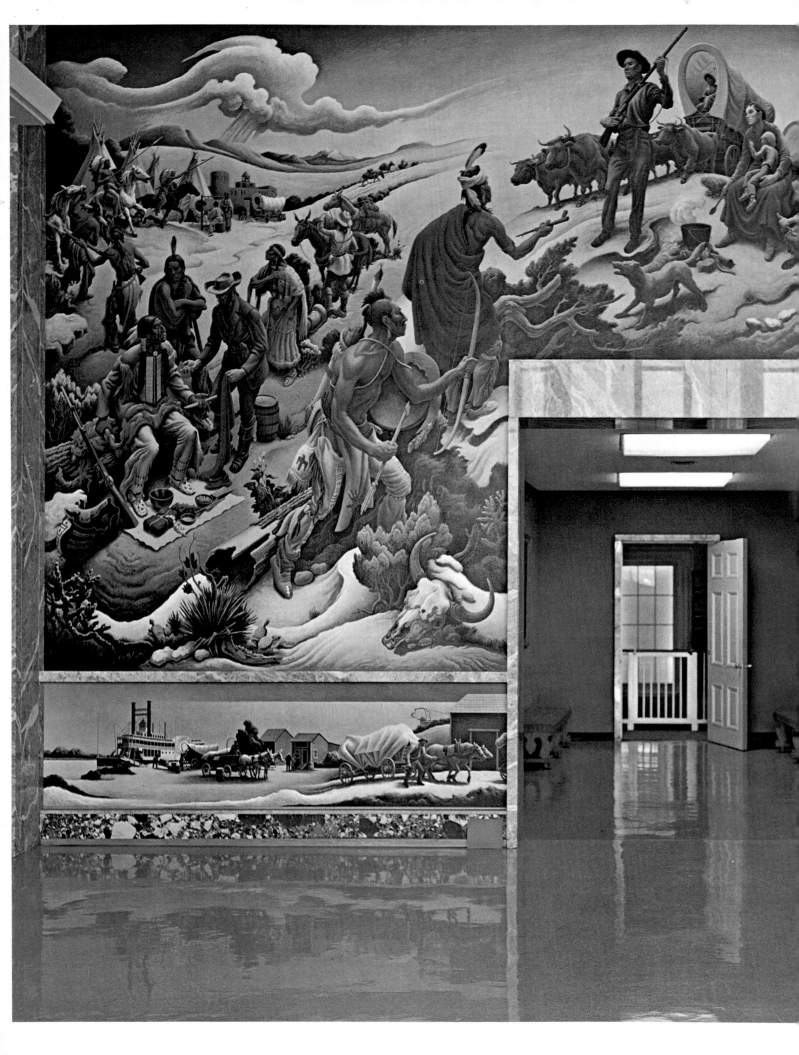

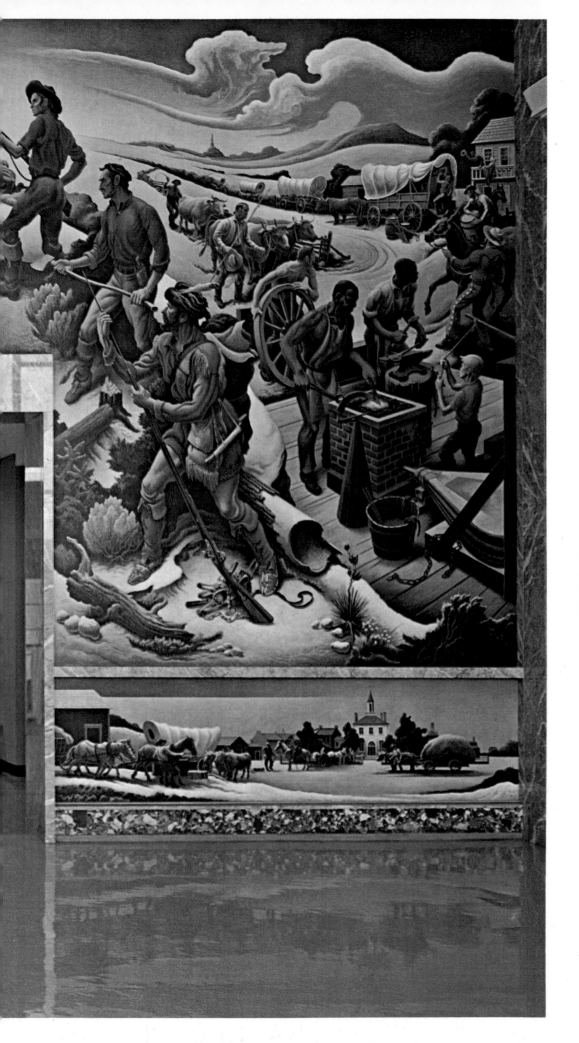

86. *Independence and the Opening
of the West.* 1959–62. Acrylic polymer
on linen mounted on panel, 19 × 32′.
Museum of the Harry S.
Truman Library, Independence, Missouri

features that Benton had added and dropped over the years (plate 80). Most striking is the greater breadth and depth of vision he achieved by eliminating obtrusive flattened patterns. But even though the space seems more realistic in the later panel, the physiognomic characteristics of the subjects appear less true to life than in the earlier work. In *The Jealous Lover* portrayals of typical Appalachian inhabitants may be recognized, whereas the Middle Westerners, although accurately costumed, seem prettified and idealized, as if individual models had been made to look more elegant than ordinary persons of the region.

External factors, again, probably played a part in this inconsistency. First, the Kansas City panel is a historical presentation, and Benton, without the steadying view of observed reality before him, invented an extraordinarily handsome group of people to populate his painting. A second important factor was Benton's advancing age, which inhibited easy contact with people to an even greater degree than during World War II.

Even if he had sought such contacts, they became increasingly difficult because of the country's growing urbanization and, paradoxical as it may initially seem, the excellent road-building program of the postwar years. In the 1920s and 1930s, as Benton has recorded, a random drive on backwoods dirt roads might lead to conversations in bars and small hotels as well as to dinners in private homes. The opportunity to view the life of a region opened up naturally. By the 1950s, and certainly in the 1960s, Benton could no longer insinuate himself easily into conversations; people had become leery of strangers, and the old roads had, as often as not, been paved, or even turned into four-lane highways. As a result, his ability to feel his way into both the contemporary situation and the past history of an area, as well as to record the typical appearance of a region's inhabitants, simply evaporated.

What he sacrificed in contemporary accuracy, he made up in historical verity. In his later murals, no longer concerned with seeking a space parallel to American reality, nor even with recording present events as molded by the past, he became more the historian.

For the installation of the Power Authority of the State of New York in Massena, Benton painted the sixteenth-century French explorer Jacques Cartier discovering the Indians and, in turn, being discovered by them (plates 82, 83). The artist's researches prompted him to travel in French Canada, to read the *Relation,* Cartier's own account of his adventures, and to study authentic costumes, ships, and artifacts of the period. He even managed to find models among the Seneca Indians now settled in Oklahoma, the tribe that Cartier initially met in the East.

The same Indian tribe had, a century after encountering Cartier, moved to western New York, and their descendants were still available to pose for the panel Benton painted

Missouri 1821·1971 **United States 8c**
THOMAS HART BENTON

87. "Missouri 1821–1971" Commemorative Stamp, showing portion of *Independence and the Opening of the West,* issued by the United States Post Office Department in 1971

for the Power Authority's Niagara Falls plant (plate 84). His concern for accuracy prompted him to search out Pawnee and Cheyenne Indians as subjects for the mural in the Harry S. Truman Library and to journey across Oklahoma, Colorado, and Nebraska to record topographical features accurately (plate 86).

The general theme of the mural in the Truman Library is the role of Independence, Missouri, in the opening of the West. Situated near rivers and overland trails, it was an important staging area for cross-country trips. The community appears at the right side of the mural. Here outfitters are at work readying a wagon train to depart for the Oregon Trail. In the distance Chimney Rock, in western Nebraska, can be seen. Leading up the hill in the center, toward a settler and his family, are a French explorer, a mountain man, and a hunter. The settler, standing at the apex of the hill, symbolizes the fulfillment of America's continental destiny. On the left he faces an Indian offering a peace pipe and another with bow and arrow. On the far left traders are dealing with a group of Cheyenne, and in the distance appear the Rocky Mountains of southern Colorado and the Santa Fe trail.

As in earlier murals, Benton avoided recounting specific events, instead allowing the drama to emerge in the blunt confrontation of Indian and white man. However, the outcome is never in doubt, because the major trails of emigration are depicted.

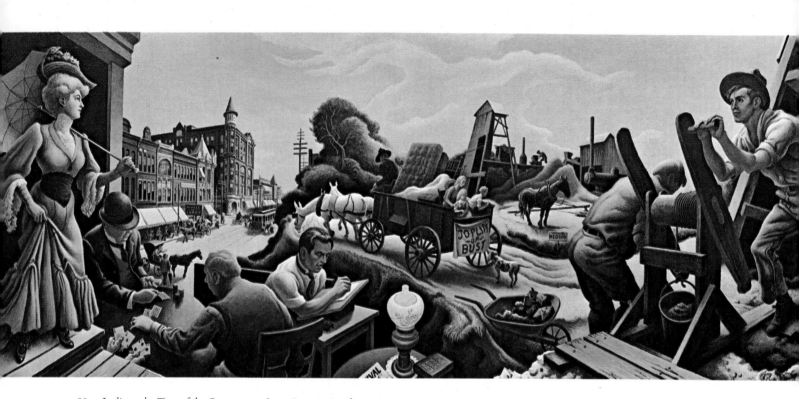

88. *Joplin at the Turn of the Century, 1896–1906.* 1972. Acrylic on canvas mounted on panel, 5 1/2 × 14′.
© 1972 Joplin Council for Arts, Municipal Building, Joplin

There is a message in the Truman Library panels, and happily it was Benton, of all American artists, who was given the opportunity to convey it. In the 1920s and 1930s the American past, and its relation to the American present, was a viable subject of concern. People, whether they praised or condemned earlier eras, were searching out those elements of continuity that linked periods together. After World War II the American past lost importance as a conscious influence on or modifier of current thought and behavior. Those who, like Benton, were intimately involved with the past became, in effect, antiquarians and historians.

Benton's murals since World War II emphasize the point. In the treatment of subject matter a clear separation of time between early and modern days is made apparent. There are no longer continuities, and the past is now irrecoverable. What might have been a condensed version of the Indiana murals became, at Independence, a hymn to the past, to an epoch distinct from our own. In the forty-year period between 1921, when the *American Historical Epic* was under way, and 1962, when the Truman Library murals were completed, Benton had sympathetically recorded in mural form the rise and fall of interest in a living American past. That interest is still apparent in his 1972 mural effort, *Joplin at the Turn of the Century,* created for the Municipal Building of Joplin, Missouri (plates 88, 89).

In his easel paintings completed since the war, Benton explored older themes and

89. Model for *Joplin at the Turn of the Century, 1896–1906.* 1971. Plasteline and wax, 12 × 27″. Collection the artist, on permanent loan to the Municipal Building, Joplin

styles, but even the casual observer will notice changes. The energies that he formerly channeled into defining an American style and spirit were directed toward a profound appreciation of his subject matter. Some of his best portraits were painted in these later years. Always a sensitive delineator of his family, he created one of his finest likenesses in the study of his daughter, Jessie (plate 90).

In many ways, though, his more remarkable achievements are the landscapes of this period. In these, it would appear that Benton's overwhelming love for America found its true outlet—in the streams, hills, and mountains of the country, populated by people unsuspectingly living out their time, quietly enjoying themselves, living easily on the land, celebrating nothing more than their existence. Perhaps cumulatively these works glorify "America the Beautiful," a dream America where every prospect pleases. Individually they describe, sometimes with great succulence, a particular segment of that landscape.

Benton traveled through the West in the 1950s and again in the 1960s. He interpreted the great mountain ranges at times as formidable presences, at times as great rococo spectacles, as if he could caress each peak and ridge, or, for a moment, hold a mountain in his hand (plate 91). Although these works were painted in his studio, his ability to recapture the clear quality of Western light was remarkable. Combined with his penchant for employing broad contours, as in *Lewis and Clark at Eagle Creek,* this facility

129

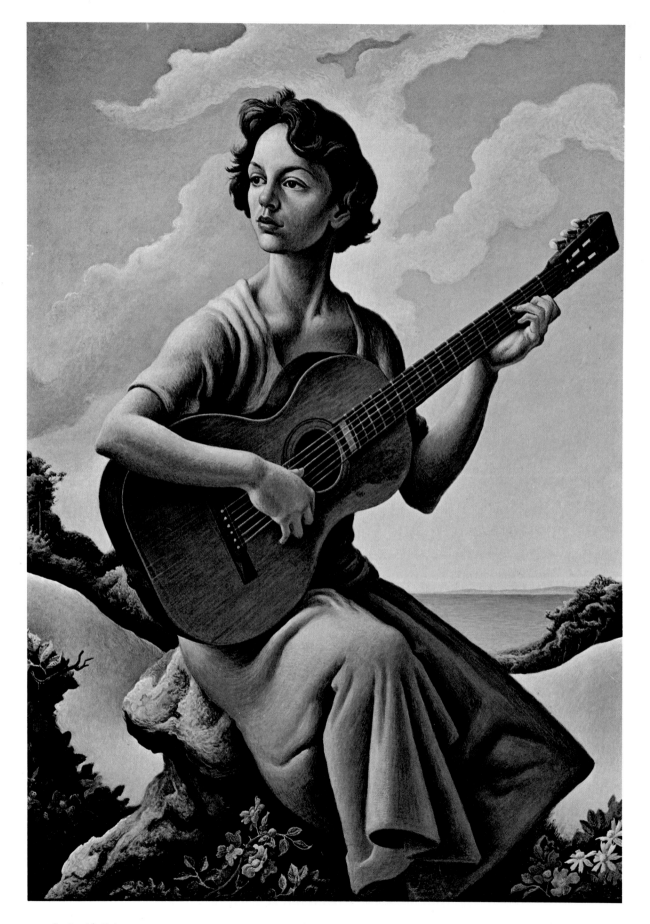

90. *Jessie with Guitar*. 1957. Egg tempera on canvas mounted on panel, 42 1/2 × 30 1/2″. Collection Jessie Benton

enabled him to approximate closely both the poster-bright colors of these upland areas and the sensuous curves of the terrain (plate 92).

In the scenes painted from landscapes closer to Benton's home the effect is more intimate. The sky appears to be closer, the horizon is nearer at hand, and the vegetation grows more lushly (plate 93). The streams, gullies, and soft hills of the Middle West—the vacation lands of the artist's mature years—become idyllic haunts of weekend fishermen and Sunday boatmen. The tumult of spirit in earlier paintings has given way to the continuous, easy pulsation of curving water banks, clumps of trees, and those familiar Middle Western clouds. The richness is sometimes overwhelming as one senses that Benton is reaching out to encompass all that he sees in a scene. It is as if he were making love to the trees, bushes, grasses, sandy spots, rocks, and pebbles. Other American artists have celebrated the American landscape, but few with such joy and innocence. Benton painted these works, one imagines, to please himself, and, even if they are stylistically related to earlier paintings, their mood is entirely personal.

Yet they are personal in a way easily accessible to anybody. Their meanings are still American. Up to the day of his death Benton remained a painter of the American scene. He died on January 19, 1975, having just added the last touches to a work commemorating what is perhaps the most American of musical styles—country music. The commission (from the Country Music Foundation of Nashville, Tennessee) delighted Benton, himself a virtuoso harmonica player. As was his habit, he researched the subject thoroughly, making copies of old instruments and even visiting the Ozark region, a few weeks before his death, to obtain accurate portraits of local musicians. Like his other murals, *The Sources of Country Music* blends biographical and historical content with pure artistic invention, combines realistic elements with mythic ones, and is larger than life.

"Larger than life" best summarizes Benton's feeling for the United States. Reading his paintings, we see typical activities given compelling importance and landscapes that are extravagantly dynamized or, in his later pictures, almost too lush. His subject, ultimately, was a nation filled with restless people, surging industrial forces, and evocative landscapes. At every level of meaning, his image of America was that of a vital, barely controllable power. Even in the late vacation scenes, the undulating contours of the terrain scarcely contain the generative forces pulsating within; he tried to express not merely his joy in experiencing the pleasures of a specific locality, but his love for the entire country.

Not surprisingly, Benton's method of applying paint corresponds to these feelings. The myriad short multicolored brushstrokes appear as constant explosive gestures, a drumfire of small but continuous staccato bursts energizing each form. It is as if Benton were triggering each explosion, as if he were trying to touch the pulsebeat of the country.

Benton's commitment to the United States was not one of blind devotion, however.

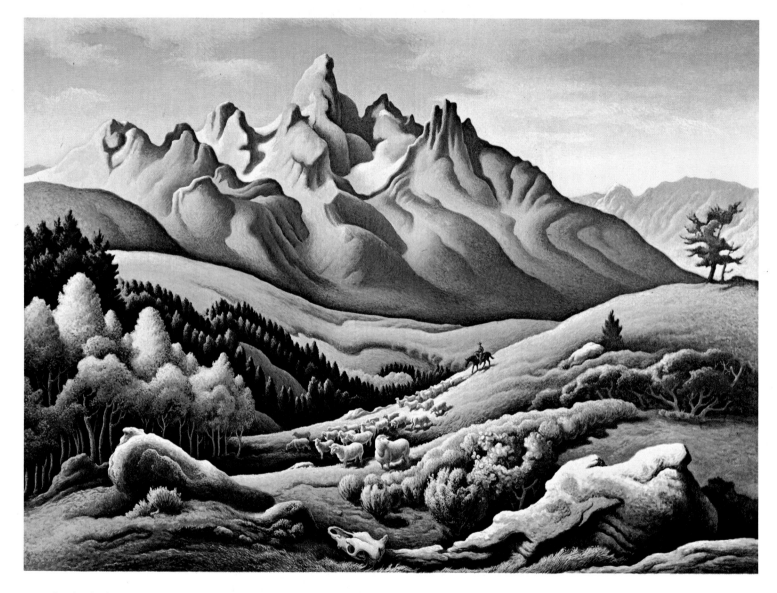

91. *The Sheepherder.* 1955–60. Oil on canvas, 48 × 66″. Collection Mr. and Mrs. Fred McCraw, Prairie Village, Kansas

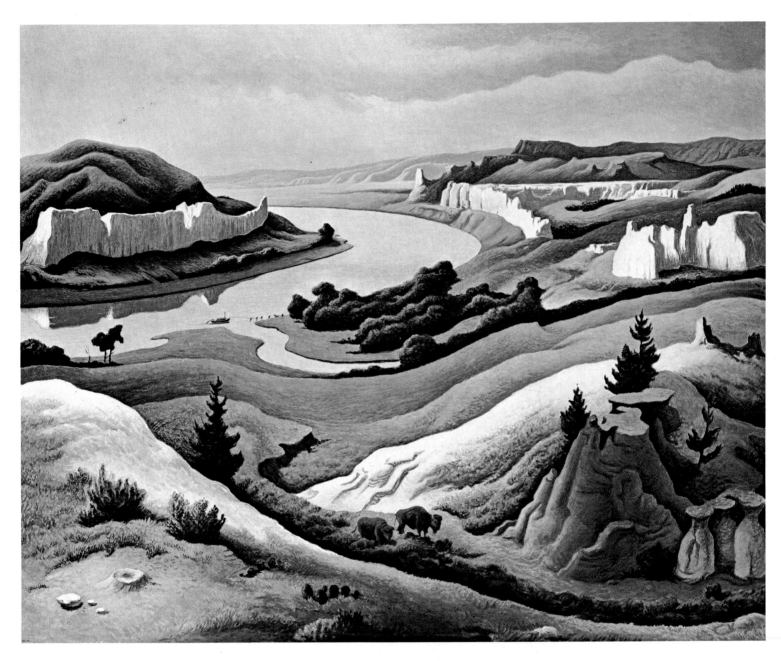

92. *Lewis and Clark at Eagle Creek.* 1965. Polymer tempera on canvas mounted on panel, 28 × 40″. Collection the artist

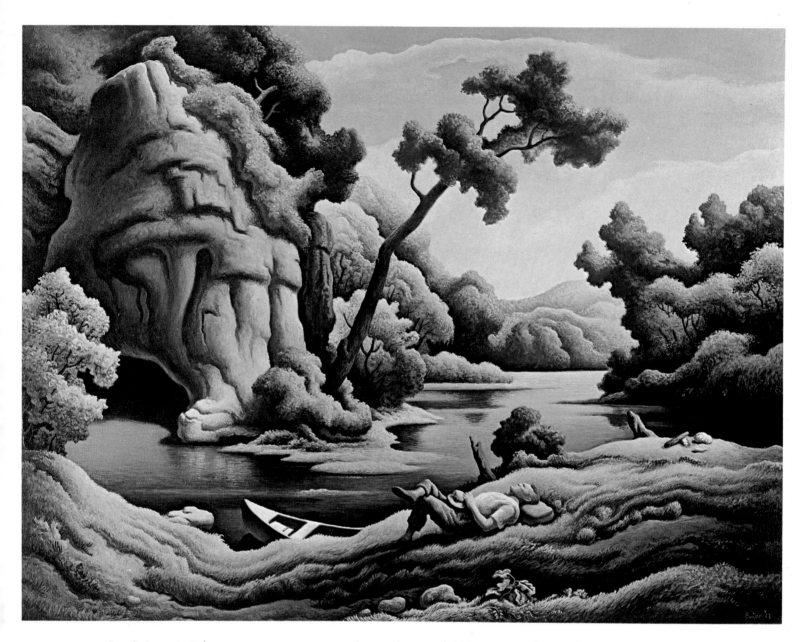

93. *Cave Spring*. 1963. Polymer tempera on canvas mounted on panel, 30 × 40". Field Enterprises Educational Corporation Collection. Courtesy *The World Book Encyclopedia*

He recognized its failures and its faults. Toward the end of his life, standing on the prairie and observing its beauty and strength, he was saddened to realize that the country was, as he said, "in deep trouble." At a time when people have grown cynical, when their experience no longer seems to coincide with the American mythos, when events do not mesh with the American dream, Benton reminds us of our hopes for this land. His art records our yearning for a still innocent America.

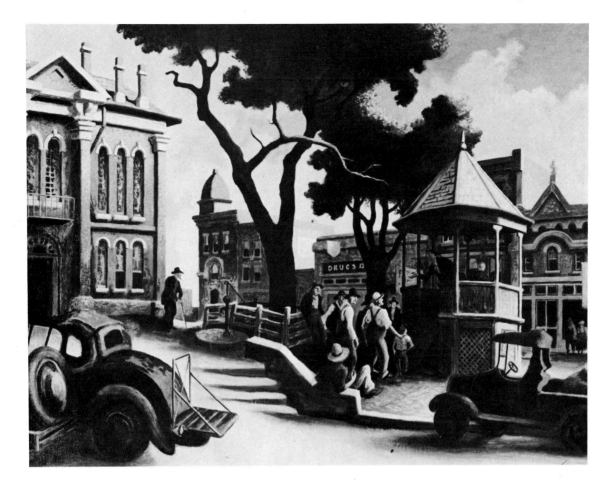

94. *Courthouse Oratory*. c. 1940–42. Oil on canvas, 28 × 36″. Collection Mrs. Marjorie L. Paxton, Shawnee Mission, Kansas

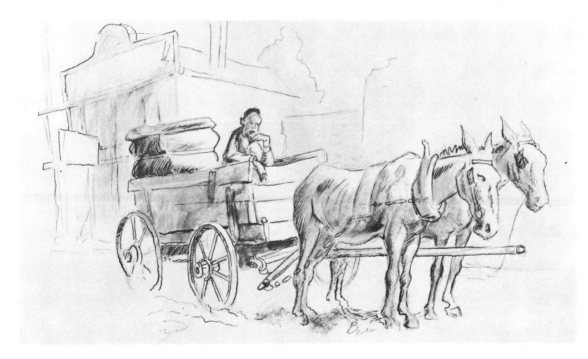

95. *Waiting*. 1940. Pencil, ink, and wash, 9 × 15 1/2″. Collection the artist

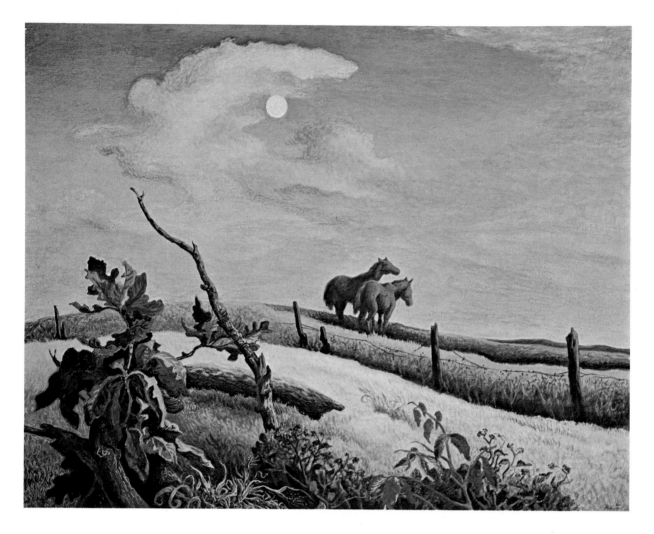

96. *Autumn.* 1940–41. Oil and tempera
on panel, 22 1/2 × 28 5/8".
Whitney Museum of American Art,
New York. Bequest of Loula D. Lasker

97. *Aaron.* 1941. Oil and tempera
on canvas, 30 1/4 × 24 1/4".
Pennsylvania Academy of the Fine Arts,
Philadelphia

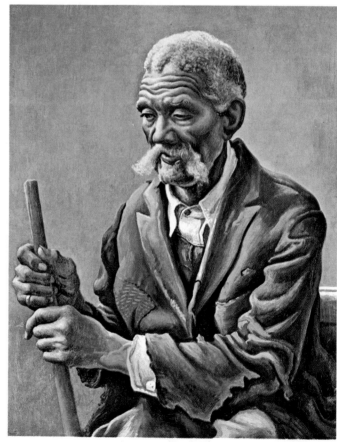

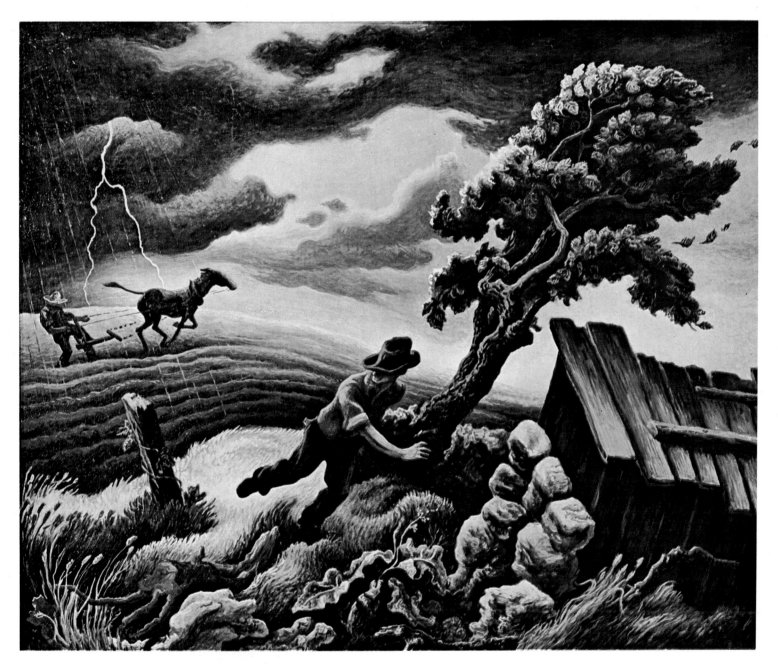

98. *The Hailstorm*. 1940. Tempera on panel, 33 × 40″. Joslyn Art Museum, Omaha, Nebraska. Gift of the James A. Douglas Memorial Foundation

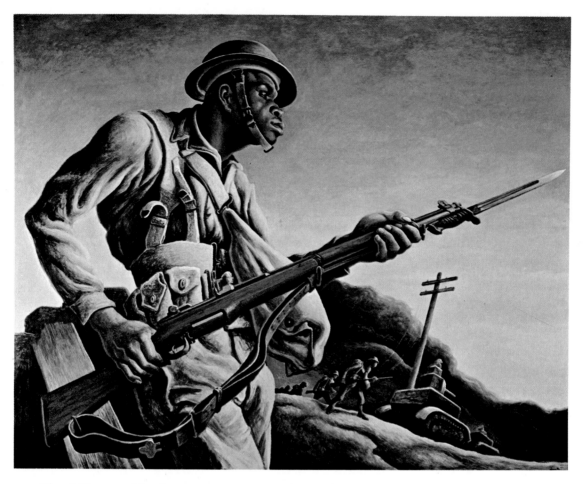

99. *Negro Soldier.* 1942. Oil and tempera on canvas mounted on panel, 48 × 60″.
The State Historical Society of Missouri, Columbia

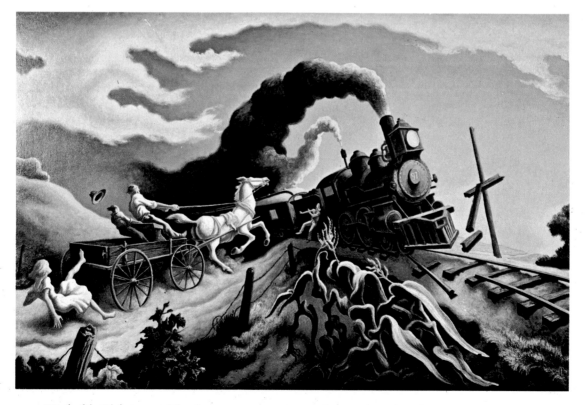

100. *Wreck of the Ole '97.* 1943. Oil and tempera on canvas mounted on panel, 29 1/4 × 46″.
Collection Marilyn Goodman, Great Neck, New York

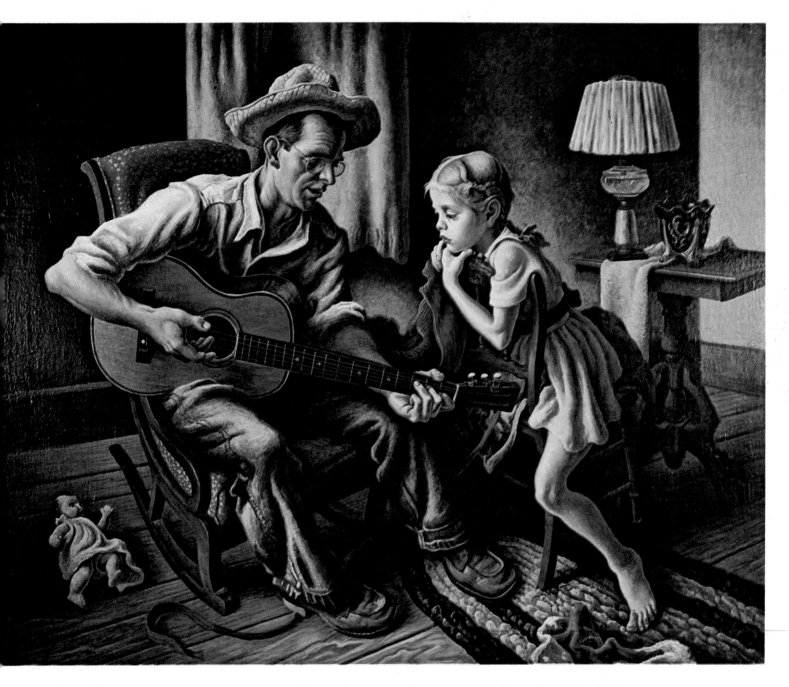

101. *The Music Lesson.* 1943. Egg tempera on canvas mounted on panel, 48 × 59″. Collection Mrs. Fred Chase Koch, Wichita, Kansas

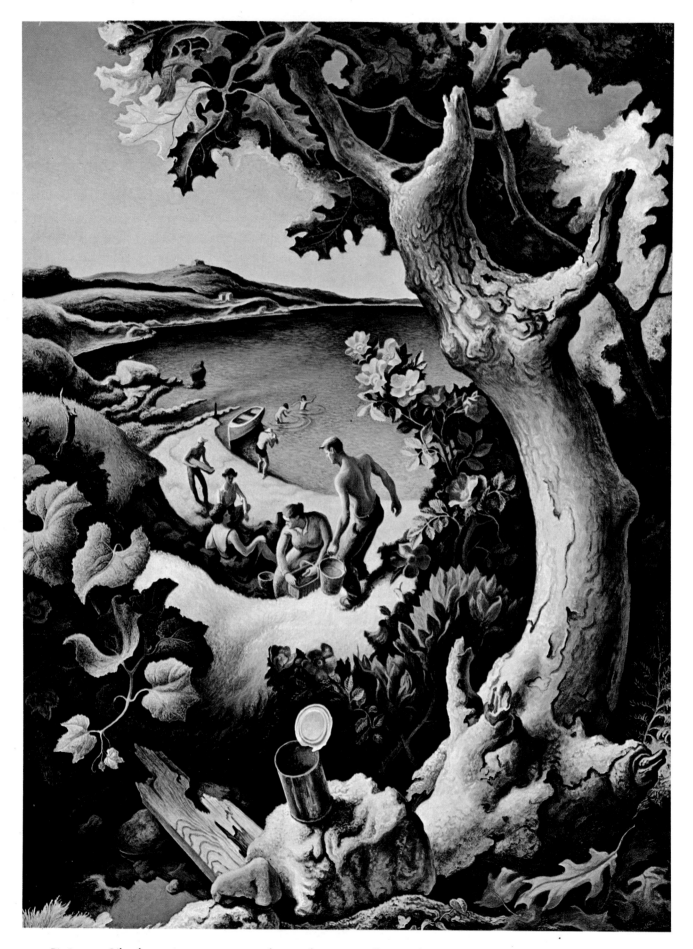

102. *Picnic*. 1943. Oil and tempera on canvas mounted on panel, 48 × 36″. Collection Thomas P. Benton

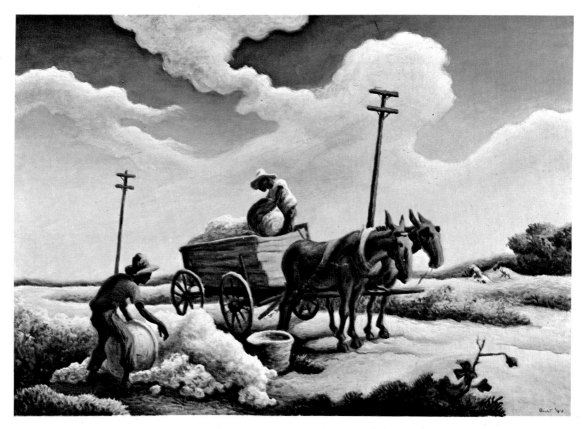

103. *Plantation Road.* 1944. Oil and tempera on canvas mounted on panel, 28 1/2 × 39 3/8″.
Museum of Art, Carnegie Institute, Pittsburgh

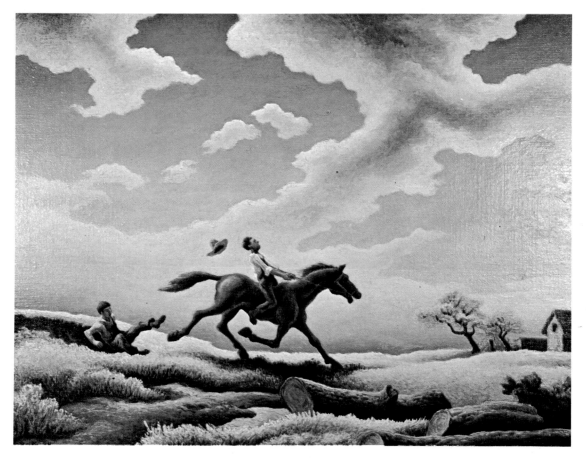

104. *Spring Tryout.* 1944. Oil and egg tempera on canvas mounted on panel, 30 × 40″.
Charles H. MacNider Museum, Mason City, Iowa

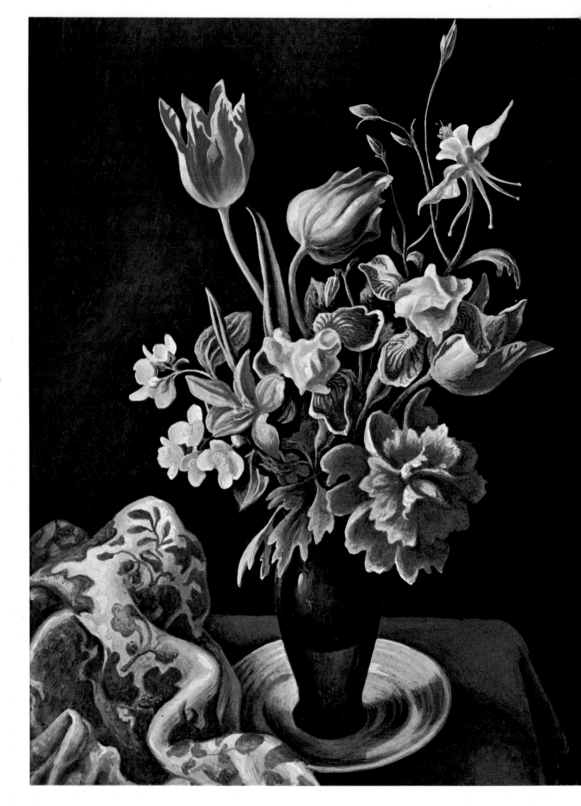

105. *Spring Still Life with Peony.*
c. 1943–46. Oil and tempera on canvas
mounted on panel, 26 × 19″.
Collection Rita Benton, Kansas City

106. *Silver Stump.* 1943. Oil and tempera on canvas mounted on panel, 34 × 22″. Collection Thomas P. Benton ▶

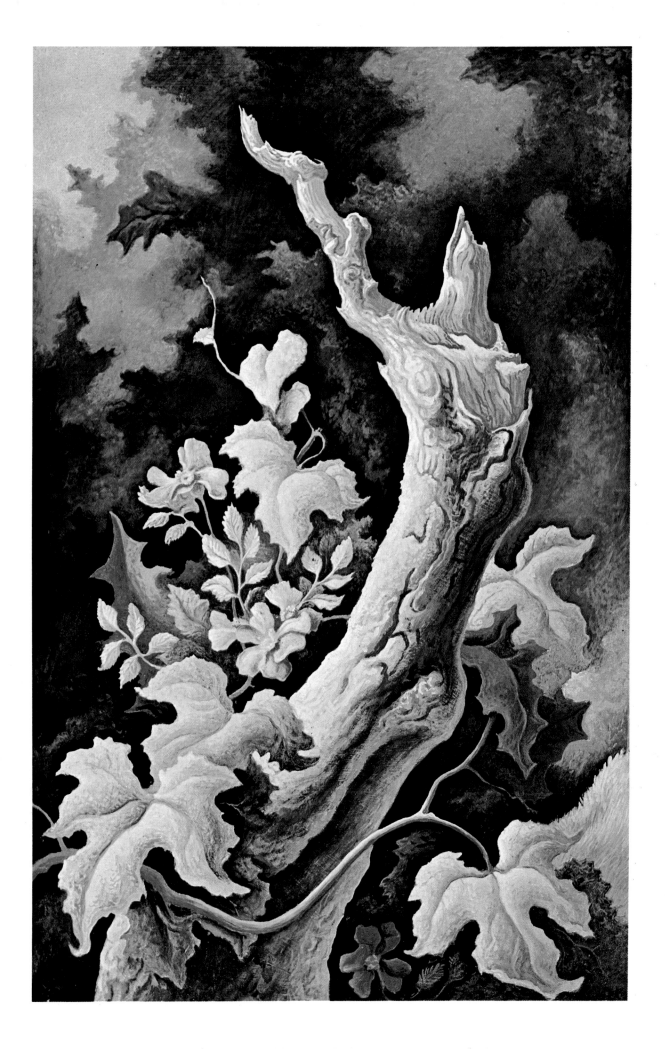

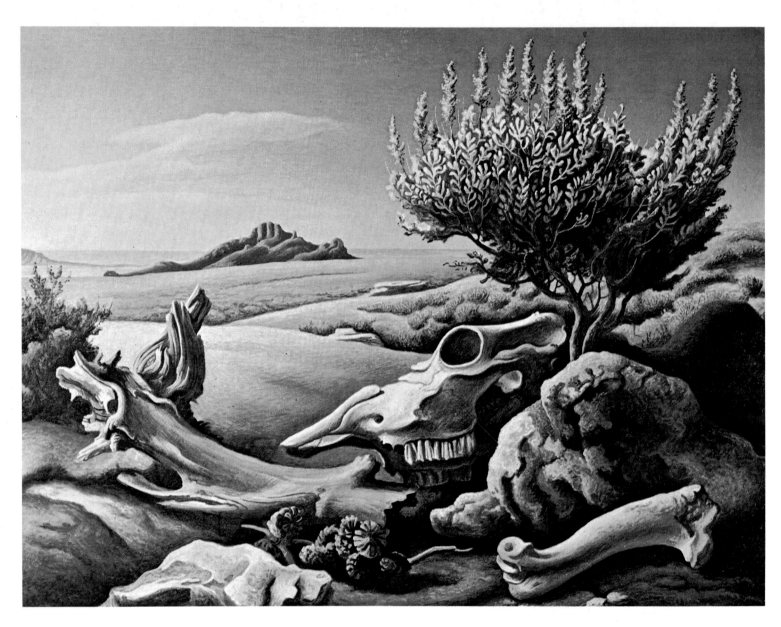

107. *Desert Still Life*. 1951. Oil and tempera on canvas mounted on panel, 27 × 35 1/4". Collection Rita Benton, Kansas City

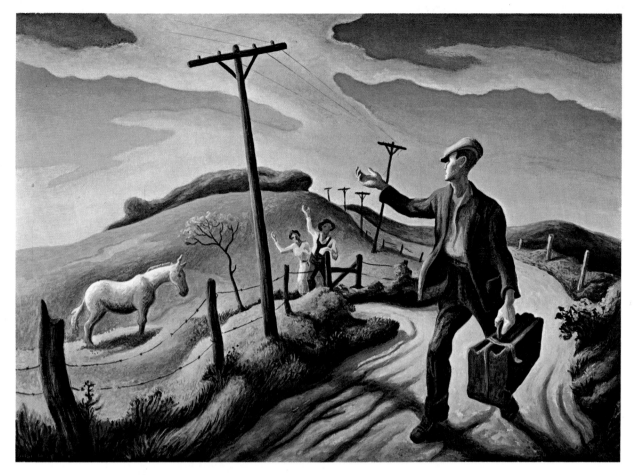

108. *The Boy.* 1950. Tempera on cloth mounted on panel, 20 1/2 × 29 1/4″.
Collection Mr. and Mrs. Jack Resnick, Palm Beach

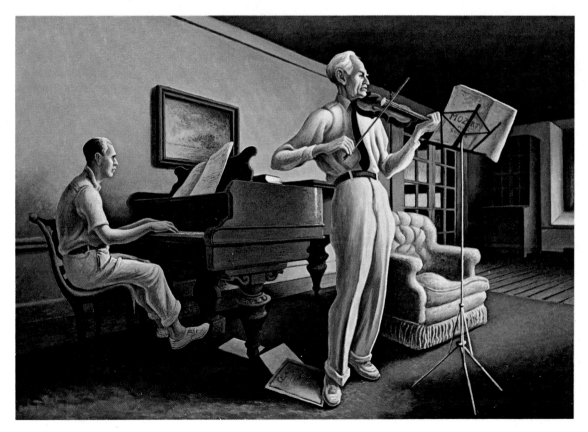

109. *Evening Concert.* c. 1948. Oil and tempera on canvas mounted on panel, 30 × 40″.
Collection Thomas P. Benton

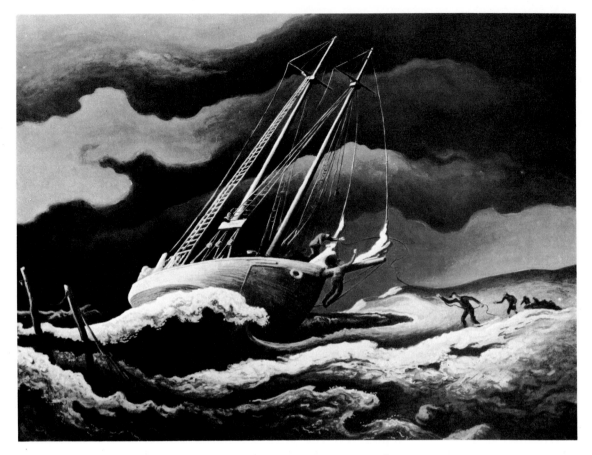

110. *After the Storm.* 1952. Oil on canvas mounted on panel, 22 × 30″. Private collection

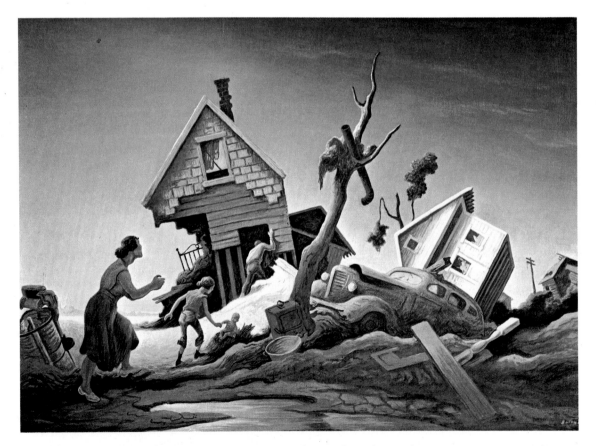

111. *Flood Disaster.* 1951. Oil and tempera on canvas mounted on panel, 25 1/2 × 36 1/2″.
Collection Mr. and Mrs. Louis Sosland, Shawnee Mission, Kansas

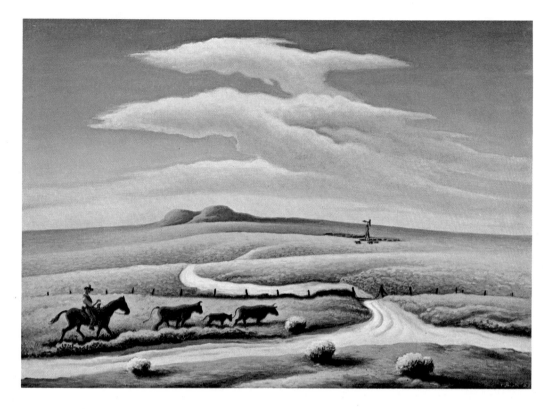

112. *High Plains.* 1953. Oil on canvas mounted on panel, 19 × 26 1/2″. Collection the artist

113. *Missouri Landscape.* 1956. Tempera on panel, 20 × 24″. Collection Mrs. Louis Piacenza, Jules Worthington, Caroline Gates

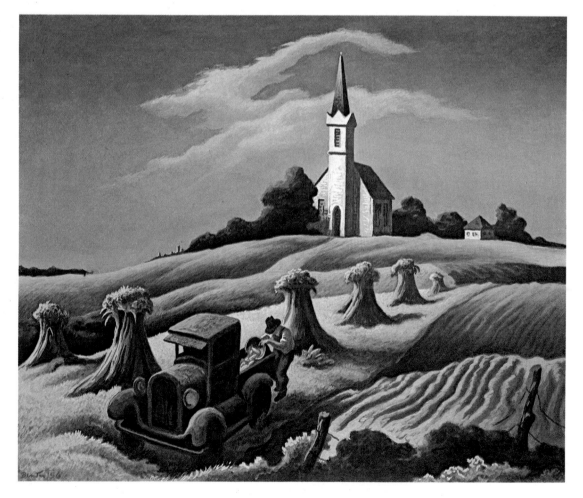

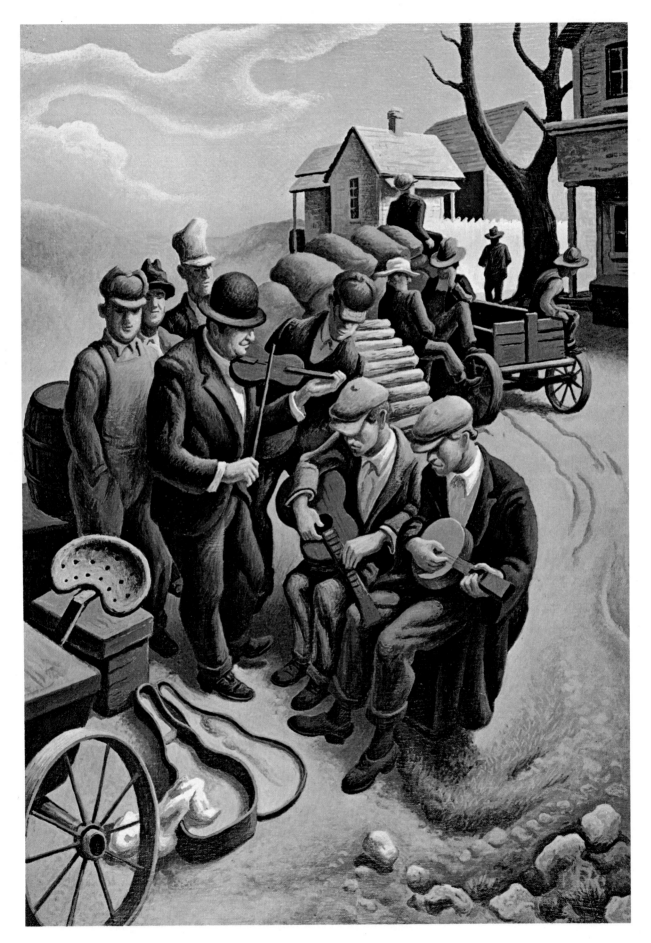

114. *Pop and the Boys*. 1963. Oil on canvas, 26 5/8 × 18 3/4″. Collection Dr. and Mrs. William Nuland, Scarsdale, New York

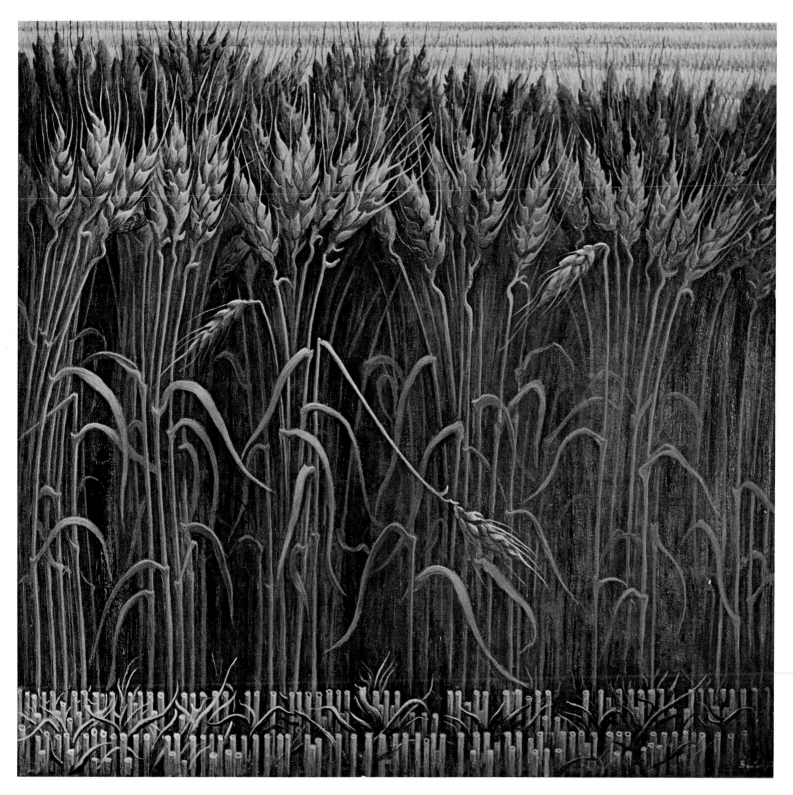

115. *Wheat.* 1967. Acrylic on panel, 19 1/4 × 18 1/4″. Collection Mr. and Mrs. R. H. McDonnell, Kansas City

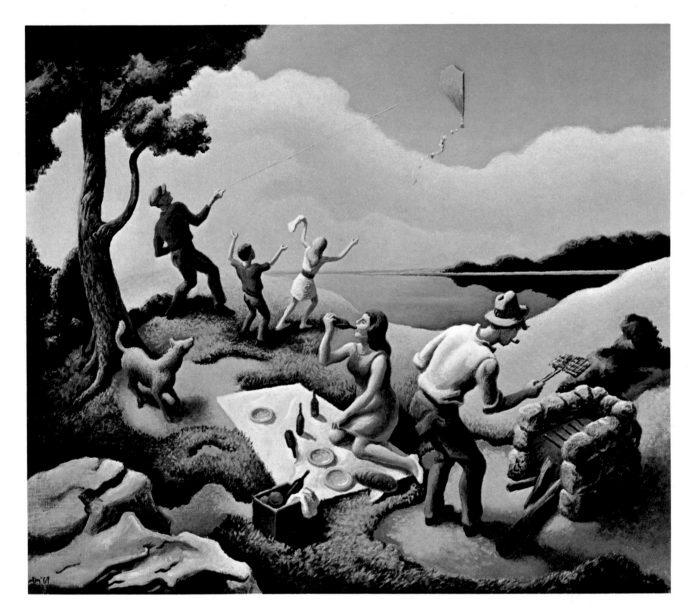

116. *Down by the Riverside*. 1969. Oil on canvas, 19 × 23″. Collection Mr. and Mrs. Erwin Katz, Leewood, Kansas

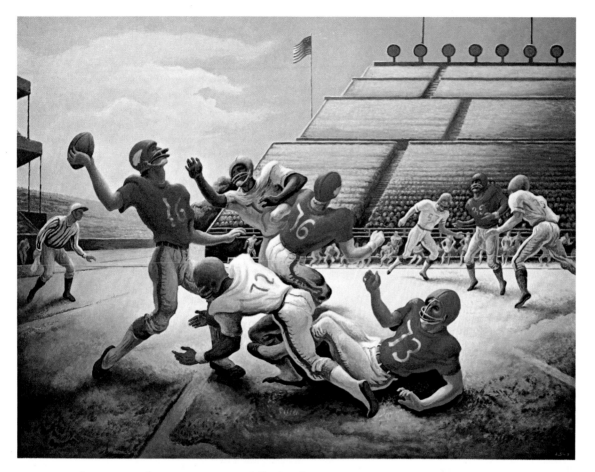

117. *Forward Pass.* 1971. Oil on canvas, 30 × 40″. Collection the artist

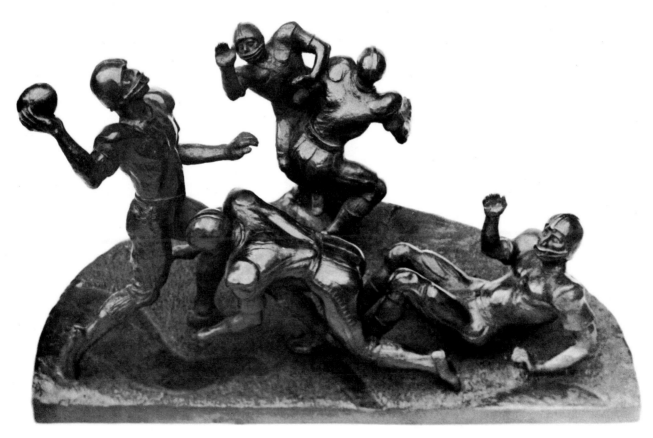

118. *Forward Pass.* 1970. Bronze, 15 × 25 × 12″. Collection the artist

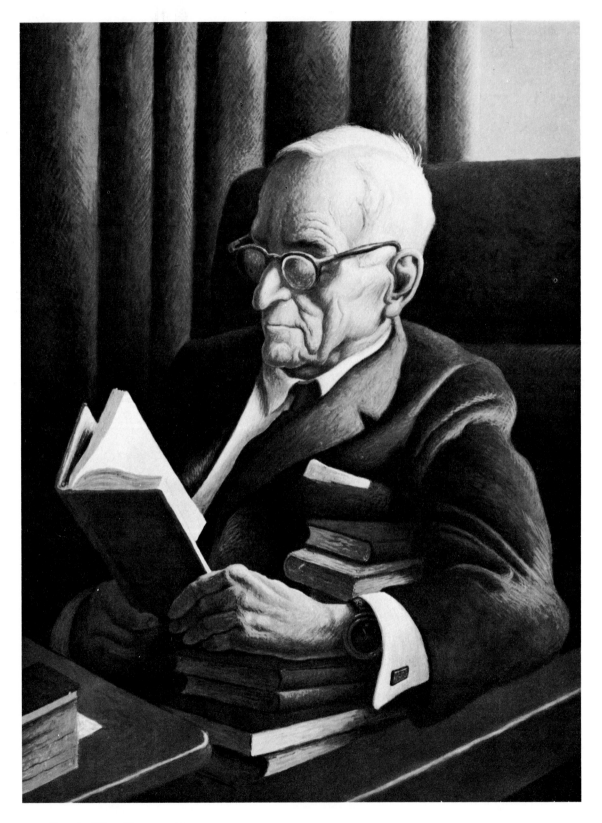

119. *Portrait of Harry Truman at 86.* 1970–71.
Egg tempera on canvas mounted on panel, 26 1/2 × 20″. Collection the artist

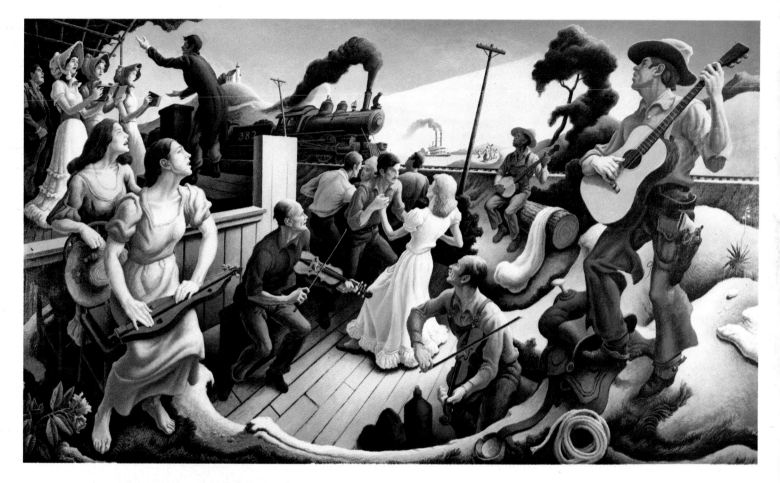

120. *The Sources of Country Music*. 1975. Acrylic on canvas, 6 × 10′. The Country Music Hall of Fame & Museum, Nashville.
© Copyright 1975, the Country Music Foundation, Inc. Commissioned by the Country Music Foundation of America under a grant from the
National Endowment for the Arts, this mural was given its last touches by the artist the day before he died.

BIOGRAPHICAL OUTLINE

1889 Born April 15 in Neosho, Missouri, son of Maecenas E. and Elizabeth Wise Benton, grandnephew and namesake of famous Missouri senator.

1896–1904 Studies art at the Corcoran Gallery of Art, Washington, D.C., during his father's four terms in the House of Representatives (1897–1905).

1906 Works in Joplin, Missouri, as cartoonist for the Joplin *American*.

1907–1908 Studies at the Art Institute of Chicago.

1908–1911 Lives in Paris, studying at the Académie Julian (autumn 1908 through spring 1909) and then daily at the Académie Collarossi. Experiments with Impressionist techniques under the guidance of John Thompson; forms close association with Stanton Macdonald-Wright. At the prompting of John Carlock, abandons formal classes in favor of study, on his own, of masterpieces in the Louvre. In these years, has contacts with Leo Stein, John Marin, Jacob Epstein, Jo Davidson, André Lhote, Diego Rivera, Morgan Russell, and others in the Montparnasse quarter of Paris.

1911–1912 Returns to Neosho, visits Kansas City (early in 1912), then moves to New York City (June).

1916 Participates in the Forum Exhibition of Modern American Painters at the Anderson Gallery (March); associated in this project with Alfred Stieglitz, Dr. John Weichsel, founder of the People's Art Guild, and most of the other New York painters who had been involved in the modernist movements in Paris.

1917 Exhibitions at Daniel Gallery and Chelsea Neighborhood Association gallery, New York.

1918–1919 Serves in U.S. Navy as architectural draftsman stationed at Norfolk Naval Base. Watercolors of naval activities exhibited at Daniel Gallery. Returns to New York.

1919 Starts practice of making clay and Plastilene models for his paintings, a procedure that becomes a permanent feature of his technique. Begins the *American Historical Epic*, a mural study of American history.

1920 Spends the summer at Martha's Vineyard on Cape Cod, hereafter his summer residence.

1922 Marries Rita Piacenza, a former student in his Chelsea Neighborhood Association art classes.

1923–1924 Finishes first chapter (five panels) of the mural *American Historical Epic* and exhibits them at the Architectural League, New York.

1924 Returns to Missouri briefly because of father's illness and death. Exhibition at Daniel Gallery, New York.

1925–1926 Completes second chapter (five panels)—the last to be completed—of the *American Historical Epic*.

1926 Obtains post at Art Students League, New York, teaching there until departure from New York (1935). Takes first of many trips through rural South and Middle West. Exhibition at Artists' Gallery, New York. Son Thomas P. Benton is born.

1927 Two exhibitions at The New Gallery, New York (February, November).

1929 Exhibition at Delphic Studios, New York.

1930 Completes set of eight murals, *America Today*, for the New School for Social Research, New York. Meets John Steuart Curry. Exhibition at Delphic Studios, New York.

1931 Exhibition at Art Students League, New York.

1932 Completes *The Arts of Life in America*, a series of five murals for the library of the Whitney Museum of American Art (now in the New Britain Museum of American Art). Exhibition at New School for Social Research, New York.

1933 Awarded gold medal for decorative painting of the Architectural League of New York. Completes series of twenty-two mural panels, *Social History of the State of Indiana*, for Indiana's pavilion in the Century of Progress International Exposition in Chicago (now in the auditorium and other buildings of Indiana University, Bloomington).

1934 Receives commission from the Section of Painting and Sculpture, U.S. Treasury Department, for a mural in the new Post Office in Washington, D.C., but drops project when Missouri legislature passes bill commissioning Benton mural for capitol in Jefferson City. Meets Grant Wood. Exhibitions at Ferargil Galleries, New York, and Dartmouth College, Hanover, New Hampshire.

1935 On basis of commission for murals in Missouri State Capitol in Jefferson City and invitation to direct painting and drawing classes at Kansas City Art Institute, moves permanently to Kansas City. Exhibition at Ferargil Galleries, New York.

1936 Completes murals for State Capitol in Jefferson City, Missouri

1937 *An Artist in America* is published. Exhibitions at Associated American Artists, New York, and Lakeside Press Galleries, Chicago.

1939 Daughter Jessie P. Benton is born. Exhibition at Nelson Gallery-Atkins Museum, Kansas City (shown also at Associated American Artists, New York).

1940 Exhibition at Dallas Museum of Fine Arts.

1941 Exhibition at Associated American Artists, New York. Records album of music for flute, harmonica, and voice with son, Thomas P., for Decca Records.

1942 *Aaron* wins Carol H. Beck Medal in the 138th annual exhibition at the Pennsylvania Academy of the Fine Arts, Philadelphia. Exhibition at Associated American Artists, New York.

1945 Named honorary member of Argentina's Academia Nacional de Bellas Artes. *Music Lesson* selected as most popular exhibit in Carnegie Institute's annual showing of painting in the U.S.

1946–1947 Executes mural panel *Achelous and Hercules* for Harzfeld's, a women's clothing store in Kansas City. Exhibition at Associated American Artists, Chicago.

1948 Begins to make paintings of the Far West. Receives honorary degree of Doctor of Arts from University of Missouri, Columbia.

1949 Named honorary member of L'Accademia Fiorentina delle Arti del Disegno in Florence and of the Accademia Senese degli Intronati in Siena.

1951 Exhibition at Joslyn Art Museum, Omaha, Nebraska.

1953–1954 Completes mural *Abraham Lincoln* for Lincoln University, Jefferson City.

1955–1956 Completes mural *Old Kansas City* for Kansas City River Club.

1956–1957 Completes two mural panels, *Jacques Cartier Discovers the Indians* and *The Seneca Discover the French*, for the Power Authority of the State of New York at Massena.

1957 Receives honorary degree of Doctor of Letters from Lincoln University, Jefferson City.

1958 Exhibition at University of Kansas, Lawrence.

1959–1961 Completes mural *Father Hennepin at Niagara Falls* for Power Authority of the State of New York at Niagara Falls.

1959–1962 Completes mural *Independence and the Opening of the West* for Harry S. Truman Library, Independence, Missouri.

1962 Elected to National Institute of Arts and Letters, New York. Homecoming Exhibition in Neosho, Missouri.

1965 Revisits Italy and studies techniques of sculpture in bronze. Resigns from National Institute of Arts and Letters.

1966 Reelected to National Institute of Arts and Letters. Exhibition at Illinois College, Jacksonville, Illinois.

1968 Retrospective exhibition at Graham Gallery, New York. Receives honorary degree of Doctor of Fine Arts from the New School for Social Research, New York.

1969 *An American in Art: A Professional and Technical Autobiography* is published. Retrospective exhibition of lithographs held at Association of American Artists, New York.

1970 Exhibition "Thomas Hart Benton: Pen and Ink Drawings and Washes" held at Graham Gallery, New York. Exhibition at Madison Art Center, Wisconsin.

1971 Exhibition at Ohio State Fair, Columbus. "Missouri 1821–1971" commemorative stamp, showing portion of *Independence and the Opening of the West*, issued by United States Post Office Department.

1972 Completes mural *Turn of the Century Joplin* for Municipal Building of Joplin, Missouri. Exhibition "Thomas Hart Benton: A Retrospective of His Early Years, 1907–1929" at Rutgers University Art Gallery, New Brunswick, New Jersey.

1973 First public showing (March 2) of "A Man and a River," a film chronicle of a canoe trip taken by the artist on the Buffalo River in northwest Arkansas. Formal unveiling of mural *Turn of the Century Joplin*, Municipal Building, Joplin, Missouri (March 24). Retrospective exhibition (1907–72) "Thomas Hart Benton: A Personal Commemorative", Spiva Art Center, Missouri Southern State College, Joplin (March 24–April 27).

1974 Awarded the Diamond Jubilee Gold Medal of the National Arts Club, New York, at a dinner held in his honor at the Club on May 21.

Exhibition "Thomas Hart Benton: An Artist's Selection, 1908–1974," at the Nelson Gallery–Atkins Museum, Kansas City.

1975 Completes mural *The Sources of Country Music* for the Country Music Foundation, Nashville, Tennessee. Dies on January 19 in Kansas City. His wife of fifty-three years, Rita Piacenza Benton, dies April 9.

121. The artist's studio, photographed the day after his death.
In the background is his last work, *The Origins of Country Music*

PHOTOGRAPHIC CREDITS

The author and publisher wish to thank the museums and private collectors for permitting the reproduction of paintings in their collections. Photographs have been supplied by the owners or custodians of the works except for the following plates: Armen, Newark, N.J., 12; Baigell, Matthew, New Brunswick, N.J., 2, 53; Blomstrann, E. Irving, New Britain, Conn., 6, 54–56; Brian, Lee, West Palm Beach, Fla., 100; Burstein, Barney, Boston, Mass., 45, 90, 102, 106; Gene Campbell Studios, Lynchburg, Va., 43; Clements, Geoffrey, New York, 9, 10, 17, 18, 20, 38, 40, 46, 47, 50, 52, 65, 70; Dickey & Harleen, San Francisco, 69; Enyeart, James, Lawrence, Kan., 80; Indiana University Audio-Visual Center, Bloomington, Ind., 57, 58; Keyser, Haz, Winston-Salem, N.C., 56; William Kirk, *Kansas City Star*, 121; Lock Photos, Mason City, Ia., 104; Martin's Photo Shop, Terre Haute, Ind., 75; W. F. Miller & Co., Hartford, Conn., 22; Missouri Tourism Commission, Jefferson City, Mo., 59–64; New School for Social Research, New York, 48, 49, 51; Pollitzer, Eric, New York, 39; Power Authority of the State of New York, Massena, N.Y., 82, 83; Power Authority of the State of New York, Niagara, 84; Raveill-Farley Advertising, Independence, Mo., 120; Schnellbacher, Elton, Pittsburgh, Pa., 103; Sims, Bill, Kansas City, Mo., 5; Stockmeyer, Lewis F., Nyack, N.Y., 140; Studio Sales and Service, Inc., Kansas City, Mo., frontispiece, 1, 4, 13, 16, 19, 23–26, 29, 30, 32, 35, 37, 67, 68, 71, 72, 74, 85, 86, 88, 89, 91, 92, 94, 95, 105, 107, 109, 111, 112, 113, 115–119; Taylor & Dull, Inc., New York, 15; Thomson, John F., Los Angeles, 7, 8, 21, 93, 113; Walther, Joachim, Wichita, Kan., 101; Warner Studio, Kansas City, Kan., 81.